Vera Brittain
& Winifred Holtby

Recipient of the
University of New Hampshire
Book Prize for 1988

Vera Brittain

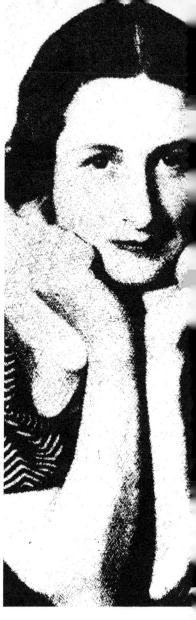

& *Winifred Holtby*

A Working Partnership

Jean E. Kennard

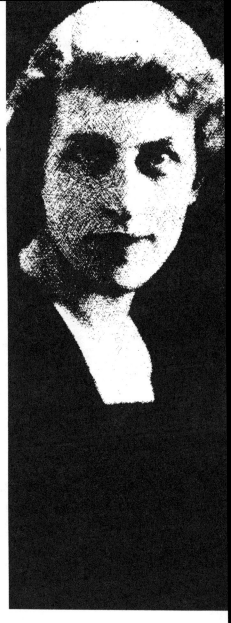

Published for
University of New Hampshire by
University Press of New England
Hanover and London

University Press of New England

Brandeis University	*University of New Hampshire*
Brown University	*University of Rhode Island*
Clark University	*Tufts University*
University of Connecticut	*University of Vermont*
Dartmouth College	

Printed in the United States of America

∞

Library of Congress Cataloging-in-Publication Data
Kennard, Jean E., 1936–
 Vera Brittain and Winifred Holtby.

 Bibliography: p.
 Includes index.
 1. Brittain, Vera, 1893–1970. 2. Holtby, Winifred,
 1898–1935. 3. Women and literature—Great Britain—
 History—20th century. 4. Authors, English—20th
 century—Biography. 5. Brittain, Vera, 1893–1970—
 Friends and associates. 6. Holtby, Winifred, 1898–1935—
 Friends and associates. I. Title.
 PR6003.R385Z75 1989 820'.9'00912 88–40351
 ISBN 0–87451–474–6
 ISBN 0–87451–482–7 (pbk.)

5 4 3 2 I

For Susan

Contents

Preface

This book was begun in September of 1981 when I found myself trapped in a small town on the south coast of England with nothing to read. My mother had suddenly become seriously ill and I had flown home without considering what I might do during the weeks I spent there. Expecting little of the small local bookstore, I explored my mother's bookshelves and rediscovered Brittain's *Testament of Youth* and Holtby's *South Riding* sitting alongside novels by Rebecca West, Mary Webb, Storm Jameson, Margaret Kennedy, and Phyllis Bentley. I had vague memories of reading both books as an adolescent in the fifties, though by that time they had already been on the shelves in our house for twenty years, long enough to become forgotten. My mother had obviously bought them when they were best sellers in the thirties, but somehow in the intervening years they had failed to establish places for themselves in the canon of twentieth-century fiction, a failure they shared with most of their companions on my mother's shelves.

I reread *Testament of Youth* and *South Riding,* discovered how good both books were, and wondered, as so many of us have about so many fine women writers, how they could have faded from memory so soon. Someone else in England shared my enthusiasm, since Brittain's *Testament of Friendship* and *Testament of Experience* had been reprinted that year and were available in the local bookstore that I had clearly underestimated. Delight in Brittain's and Holtby's work became fascination with their lives, particularly with their relationship to each other and to the women friends who were also writers and whose novels sat abandoned beside theirs on my mother's shelves.

As I worked on this book in the years that followed, more of Brittain's and Holtby's work was reprinted, thanks largely to the efforts of Paul Berry, Alan Bishop, and Virago Press, but to this date, apart from Hilary Bailey's short biography of Brittain and a few brief articles, no one has given them the attention they

deserve. This book is an attempt to rectify that omission. It is, in other words, my effort to witness to the lives of Brittain and Holtby as they spoke for their foremothers and for each other. Like so many women writers of the twenties and thirties, they testified to a generation, one they saw as partly lost, destroyed in a war Brittain at least lived to see repeated. They spent much of their lives speaking for those who had no voices of their own, either because they had died prematurely or because they were, in terms of gender or race, underprivileged. It seems, then, particularly ironic that their own words should have been forgotten so soon.

But their work is not just a testament to a certain period of English history, though Brittain's books in particular are valuable for this reason. Nor are their novels merely examples of British local color, though Holtby's *South Riding* evokes Yorkshire life as few other books do. The work they produced in the thirties stands comparison with the best literature. Brittain's *Testament of Youth* is one of the finest of autobiographies, and her *Honourable Estate* and Holtby's *South Riding* well deserve places in the history of fiction.

Their novels, together with those of other neglected women writers of the period, are important also because they represent a continued realistic tradition well into the twentieth century, one which has gone largely unrecognized and which should make us rethink our rather limited definition of modernism. *Vera Brittain and Winifred Holtby: A Working Partnership* is about Brittain's and Holtby's place in this tradition, as it is about women's friendship and, as you might expect, daughters' relationships with mothers.

Acknowledgments

Unpublished material by Vera Brittain is quoted by permission of Paul Berry and Geoffrey Handley-Taylor, joint literary executors for Vera Brittain. Unpublished material by Winifred Holtby is quoted by permission of Paul Berry, literary executor for Winifred Holtby. The photograph of Vera Brittain is reproduced by permission of The William Ready Division of Archives and Research Collections, McMaster University, Hamilton, Ontario, Canada. The painting of Winifred Holtby by F. Howard Lewis is reproduced by permission of Somerville College, Oxford.

I should also like to thank the University of New Hampshire, particularly the College of Liberal Arts, for grants of money and time in support of this project.

Vera Brittain
& Winifred Holtby

Gordon will never be *quite* the same; never quite my second self in exactly the same and dependable way.

Vera Brittain to Winifred Holtby, October 1, 1925

Whatever I may do, remember that I love you dearly . . . I'm intensely grateful to you—you're the person who's made me.

Winifred Holtby to Vera Brittain, September 26, 1935

Friendship becomes a vehicle of self-definition for women, clarifying identity through relation to an other who embodies and reflects an essential aspect of the self.

Elizabeth Abel, "(E)Merging Identities: The Dynamics of Female Friendship in Contemporary Fiction by Women"

Women writers often use their texts . . . as part of a self-defining process involving empathetic identifications with those characters . . . Through such identifications, women writers intimately unite with female readers and so foster each other's self-awareness through their texts.

Judith Gardiner, "Mind Mother: Psychoanalysis and Feminism"

When I am absorbed in reading, a second self takes over, a self which thinks and feels for me.

Georges Poulet, "Criticism and the Experience of Interiority"

Introduction

The Second Self

The quotations that begin this study are an attempt to define its parameters. They are linked by the idea of the second self, someone close enough to be experienced as inseparable from oneself and yet different enough to be felt as other. They bring together three concepts: the friendship between Vera Brittain and Winifred Holtby, the idea of female friendship as a means of self-definition, and the two selves present in any reading experience. This is a book, then, about a particular friendship, but it is also an attempt to define a way of describing the interaction that takes place between female friends and the effect of that interaction on the development of the two women. Because these women were writers who read what each other wrote, this book is also a study of the reading process, one reading, at least, of how two writers read each other's life and work.

Vera Brittain (1893–1970) and Winifred Holtby (1898–1935) were British writers whose friendship was the strongest intellectual influence on each other's work. They met at Somerville College, a women's college of Oxford University, in 1919, the year before women were finally allowed to take degrees at Oxford. Convinced by their experiences in World War I of the necessity for understanding world events in order to protect the peace, they both took degrees in history. After graduation they shared first a flat and later, together with Vera's husband, political scientist George Catlin, a house in London, and lectured widely against sexism, militarism, and racism. Besides articles for the *Yorkshire*

Post, the *Manchester Guardian,* and the feminist periodical *Time and Tide,* they both wrote fiction, nonfiction, and poetry. Holtby also wrote drama. Each is remembered primarily for one work, Brittain for her autobiography of World War I, *Testament of Youth,* Holtby for her last novel, *South Riding.* Their working partnership lasted sixteen years, despite (or possibly because of) Brittain's marriage, and was ended only by Holtby's death from Bright's disease at the age of thirty-seven. Even then the friendship exercised a strong influence on Brittain's later work and is recorded in her biography of Holtby, *Testament of Friendship.*

In terms of appearance and personality it was a friendship between two very different women: Brittain, short and dark, was moody and quick-tempered; Holtby, tall and blond, was warm and gregarious. Paul Berry calls it "a marvellous friendship,"[1] and it was literally something of a marvel. It survived Brittain's marriage and temporary absences in the United States and the demands of Holtby's numerous other friends and her family, as well as all the social pressures of the period against a friendship between women.[2]

Nevertheless, the friendship was very much the product of its period. In the years following the First World War, the particular kind of partnership Brittain and Holtby established became possible between women for the first time. This is not to say that women's friendships, although infrequently recorded, have not throughout history provided support, even primary emotional support, for the women involved. Recent work on women's friendship has documented this extremely well.[3] As Martha Vicinus has shown, close, often lifelong relationships between first-generation college women in England provided an alternative to marriage and children, which were seen as incompatible with professional careers.[4]

Like these women, Brittain and Holtby took their own and each other's intellectual ambitions seriously. It was, as Carolyn Heilbrun points out, the cherishing of each other's "ambitious dreams"[5] that provided the rock upon which the relationship was built. Unlike the earlier generation of women, though, they had ambitions that sought and could reasonably expect satisfaction in the public sphere. As lecturers and journalists they were in direct competition with male peers, as they would not have been, for example, teaching in a girls' boarding school. Brittain describes

the experience of going to lecture for the League of Nations Union and being greeted with the words, " 'I thought headquarters was sending us a *proper* lecturer.' "[6] Their friendship followed "a male pattern," Heilbrun explains. "They looked forward, as young men did, to leaving the university for London, work and 'life.' "[7]

Brittain and Holtby differed from the earlier generation of college women also in their attitude toward marriage. Their female role models, like those of their predecessors, were primarily academics and primarily celibate, and as Carol Dyhouse points out, the celibate life-style of women in single-sex schools and colleges "helped to foster the illusion of there being a necessary choice confronting all women between career and marriage."[8] Neither Brittain nor Holtby was prepared to accept this choice as a given; they discussed the issue frequently in letters and, more formally, in print. Brittain writes to Holtby in 1931: "The only questions that remain to be answered are: (1) How many married women don't write at all, who, left alone, would? (2) Would the ones who do write well write more if unmarried, and would their place in literature be better if they did—i.e. with more time would Alice Meynell have been a Shelley? Or is it really an advantage to be interrupted—because then your work is your play and you go to it with a zest which soon stales if one thinks of work as work?"[9] Holtby writes to Brittain in 1923: "I for one do not believe that it is right to leave the upbringing of the bearing of children to the mediocre. Neither sex nor marriage as its social expression are wrong, I think. What is wrong is this collision between the institutions of domesticity, and public service, and the reason for this collision is not unavoidable. It has occurred because we live during a transition period."[10]

For Brittain there was clearly tension between the idea of an academic career and her concept of femininity, perfectly understandable in a world where one of her mother's acquaintances, upon hearing that Brittain had been accepted to Oxford, could say, " 'How *can* you send your daughter to college, Mrs. Brittain! . . . Don't you want her ever to get *married*?' "[11] So while Brittain is critical of her school friends at St. Monica's who are only interested in getting engaged before everyone else, she is equally critical of schools that "sterilised the sexual charm out of their pupils"[12] in order to train them for exams. Her attitude to the celibate women dons at Oxford reflects the same ambivalence.

While respecting them academically, she regrets that they would only give advice on matters concerned with "brains" and suggests that this "lack of compassion" will not be remedied until "teaching posts in schools and universities are open to married women who have known the humors, exasperations and minor tragedies of normal family life."[13]

These comments are interesting in that they reflect one of the most significant postwar influences affecting women, the emphasis on heterosexual experience as healthy, liberating, and "normal," and its lack as damaging to mental health. The postwar attitude to sexuality did indeed represent liberation in some ways. Work itself had made women's clothes more practical, in Edwardian terms more revealing. Nursing the wounded had given some unmarried women—Brittain among them—a practical knowledge of the human body that made the euphemisms of prewar conversation ridiculous. "Amongst our friends," says Brittain, "we discussed sodomy and lesbianism with as little hesitation as we compared the merits of different contraceptives."[14]

Although for many, as for Brittain herself, this liberation may have been merely verbal, the number of so-called war babies alone suggests that some women also acted upon it. "Chastity seems a mere waste of time," explains Helen Zenna Smith in *Stepdaughters of War*, "in an area where youth is blotted out so quickly."[15] Many women were away from home for the first time. "It was still an adventure to go about London alone,"[16] writes Brittain. Since being restricted to the house had, symbolically if not actually, been a way of ensuring female celibacy, no wonder that freedom from home represented for many sexual freedom.

If the postwar attitudes toward sexuality were in some ways liberating, in other ways they narrowed the options for women. The contemporary view of marriage also, for example, served to label intense relations between women as deviant. Psychologists Havelock Ellis, Stanley Hall, and Freud gave women the right to erotic pleasure but limited where it might be obtained. Rather than in motherhood, women were now expected to find fulfillment in the arms of a male sexual partner. Marriage as a partnership of equals for the physical and mental benefit of both became an ideal, an ideal very much in Brittain's mind when she married George Catlin. Rayna Rupp and Ellen Ross point out

that "the same psychologists who 'liberated' women's heterosexuality pinned punitive labels on those who could or would not conform to the new prescriptions. . . . Psychologists diagnosed feminists as neurotic."[17] Female bonding, whether overtly lesbian or not, was sufficiently feared by educators for provisions to be recommended against it. In a book on adolescence that actually predated the war but was typical of what came after it, Stanley Hall recommended that every female institution have at least one very attractive married man on its staff.[18]

Brittain appears to have accepted without question the post-Freudian attitude to sexuality. As Hilary Bailey says, "Vera had some faith in the theory that marriage was essential and celibacy highly deleterious to women."[19] This attitude is reflected in Brittain's description of "pleasant, normal afternoons" spent with male officers, albeit limited to "agreeable teas," as occasions that "saved us from the neuroses that spring from months of conventual life."[20] Similarly, she explains her brief engagement to an undergraduate in 1920 as a folly into which she was driven by "the biological needs of that tense, turbulent year."[21]

It can be seen too, I think, in her concern that her friendship with Holtby should not be labeled lesbian despite her comparison of it to the relationship between David and Jonathan[22] and the often passionate language with which she records their closeness. "What disturbs Brittain, of course," as Lillian Faderman says, "is the possibility that her readers would see in her love a congenital taint, or arrested development."[23] No longer living in a world where close friendships between women were assumed to be sexually innocent, Brittain offers explicit disclaimers. "Skeptics are aroused by any record of affection between women to suspicions habitual among the over-sophisticated," she says in *Testament of Friendship,*[24] and later she laughs at the typical "Chelsea" suspicions of the ménage à trois with her husband and Holtby. In preparing the letters between herself and Holtby for publication as *Selected Letters,* Brittain removed all terms of endearment from them as if concerned about lesbian speculations. In his introduction to her journalism, Paul Berry quotes a letter to Sybil Morrison in which Brittain denies having had any relationships with women. He claims, too, that "she left among her papers a scarcely legible pencilled note written when she was ill

and knew she was not going to get better. 'I loved Winifred,' she had scribbled on a leaf torn from a small pocket notebook, 'but I was not in love with her.' "[25]

The extent of Brittain's concern over this question is perhaps understandable given the homophobia of the period, though it is hard to believe it would have extended into the 1980s. Even by 1968, when she is writing her book on the *Well of Loneliness* law case, she is much less defensive about homosexuality. In her foreword to that book, she claims that her 1928 review of Radclyffe Hall's lesbian novel was not what she would write at present. She points out that a book must be reviewed "within the climate of its generation." This climate, she says, "has changed beyond recognition in the past forty years" on the subject of "sexual inversion."[26]

Holtby was far less defensive than Brittain about charges of lesbianism. Her 1928 response to *The Well of Loneliness,* recorded in an unpublished section of a letter to Brittain, indicates this. She claims that Radclyffe Hall was completely wrong and that love between women is not pathological. She ends *Women and a Changing Civilisation* with a plea for that recognition of individuality that was so characteristic of her work. Pointing out that we do not know "whether the 'normal' sexual relationship is homo- or bi- or hetero-sexual," she calls for acceptance of difference in the name of freedom. " 'We want men who are men and women who are women,' writes Sir Oswald Mosley. He can find them," she says, "at their quintessence in the slave markets of Abyssinia."[27]

Holtby recognized that the association of heterosexual experience with fulfillment was a historical construct. Blaming Freudian psychology and D. H. Lawrence for our veneration of sex, she argues against associating spinsterhood and frustration. "All flesh is not the same flesh," she claims. "If we did not suffer from a lamentable confusion of thought we should not allow one form of satisfaction to blind us to all others, and we should permit a more common and more merciful realisation of the fact that in the twentieth century frustration and spinsterhood need not be identical."[28]

Writing in the 1980s I am, of course, as bound by the constraints of my time as were Brittain and Holtby. It is not possible today to write about a female friendship such as this, and feel

one has adequately treated the subject, without raising directly the question whether or not it was a lesbian one. Paul Berry claims it was not; Lillian Faderman writes of Brittain and Holtby as a lesbian couple. Their definitions of *lesbian* are, of course, not the same, and the answer to the question may well be a matter of definition. Berry assumes that *lesbian* necessarily implies an erotic physical relationship. Certainly there is no written evidence that I am aware of for a physical relationship between Brittain and Holtby, though I do wonder whether, given Brittain's anxiety on the subject, one could reasonably expect there to be at this time. It is also true that when Brittain and Holtby talk about sexual experience in private letters there is a clear implication that physical love means heterosexual sex. For example, in a very significant unpublished letter written to Holtby while Brittain was on her honeymoon, Brittain says, "Apart from physical love—which in my case is much less vigorous than I thought and much more easily satisfied—I am sure that I love you best, and that your companionship is more adequate."[29]

On the other hand, the terms of address between Brittain and Holtby are terms more characteristic even at that time of an erotic relationship. "Darling," "sweetieheart," "beloved" are common; Brittain is "V.S.V.D.L.," very small, very dear love; at various times Holtby calls her friend "lover," "spouse," "husband," talks of kissing her "pretty fingers tip by tip," and of loving her "small beloved body." Almost all these endearments have been edited out of the published correspondence. Even more significant, it seems to me, is the fact that, particularly in the period immediately following her marriage to Catlin, Brittain frequently compares the two relationships as if they have been in competition with one another, as the quotation above illustrates. In the same letter she looks forward "to an ideal life, perhaps not more than a year or two ahead, in which you and he play an equal part."

The friendship between Brittain and Holtby may not have been an erotic one, or it may have been for a brief time before Brittain's marriage, but in terms of Faderman's definition, which depends upon primary emotional intensity rather than upon physical contact, it was certainly lesbian. In 1975 Carroll Smith-Rosenberg opened up the possibility of a broader definition of lesbianism by demonstrating that women in nineteenth-century America frequently formed lasting, primary emotional bonds with other

women that were often expressed in passionate language though probably not in sexual contact.[30] Since then several scholars have adopted a definition that does not necessarily include genital contact or even eroticism. Such a definition is the basis for the selection of the couples discussed by Faderman and is the one Blanche Cook supports. Cook claims that "women who love women, who choose women to nurture and support and to create a living environment in which to work creatively and independently, are lesbians."[31] Similarly, Adrienne Rich suggests using the terms *lesbian existence* and *lesbian continuum* to "embrace many more forms of primary intensity between women."[32]

It is impossible to deny that the partnership between Holtby and Brittain was one of primary intensity, whether or not one is willing to call it lesbian. And it is important to an understanding of their development both as women and as writers to recognize this. Holtby writes to Brittain, "I love you in a way that part of me has become part of you. . . . I who am part of you, can only gain by your gains."[33] Although Brittain was married, Holtby remained the primary influence in her life; in 1926 she writes of Catlin to Holtby in an unpublished letter, "You are more necessary to me than he is, because you further my work."

Their relationship was rooted in the sharing of their work. The work was writing, primarily fiction and journalism; it was both their means to independence and a primary reason for desiring independence. They justified this "selfish" emphasis on their own ambitions by claiming the benefits to society. What women today would have little difficulty in calling self-development, Holtby and Brittain called public service. And this shared stress on public service is a primary context within which to understand their mutually enabling relationship. The secular idea of service was inherited from an earlier generation of women who were trying to resolve the conflict between their ambitions and the qualities they had been taught were acceptably feminine. Carol Dyhouse points out that "a very common resolution of the conflict was for women either consciously or unconsciously to seek to channel their ambition and their energies into the traditionally female area of service, either to God or to fellow mortals . . . Learning was not, for any of them, a form of self-development, it was a form of service."[34]

For both Brittain and Holtby the definition of public service

was broader than for such a woman as Dorothea Beale, principal of Cheltenham Ladies' College in the previous generation, who saw it as a form of self-renunciation, but like her they defined their life's work in humanitarian terms. Looking back at the end of World War I, Brittain writes, "It may be that our generation will go down in history as the first to understand that not a single man or woman can now live in disregarding isolation from his or her world. I don't know yet what I can do, I concluded, to help all this happen, but at least I can begin by trying to understand where humanity failed and civilisation went wrong."[35] Brittain describes Holtby's desire to serve as rooted in her family's tradition of philanthropy, as inherited particularly from her mother. "Winifred," she says, "had a stern moral battle to fight every time she resisted the summons of a good cause or ignored an unfortunate fellow creature."[36] Studies of nineteenth-century women show that Holtby had in fact inherited this attitude from a wider group of foremothers.

Nevertheless, although Brittain is perhaps readier to admit to being ambitious, both acknowledge the aspect of self-development, in the sense of maximizing one's talents, in their desire to perform public service. "To ladle soup in a slum kitchen when one should be defending Justice as a King's Councillor, or Truth as a writer or philosopher is blind sacrifice, which may even be deliberate cowardice and fighting away from the light," writes Holtby to her mother.[37] In talking about Florence Nightingale, Brittain admits that the "womanliness" of the nursing profession, the most readily acceptable career for women because of its nurturing aspects, attracted her and many others during the war. Yet she recognizes that no profession "has suffered so emphatically as nursing from the glamorous falsifications of sentimentality." The changes brought about by Florence Nightingale, she claims, could only have been wrought "not through the gentle 'Lady of the Lamp' but by a hospital matron of the most ruthless and aggressive type."[38]

The Victorian myth of Florence Nightingale that transformed the hospital matron into the saint clearly illustrates the terms upon which female drive and energy were acceptable. Although new schools were founded in the late nineteenth century that improved education for females, they were basically supportive of this conventional view of woman as nurturing angel. Such schools as

Roedean, Cheltenham Ladies' College, and those belonging to the Girls' Public Day School Company may have had feminist results but were not, as has been claimed, truly feminist projects. They did not educate girls to challenge the status quo; indeed, they were often ventures supported by middle-class men who would not knowingly have supported any challenge to the conventions of family life.[39] Brittain defines her own school, St. Monica's, as "apparently regarded by many of the parents who patronised it as a means of equipping girls to be men's decorative and contented inferiors."[40] Even her history teacher, Miss Heath Jones, an "ardent but always discreet feminist,"[41] who lent her books and took the girls to a suffrage meeting, gave them cuttings from newspapers but never the whole newspaper. As Carol Dyhouse points out, "This prohibition on newspapers in so many girls' private schools stemmed, of course, from the belief that the public world of newspapers and business was a male concern—women needed to be insulated from the world."[42]

It is hardly surprising, then, that those women who wanted careers even after 1918 felt the need to reconcile their ambitions with social good. Both Brittain and Holtby felt this need, but because, like other women of their generation, they were no longer content to choose between marriage and work but claimed the right to both, their challenge to the sexual division of labor and thus to society as a whole was more fundamental than that of their college-educated predecessors. They aimed to help society by changing it radically.

In the most obvious sense they did this by working directly for a variety of social and political causes. They worked actively for peace, primarily through the League of Nations Union, and for a number of feminist causes, and Holtby in particular was involved in the fight against racism in South Africa. For Brittain and Holtby these were in a fundamental sense one cause, the fight for "equal humanity," as Brittain called it in an article on Mrs. Pankhurst,[43] the fight against the oppression of the individual. Their view of these issues as a common cause affected the arguments they used to support them and the way in which they worked both with each other and with other people. Because opposition to oppression of any kind was the base upon which their views were built, they resisted imposing their views upon each other. In a 1924 letter to Brittain, Holtby refers to her "in-

vincible belief that no one person should lay too heavy claims upon another," to the importance of letting "each one of one's beloveds feel completely free."[44]

Nevertheless, what is celebrated by both of them is thinking alike. Brittain describes an instance of apparent telepathic communication between them and attributes it to being so much together: "After a year or two of constant companionship, our response to each other's needs and emotions had become so instinctive that in our correspondence, one of us often replied to some statement or request made by the other before the letter which contained it had arrived."[45] It is in part this sense of identity that makes Brittain describe Holtby as her "second self."

The movement in their intellectual relationship was, then, toward consensus, an effort toward identity of viewpoint. Brittain did not agree to differ with Holtby as she did, for example, with her husband. The biographical material suggests that effort was necessary, that their intellectual unity was acquired, the result of an ongoing conversation with one another. For example, Holtby claims Brittain taught her to be a feminist; Brittain claims Holtby "helped me to think more clearly, and I hope I did the same for her. Often in our correspondence, we were feeling our way to conclusions not immediately obvious or easily reached."[46] A description of their relationship, then, must inevitably be in part a description of this conversation.

Their friendship was, of course, more than an intellectual discussion. It had a powerful effect on their individual development both as women and as writers. Each quest for self-definition, each voyage toward maturity, was made possible by the other. I shall, then, also be tracing in this study the effect of the relationship on those individual quests in terms that I believe apply to female friendships generally. That the two women were writers is helpful in that it makes it possible to trace their development in their written material and to speculate on the connections between their personal development and the nature of the literature they wrote.

In the case of Brittain and Holtby, perhaps even more than with other writers, the written word is evidence of their interaction. Almost always they responded only to each other's completed work; any attempt to influence the process was seen as a form of oppression, a stifling of the individual creative act. In a

1925 letter now at McMaster University, obviously written to Catlin in an attempt to mediate between him and Brittain, Holtby discusses this aspect of her working relationship with Brittain:

> I know this from experience, for curiously enough, when I first saw Vera she tried to do to me what you try to do to her. Knowing my very great faults as a writer, she tried to cure them by analysing and criticising my ideas before they became books; by suggesting how and what and why I should write. It really drove me crazy until I had to set a complete taboo upon her discussion of my work save after it was done. Her criticism of my finished and published stories is most helpful. It enables me to avoid errors next time; and I think has been of more value to me than anything.

Both Brittain's and Holtby's work shows the need to struggle with certain concepts or problems—companionate marriage, for example, is a central topic in Brittain's fiction—a fact which suggests that writing was their way of dealing with life. Brittain wrote of one of her later novels, *Born 1925,* "in this novel I have sought to work out some of my own problems vicariously."[47] Events, people they knew, and particularly each other and each other's work thus became texts to be read and interpreted in print. For their readers, then, their written work can become an opportunity, among other things, to understand their psychological development and their relationship with each other. My reading of Brittain and Holtby will in this respect draw on the work of Meredith Skura in *The Literary Use of the Psychoanalytic Process.*[48]

For Brittain and Holtby, dealing with life through literature involved two major activities: writing as a form of catharsis and writing as a means of self-definition. In *On Being an Author* Brittain devotes several pages to quoting other writers on the subject of writing as catharsis. She describes her own coming to terms with the personal tragedies of World War I through writing *Testament of Youth.* The author, she claims, "is one of the few men and women who can set himself free from fear and sorrow. He can, if he chooses, write these scourges of the spirit out of his system."[49] Similarly, Holtby describes writing her first novel, *Anderby Wold,* as a way of curing the heartbreak she felt when her father sold the family farm.[50]

While in a general sense it is obviously true that all writers express their own personalities in their work, the particular pro-

cess of self-definition that both Brittain and Holtby underwent through their writing seems to have been a peculiarly female one. Writing about Margaret Fuller's texts, Bell Chevigny says, "I interpret them, like those of other writers, as imaginative constructions. In Fuller's case, I read them as strategies by which the author sought to explain or justify her current sense of herself, a need that might be especially strong in a woman who felt herself moving into uncharted waters."[51] Talking of the way in which women writers use their texts as part of a self-defining process, Judith Gardiner suggests that "the author often defines herself through the text while creating her female hero in a process analogous with learning to be a mother, that is, learning to experience oneself simultaneously as a well-nurtured child and as one's own nurturing parent, and, at the same time, learning that one's creation is separate from oneself."[52]

Gardiner's words link the concept of self-definition or female development to the relationship between mother and daughter, a connection that is a particularly fruitful beginning for a discussion of female friendships. "Female identity formation," Gardiner says elsewhere, "is dependent on the mother-daughter bond."[53] In recent years feminist scholars, drawing on object-relations theory, have established a body of work that has challenged the traditional Freudian account of psychosexual differences. Dorothy Dinnerstein, Nancy Chodorow, Adrienne Rich, Carol Gilligan, and Kim Chernin among others trace the effect of gender on the development of identity to the mother-daughter bond and thus to early infantile experience rather than to biological differences.[54] The importance of this work has become accepted by feminist scholars generally and is beginning to prove very useful to literary critics.[55] My discussion of female friendship will use the mother-daughter scholarship as a starting point, accepting its premises while looking at a later stage of female development.

According to the mother-daughter theorists infancy is a period in which the seeds of all future development are sown. The mother, seeing the daughter as an extension of herself, remains more closely bonded to her female than to her male offspring. While boys are encouraged to become separate from the mother and thus move more easily toward a sense of an independent self, for girls this process is far more difficult. "Ego boundaries between mothers and daughters," Marianne Hirsch says, "are more

fluid, more undefined. The girl is less encouraged to be autonomous, but she is also less nurtured, since the mother projects upon her daughter her own ambivalence about being female in a patriarchal culture."[56] Holtby's mother, for example, encouraged her daughter to go to Oxford and had her first volume of poetry privately printed but still insisted on her meeting her obligations as a dutiful daughter; she was "constantly summoned to Yorkshire by a matriarchal parent whose strong sense of feudal obligation embraced the whole family in its comprehensive sweep."[57] Holtby herself writes about her experiences at Oxford: "I thought I was learning how to get a first and please my mother and my tutors. I did neither. What I was learning was how to earn my living as a journalist and please myself."[58]

The result of incomplete separation is continued ambivalence toward the mother on the part of the daughter, an ongoing process of separation and fusion, an attempt to balance symbiosis and matrophobia. Because she is bound to her mother by recognition of their shared physical characteristics, trained to adopt the patterns of her relationship to the world, the female child's assertion of separateness and independence necessarily involves a rejection of the mother. Female development can be described, then, as an attempt to resolve this conflict.

The struggle must, of course, be particularly severe in a period when the expectations and the opportunities for women are changing dramatically between generations. In her introduction to their selected letters written in 1960, Brittain is much harsher on the subject of the oppression of daughters by mothers in her generation than she had been in *Testament of Friendship,* when both Holtby's mother and her own were still living. As in the earlier work she quotes May Sinclair—"A woman cannot get away from her family even in its absence"—and talks of "the benevolent but costly despotisms still rampant during Winifred's youth and mine."[59]

For Nancy Chodorow the resolution of the conflict between mother and daughter lies for most women in "the reproduction of mothering"; women work out their relationships with their mothers in their relationships with their daughters. Women become mothers in order to reexperience connection and to compensate for a heterosexual relationship with a man whose desire for emotional connectedness has been curtailed in early infancy.

"Thus," Chodorow says, "women's heterosexuality is triangular and requires a third—a child—for its structural and emotional completion. For men, by contrast, the heterosexual relationship alone recreates the early bond to their mother; a child interrupts it. Men, moreover, do not define themselves in relationship and have come to suppress relational capacities and repress relational needs."[60]

There is general agreement among feminist scholars of female development that women retain a desire for connection with others and both achieve and evaluate a sense of self through personal relationships. "In their portrayal of relationships," says Carol Gilligan, "women replace the bias of men toward separation with a representation of the interdependence of self and other, both in love and in work."[61] Commenting on Chodorow's ideas, Gardiner writes, "Throughout women's lives, the self is defined through social relationships; issues of fusion and merger of the self with others are significant."[62]

This desire for connection accounts for the emphasis such women as Brittain and Holtby placed on their friendship, but it does not explain the function of that friendship in their individual quests for maturity. I suggest that an alternative formulation to Chodorow's hypothesis that a child is needed for a woman's "structural and emotional completion" might be the concept that a close female friend can help to resolve the ongoing struggle of the woman with her mother. The friend as a second self provides a way of separating from the mother without rejecting the female self-image she represents, for the friend is after all a similar image. The friend, like the mother, provides connectedness but not a connection that is an obstacle to independence. That the friend can—though I do not mean to suggest always does—take the place of a child in Chodorow's triangle is suggested in the unpublished letter to Holtby Brittain wrote on her honeymoon: "You may marry yourself, but I venture to say—the likenesses between us justifying me in so saying—that even if you do, you will continue to feel the same persistent need for my companionship and my understanding as I now feel for yours."

Chodorow's own comments on the prepubescent period of female development suggest the possibility of extending the formulation into adulthood. In discussing Helene Deutsch's description of the girl's attempt to break from the mother, Chodorow

says, "Another solution . . . and one adopted by many prepubertal girls, is to find a 'best friend' whom she loves, and with whom she is identified, with whom she shares everything. This friend in part counteracts the feelings of self-diffusion which result from the intensely experienced random identification-attachments in which the girl has engaged. Her friendship permits her to continue to experience merging, while at the same time denying feelings of merging with the mother."[63] In her account of adolescent Victorian girls, Martha Vicinus suggests a similar proposition: "The proper use of friendship could actually enhance the development of personal autonomy without loss of family ties."[64] Elizabeth Abel has indeed pointed out the possibility of female friends as an alternative to children in Chodorow's scheme, but she stresses the literary representation of female identification with "a woman who is older or who is perceived as either older or wiser."[65] I want to extend the valuable work of these feminist scholars into an examination of a partnership between two adult women who saw themselves as equals.

"Female friendship," explains Janice Raymond, "begins with the companionship of the Self."[66] It is a recognition of another like oneself, a second self, that prompts the relationship and allows for a break with the mother. The friend as mirror reflects a sense of the ways in which one differs from one's mother. Holtby was Brittain's age, her peer in education and in experiences of the war; she presented the possibility of a femaleness that was not that of Brittain's mother or the world she represented.

Second selves are mutually empowering. Using the term *Gyn/affection* for female friendship, Raymond explores the meanings of the word *affection*. "There is another meaning to affection, however," she says, "which conveys more than the personal movement of one woman toward another. Affection in this sense means the state of influencing, acting upon, moving, and impressing."[67] Similarly, Bell Chevigny, talking about the process of women writing the biographies of other women, examines the term *authority* in ways which are relevant to a discussion of female friendship: "Authority is male, but we know that women can and do *authorize,* and we can learn to authorize the challenging and independent aspects of one another."[68] It is, as Brittain said to Holtby, in the July 1925 letter I quoted above, "likenesses" that "justify." It is this confirmation of self that makes Brittain claim

in unpublished correspondence of the same period that "the companionship of even the most charming man is so much less adequate than that of a woman," and tell Holtby that "a world with Gordon, but without you, would be much more lonely than a world without Gordon but with you." It was unfortunately a statement she was destined to test.

No two people, of course, can be exactly alike, and the relationship with the second self must necessarily involve an awareness of differences. Chevigny suggests that the excitement of recognition itself "bears within it the urge to scrutinize those elements that keep it from being an exact duplication." This sort of identification is, then, "potentially analytical," "dialectical rather than static."[69] Two friends such as Brittain and Holtby are involved in an ongoing dialogue, the aim of which is to resolve differences because what is valued is thinking alike; strength is drawn from the image of sameness. They both empower and rewrite each other in an attempt to reach consensus. They "authorize" in both senses Chevigny names, then, "not only the granting of sanction but also, and simultaneously, a recreating ('authoring')."[70]

One way of describing the process between Brittain and Holtby is to see it as the mutual creation of acceptable fictions. These fictions are versions of each other and the other's world compatible with images of the self that each is able to live with. As Patrocinio Schweickart says, women "are most concerned in their dealings with others to negotiate between opposing needs so that the relationship can be maintained."[71] Women also authorize each other in a third way, then, by making authors of each other. Brittain and Holtby did this in a literal sense, of course, since they encouraged each other to write. Their conversation, their attempt to reach consensus, took place on the page; they defined themselves through their written texts. This female friendship is thus not merely paradigmatic of the reading process but a literal illustration of it.

Elizabeth Abel has pointed out that "the clearest emphasis on a collaborative relationship that echoes the dynamics of female bonding occurs in reader-response criticism."[72] Basically, reader-response theorists see reading as a meeting between the reader and the text that depends as much upon the nature of the reader as upon the nature of the text. The reader is thus an active agent

in the creation of the text. This transaction parallels the personal interaction of friendship and like it involves the meeting of the self with a second self, a character or characters in a novel, for example.

In the case of Brittain and Holtby, who are both writers, the reader of one text becomes the author of another text, which is a rewriting of what she has read. In particular, fiction, with its imaginative license not to have to pretend to be the truth, becomes the opportunity to rewrite each other in relation to the self, to construct a reading of the other compatible with an acceptable version of oneself. Thus each becomes the other's subject and each the other's author—"you're the person who's made me," writes Holtby to Brittain—as well as being each the other's reader (in the sense also of being the work's intended audience or implied reader). As a reader each necessarily compares her own view of herself, of a shared experience, of an idea, with its presentation in the other's text and in turn reflects this response in her own rewriting. So, for example, Holtby's *The Crowded Street* can be read as an answer to Brittain's *The Dark Tide,* Brittain's *Not without Honour* as a comment on *The Crowded Street.*

Wolfgang Iser, whose work on reading as a transaction provides useful language in which to describe this sort of peer influence, talks of it as a "need to familiarize the *unfamiliar.*"[73] Another way of saying this might be to talk of the reader, Holtby for example, attempting to reach an accommodation, a consensus with the text, say a novel by Brittain. The reading process, according to Iser, involves "a junction of new and old," in which the "old conditions the form of the new, and the new selectively restructures the old." There are, then, two selves involved in the process, the reader's old, familiar self and the new or second self encountered in the text; the reader's reception of the text is based "on the interaction between the two."[74]

Iser draws on theories of social interaction as paradigms for reading, but the usual reading experience differs from social interaction in two ways, as Iser himself realizes. One, reading moves inevitably toward closure and ends with a finished text. This would be true even if, as some critics claim, the text is wholly the creation of the reader. Two, with reading, unlike social interaction, "there is no face-to-face situation." The reader "can never learn from the text how accurate or inaccurate are his views

of it."[75] But in the case of two readers/writers who are friends, theories of social interaction are clearly a far more exact paradigm for the reading process. The text may close but is repeatedly reread and so in a sense never closes; and the reader may learn from the text's next rewriting how accurate her reading was. In the case of Brittain and Holtby, as I suggest for female readers generally, the word *accurate* should be replaced with *acceptable,* since the psychological comfort to be drawn from consensus is the motive behind the rewriting. The model I am suggesting here is consistent with that of Patrocinio Schweickart in her essay "Toward a Feminist Theory of Reading." Drawing, as I do, on the work of Chodorow, Gilligan, and Rich, Schweickart points out that the differing attitude of men and women toward relationships is consistent with the difference between other models of reading and the feminist dialogic model she proposes, which is characterized "by the drive 'to connect'" rather than by "the drive to get it right."[76]

The process of reading for women is a search for similarity and, in the face of difference, a modification in the direction of similarity, because it is fundamentally a search for the empowering image of a second self. Talking of her class of women students reading literature by nineteenth-century American women writers, Judith Fetterley says, "Many of them spoke about the ratification and legitimization of self, indeed the sense of power, they derived from reading these texts and the relief they felt at finding within the academy an opportunity to read something other than texts by and about men."[77]

But to read is inevitably to recognize differences. "We may stress the value of sympathy," says Virginia Woolf, "we may try to sink our identity as we read. But we know that we cannot sympathise wholly or immerse ourselves wholly."[78] Indeed, the harder we attempt to identify the more likely we are to experience difference. This phenomenon is explained by a concept I call polar reading that is based on the therapeutic techniques of Joseph Zinker.[79] Attempting to identify we "lean into" a text, but this in the end only draws our attention to our differences. When we exaggerate one side of a polarity or aspect of the self, the other side gets attracted toward it, pulled as if in a magnetic field. The side that gets pulled is redefined and solidified in the process. Zinker calls this the "around the world" phenomenon: "If you

keep flying north long enough, you'll eventually be heading south."[80] For example, Holtby identifying with Brittain's portrayal of her as Daphne Lethbridge in *The Dark Tide* comes inevitably to particularize the ways in which she is unlike Daphne. Her sense of her self is thus strengthened rather than weakened. We do not lose ourselves in books; rather, we redefine aspects of ourselves through contrast with the opposite aspects in a fictional other self whom we have temporarily experienced. Thus, as Iser says, the result of the reading process is therapeutic to us for "it enables us to formulate ourselves."[81]

As I suggested above, the empowerment provided by the second self in life and in literature allows women to resolve their ambivalent relationship with their mothers, but this is an ongoing process with several stages. In the case of female writers like Brittain and Holtby these stages are clearly reflected in the literature they wrote, so to trace their individual quests for self-development is also to trace their development as writers.

The first stage is characterized by the attempt to separate from the mother and what she represents. Individual mothers of course differ, as Brittain's and Holtby's did, in their relationships with their daughters, but they all necessarily represent to those daughters what it means to be female in the world into which they are born. In some sense, then, they always stand for home. To separate from the mother means to separate from the nurturance and connection she embodies as well as from her limitations. In her discussion of female heroism Lee Edwards points out that "as long as the mother is conceived as standing for qualities inherently opposed to those required for achievement in the larger world, as long as she either stand aloof from this world or becomes its victim, heroism must necessarily divorce itself from the human virtues of her sphere as well as from its rigidities and confinements."[82]

For this reason the first stage is initially fraught with ambivalence, as it is in both Holtby's and Brittain's first novels, *Anderby Wold* and *The Dark Tide*. The love/hate relationship of Holtby with the Yorkshire world of her upbringing reflected in *Anderby Wold* is typical of this stage. Interestingly, ambivalence can sometimes produce a more complex and more richly textured novel than the completed rejection of the mother's world. *Anderby Wold* is in these respects perhaps a better novel than either Brittain's

or Holtby's second novels, *Not without Honour* and *The Crowded Street,* which are harshly critical of female provincialism. The work of this first stage is, as one would expect, thematically concerned with the concepts of separation and power.

At the second stage female friendship provides more than a mirror or an alternative model to mother; it provides a base from which to look outward. Janice Raymond explains this function of friendship for women particularly well: "Friendship gives women a point of crystallization for living in the world. It gives form, shape, and a concrete location to women who have no state or geographical homeland and, in fact, no territorial ghetto or diaspora from which to act . . . Thus a sharing of personal life is at the same time a grounding for social and political existence."[83] A woman's task at the second stage is to find her relation to, her place in, the public world.

While Brittain and Holtby's shared personal life provided exactly this sort of grounding from which to launch their various individual social and political activities, it also allowed them at this stage the freedom to write works that were, superficially at least, very different from each other's. Brittain's way of defining her place in the public world was to write an autobiography, *Testament of Youth,* which she describes as a story of rebirth after the emotional death caused by the loss of her fiancé and brother in World War I. It was a work of rebirth in other ways too, for in it she remade herself, taking her own diaries and letters and rereading them with older eyes. Unlike Brittain's apparently very personal document, Holtby's work at this stage became increasingly impersonal, moving toward satire in *Poor Caroline* and into what Marion Shaw has called "a masculine form, the novel of political comedy,"[84] in *Mandoa, Mandoa!* Shaw points out that this novel "can be seen as the antiphonal voice to that of a work which was being written alongside it, Vera Brittain's highly personal and 'feminine' *Testament of Youth.*"[85] Despite the obvious differences in form, however, Brittain's and Holtby's work at this period shares a common, dominant theme, the relationship of the personal and public selves.

The third stage, which seems to produce the richest and most mature work, is characterized by a continued rewriting of one's own earlier material, an activity Brittain began in part in *Testament of Youth* and Holtby in *The Land of Green Ginger.* Holtby's

South Riding is in many ways a rewriting of *Anderby Wold,* for example; Brittain's *Honourable Estate* a rewriting of her own life. They have become their own second selves. At this stage the mother is in a way reclaimed, often in the form of a different, more acceptable female figure. The self in these novels finds her place in a recreated world, and the claims of the personal and the public worlds are balanced. But this synthesis can only come about, as Lee Edwards says, after the reconstruction of the bonds "between mother and daughter, so that the claims of the mother will not be synonymous with those of the socially conventional feminine." The daughter comes to see herself as "a person possessing a legitimate inheritance from a spiritual if not a biological mother, an inheritance that, as it no longer implies a balance of infantile dependency and fearful tyranny, can be passed on as a useful model."[86]

The kind of self-development I am describing here may at first seem to differ little from the classic form of the male *bildungsroman* or even of the novel as genre. The relationship of the private and public selves, of the individual to society, is, as Northrop Frye among others says, the chief interest of the novel.[87] In particular the kind of separation from and rejection of society representative of my first stage may seem to resemble the kind of exile chosen by so many literary heroes and their creators at the beginning of the twentieth century. But the female writer, like her female protagonist, is no Stephen Dedalus. Firstly, she remains to a certain extent always ambivalent about some of the values she has been forced to give up in the name of autonomy. Secondly, since a place in the public world is not automatically provided for any woman, she starts from a position of alienation. Her rejection is only of the confinements of her mother's world; her struggle is to enter a larger world. Stephen Dedalus may have to define what kind of writer he is to be but he does not have to defend his right to define himself as a writer. Rachel Blau DuPlessis points out that once women have achieved a place in the public sphere, they remain more involved with society. The woman writer, she says, makes her female protagonist "try to change the life in which she is also immersed. This differentiates the figure in the female *Kunstlerromane* from the fantasies of social untouchability or superiority that are prevalent in modernist depictions."[88]

Brittain and Holtby are representative of many women writers

in the twentieth century who worked in a basically realistic mode. Several of these women—Rebecca West, Storm Jameson, Phyllis Bentley, Hilda Reid, Beatrice Kean Seymour, for example—were personal friends, many of them fellow Somervillians. Together with these women and others, Brittain and Holtby, I suggest, continued a tradition of English fiction exemplified by George Eliot. Conscious of the connection and deeply admiring of Eliot, they referred to her frequently in letters and other nonfiction prose.[89] Marion Shaw points out that *South Riding* is in the tradition of George Eliot's *Middlemarch*.[90] The tradition that "played out its possibilities for males" still offers a vital form for women, claim Elizabeth Abel, Marianne Hirsch, and Elizabeth Langland. "Women's increased sense of freedom in this century, when women's experience has begun to approach that of the traditional male *Bildungsheld,* finds expression in a variety of fictions."[91]

The pattern of self-development through interaction with a second self that I see epitomized in Brittain and Holtby is in some ways uniquely female, but its expression in literature links their work to one of the great traditions of the English novel and in so doing makes it part of a counter-tradition to the dominant male modernist mode of exile and alienation. The journey that I trace here has a significance, then, that transcends the people who made it. But it is most interesting surely in the end as the story of a friendship between two women who "asked no better travelling companion"[92] than each other.

Chapter 1

"We did not, to begin with, like each other at all"

Anderby Wold and *The Dark Tide*

The two women who met each other in an Oxford tutorial in October 1919 were conscious at first only of their differences. Holtby's breezy vitality, her apparent indifference to the prescribed texts, her "gay, stimulating popularity" provoked Brittain "to barely concealed hostility."[1] Even Holtby's appearance—"superbly tall, and vigorous as the young Diana with her long straight limbs and her golden hair"[2]—was a source of irritation to Brittain's nerves, jaded by the deaths of her fiancé and brother and by years of war service in military hospitals.

The sources for this information, Brittain's autobiographical works *Testament of Youth* and *Testament of Friendship* and her novel *The Dark Tide,* do not tell us directly how Holtby read Brittain. Holtby told Brittain later that their history tutor, Mr. Crutwell, " 'put her off,' "[3] and it is easy enough to imagine that she was equally put off by the cynical young woman with "an exasperatingly superior air" gloating triumphantly over her failures of style and confused subject-matter.

It was no doubt Holtby's resentment of Brittain that resulted in the incident of a college debate in which their fellow students, aided by Holtby, took the opportunity to tell Brittain publicly what they thought of her self-importance and disdain for their society. Brittain, who had been invited by Holtby to propose the motion "that four years' travel are a better education than four years at a university," later had her revenge in *The Dark Tide*. At the time she demanded and received an official apology from Holtby as secretary of the debating society and saw little more of her until the Easter term, when Holtby unexpectedly brought Brittain a bunch of grapes while she was nursing a cold in her room. From that moment on Brittain dates her "second life, the one that began with Winifred's companionship in 1920."[5]

Once the friendship was established, their differences were soon forgotten in the joyful recognition of similarities. Holtby, too, had served abroad in the war, "had lived beside the same historic railway-line, and heard the same rattling engines go shrieking through the night."[6] "Even before we met," Brittain claims, "we were invisibly linked by the unique bond of our war service,"[7] and "the link which the war had forged between us was too strong to be broken by these trivial hurts and temporary resentments."[8] Although Holtby herself had not lost anyone close to her in battle, she "identified so closely in imagination with Edward and Roland that they almost seemed to be her dead as well as my own."[9]

The bond of war service drew Brittain and Holtby together initially and led to long walks in the countryside around Oxford, where they discovered that they shared future ambitions as well as past service. They both intended to support themselves by writing and both saw Oxford "as a valuable prelude to a writer's career."[10] Ideas for their first novels were already germinating, and during the vacations from Easter 1920 onward they "corresponded regularly on literary projects, planned articles and short stories, and exchanged fragments of dialogue and descriptions intended for *Anderby Wold* and *The Dark Tide*."[11]

It was Brittain who suggested they continue the partnership beyond university and share a flat together in London, where they could support each other's ambitions. The flat on Doughty Street, chosen for its proximity to the British Museum, was small, badly lit, noisy, and usually freezing cold. "Superficially,"

says Brittain, "it was a supremely uncomfortable existence and yet I felt that I had never known before what comfort was . . . to me it was Paradise."[12] The comfort she describes lay in what she calls "the luxury of privacy,"[13] which was in part a question of enjoying for the first time a physical freedom denied to middle-class girls in Edwardian England. To come and go as one liked was only part of what made this life "Paradise," however; the privacy was more significantly psychological, freedom from the "family searchlights"[14] that had played upon her life since birth.

Brittain describes growing up in the provincial town of Buxton as a form of imprisonment. "I felt trammelled and trapped," she writes. "I was wholly at the mercy of local conditions and family standards."[15] The hills surrounding Buxton represented for her "the walls of a prison."[16] "Unhappy, shut up little Buxton," she wrote in her diary in 1913. "Oh! to escape from it!"[17] This feeling increased when she was summoned back from war service in France to nurse her mother, now living in Kensington: "The old feeling of frustration that I had known in Buxton came back a thousand times intensified . . . I seemed to be marooned in a kind of death-in-life."[18]

Limiting though life in provincial England may have been at this time, the real issue clearly is not place. It is the situation of women in relationship to their families, especially to their mothers. Brittain's diaries of the period 1913–17, published in 1982 as *Chronicle of Youth,* give a detailed contemporary picture of her ambivalent relationship with her mother. "It is characteristic of Mother," she writes, "that though I always want her to come home she always upsets me when she does."[19] Continually hoping for a close communication with her mother, Brittain is surprised on the rare occasions when it occurs: "Mother and I actually had a long and animated conversation after supper."[20] Her mother encourages her engagement to Roland Leighton but, when he is killed, can offer no real comfort. In her despair Brittain experiences her mother as a stranger and is no longer able "to pretend to live" in anything but her "own atmosphere."[21] In Brittain's "own atmosphere" Edith Brittain has no place. The Vera Brittain for whom "love of learning is part of the very essence of my being,"[22] who is reaching out through the intellectual life to an autonomous self, feels alone at home. In 1914 she writes that it is impossible to talk to her mother about Oxford; "It is a queer

thing that it is here more than anywhere I am least myself and most a stranger."[23]

Brittain is well aware of the social inequities informing her individual situation and reflects this knowledge even as early as the war diaries. Writing to her brother Edward, she makes her letter "express tranquillity, even in complaints of women's enforced inactivity in the military part of the war. There are some feelings which we dare not begin to show."[24] She frequently generalizes, often with some bitterness, as in the introduction to *Selected Letters,* on the conflicting demands facing women of her generation who wish to do something other than become carbon copies of their mothers. Even in wartime, she says in *Testament of Youth,* what exhausts women the most "is the incessant conflict between personal and national claims";[25] "because we were women we feared perpetually that, just as our work was reaching its climax, our families would need our youth and vitality for their own support."[26]

Women nursing wounded soldiers, of course, are conforming in the clearest way to the service ideal laid down for their sex; their conflict, therefore, is not nearly so severe as that of women asserting the right to exercise their own talents in less acceptable ways. In a powerful 1923 essay entitled "The Whole Duty of Woman," Brittain examines the situation for women like herself growing up in "the average middle-class family" where "the talents of a girl are seldom the source of anything but domestic controversy."[27] Beginning with Mrs. Gaskell's description of Charlotte Brontë tied by duty to a dying father and family responsibilities, Brittain sees that little has changed for women in this respect since the mid-nineteenth century. "We are living still," she says, "under the shadow of an age which made a woman the first servant of her parents, with the usual alternative of standing in the same relation to her husband, and later to her children."[28]

Brittain understands that this is a heritage passed on from mother to daughter: "Our mothers were brought up to believe in this supreme duty of individual service; they have bound the consciences of their daughters to the same iron tradition."[29] Although she does not analyze the mother-daughter bond in the same language as Kim Chernin and Nancy Chodorow, what Brittain says is compatible with their views. She understands that the

worst danger of such a system lies in internalizing it, a danger she sees realized more in Holtby than in herself. But she describes both of them as feeling "quite guilty, sometimes, for revelling in the uninterrupted companionship of those crowded days, so busy and yet so free, so stimulating and yet so dignified."[30] Always afraid in the early days that Holtby's social conscience would make her abandon the literary life, Brittain provides her with an alternative image to those friends teaching miserably in conventional schools. Her job and Holtby's, she suggests, is "to remain outside and if possible acquire a standing which may enable us one day to combat that system."[31]

There was much in Holtby's upbringing that resembled Brittain's. She too was expected to play the dutiful daughter at home, to nurse sick family members sometimes at the cost of her own health, to participate in an active social life "in a hospitable household where the bedrooms were always full and every hour of privacy meant a discreet battle with circumstance."[32] Holtby's resentment at having to waste her time on tennis parties when "'there is a table here covered with books waiting to be read and *Anderby Wold* waiting to be written'"[33] was apparently easy enough for her to express. Her more valuable services to family and friends, although in the end far more demanding and draining of her time and energy, were, Brittain tells us, "ungrudgingly given."[34]

Brittain also informs us, however, that Holtby once told her "how passionately . . . she had resented the duties which preoccupied her mother, to whom she was ardently and strenuously devoted."[35] Alice Holtby was a far more ambivalent figure in her daughter's life than Edith Brittain, whose direct conflict with her daughter was much more obvious. To Brittain her mother, in Chodorow's words, represented "regression and lack of autonomy."[36] Brittain may have felt guilt about rejecting the values of her mother's world in the name of her own independence, but there could have been little doubt in her mind that those values were not her own. Holtby was far more integrally tied to her mother, as her willingness to resent for her mother what she could not resent for herself suggests.

Brittain is very careful about her comments on Alice Holtby while Mrs. Holtby is still alive. In *Testament of Friendship* Alice Holtby's tending of the village of Rudston in Yorkshire is com-

pared favorably to the fictional version of it in *Anderby Wold*[37] and her relationship with her daughter described as "always one of unbroken harmony."[38] It is not until 1960 in the introduction to *Selected Letters* that Mrs. Holtby becomes the "matriarchal parent" whose tyranny exhausted her daughter's energies.

What seems clear is that Alice Holtby, like many conventional but strong women, gave her daughter mixed messages. She expected her to perform all the duties of a female family member but also encouraged the incompatible values of ambition and intellectual growth. Holtby claimed she was "one of the very few women who went to Oxford because their mothers wished it rather than from any strong personal impetus,"[39] and that "she had never realised the need for a feminist movement until she went to Oxford, as their house was a matriarchy."[40]

It was her encouraging mother who had Holtby's first volume of verse, *My Garden,* published privately and secretly, who invited an audience of local people to see her daughter's juvenile dramatic efforts, who circulated and sold a letter written by her daughter describing the bombardment of Scarborough on December 16, 1914. Chernin's ideas suggest that Alice Holtby was trying to live vicariously through Winifred;[41] and it seems fairly obvious that all this encouragement was in part a way of keeping control, of owning her daughter.

Holtby's own attitude to her mother is less clear. The strength of the bond is undeniable; Holtby clearly admired her mother's power, especially in contrast to her father's passivity, and could draw from it a model of female possibility far more enriching than that provided by Brittain's mother. But desire for separation and autonomy created resentment also. She resents the title given to one of her poems by her mother[42] and, in an article significantly entitled "Mother Knows Best," describes herself as being "pushed and prodded into authorship."[43]

A short story called "The Silver Cloak" suggests that Holtby was certainly conscious of the kind of mother/daughter conflict I am suggesting here. In that story a mother, Annie, competes with her daughter Katie for male approval, but finally realizes what she has been doing and makes amends: "She had been greedy, usurping the girl's place . . . She knew it was time for her to step aside and yield the center of the stage to her daughter."[44] Here Holtby does, then, what she is to do frequently in her novels,

remake her own situation into one she prefers, correcting life through art in the way both Bell Chevigny and Judith Gardiner see as characteristic of women writers.

The differing degrees of ambivalence toward their mothers and their roots are reflected in Holtby's and Brittain's first novels, *Anderby Wold* and *The Dark Tide,* which were both published in 1923. *Anderby Wold* was finished in the spring of 1922, initially rejected by Cassells, accepted by John Lane in August 1922, and published the following March. *The Dark Tide* went through a longer series of rejections and was published by Grant Richards in July 1923 only because Brittain agreed to subsidize it.

Brittain admitted that the acceptance of Holtby's novel before her own precipitated "something of a psychological crisis."[45] Holtby was her junior and Brittain had acted at Oxford as her guide in literary matters. She had never dreamed that Holtby's work "could be preferred and published before my own."[46] It is characteristic of the dynamics of their partnership that after an initial inability to offer her friend congratulations, Brittain moved almost immediately to a reconciliation, acknowledged to herself that "*Anderby Wold* was a better book than *The Dark Tide,*"[47] and wrote her friend a generous and celebratory letter.

By July 1923 Brittain and Holtby had been living together in London for eighteen months. The two novels, then, though in some ways very different, were written under mutual influence and encouragement. Holtby's initial ideas for *Anderby Wold,* which draws most directly on the knowledge of rural life in Yorkshire provided by her upbringing, had been formed before she met Brittain at Oxford in 1919. Brittain reveals in *Testament of Friendship* that in one of their first conversations Holtby told her of her attempts to write it,[48] and from Easter 1920 on they were showing each other sections of their novels.[49] *Anderby Wold* does not deal overtly with any experience shared with Brittain or record any event later in date than their partnership. But, however dissimilar in background and time, it has thematic links with *The Dark Tide* that reflect the personal concerns of the two women at this period. Like Brittain's work it can be read as a novel about female self-empowerment.

Brittain claims in *Testament of Friendship* that "neither the pacifist, the feminist, nor the anti-imperialist wrote *Anderby Wold;* its author," she says, "was the Yorkshire-born artist who endea-

vored from the beginning to see her creatures in the round, as God sees them, and with the true artist's detachment to do even more justice to the characters with whose outlook she disagreed than to those who shared her opinions."[50] Although she sees the connections between *Anderby Wold* and Holtby's final novel, *South Riding,* Brittain does not point out that Holtby's "artist's detachment" was rooted in the same soil as her feminism, pacifism, and antiimperialism, in an opposition to the oppression of the individual and in a belief in self-empowerment.

Holtby's willingness to grant autonomy to her characters sprang from that fundamental ethical position that was clearly formed by the time she wrote her first novel and was apparent in all her subsequent work. It recurred frequently in her short stories as, for example "The Creditors," in which the protagonist learns too late that her money has been made from the misery of her tenants, or in "Pavements at Anderby," which stresses the necessity for social responsibility even at the cost of private peace. In her personal life it made her a supportive but nonpossessive friend, constantly paying a debt to others who she felt had not had her advantages, trying to compensate for a "quality that she called her 'immunity'" that "persistently oppressed her."[51] In her professional life it made her the supporter of individual right against any form of institutionalized oppression.

It is this theme that stands out most clearly in *Anderby Wold.* The novel is the story of a clash between paternalistic (here significantly recast as maternalistic) attitudes and socialist ones, fought over farming methods in early twentieth-century Yorkshire. Control by others, however benevolent, is seen as finally iniquitous, whereas individual freedom is a necessary good even when its advocates are self-serving and objectionable people. Holtby wrote in a much later letter to her mother that in "my very first book I said truth is taught most often through unworthy prophets."[52]

Much more interesting, however, is the way in which Holtby works out her personal version of the same conflict in the novel, expressing her ambivalence both toward her mother and her mother's values and toward her own ambitions and desire for personal autonomy. Read this way, *Anderby Wold* becomes what Meredith Skura has called literature as case history.[53] It also becomes a much richer novel because emphasis is necessarily placed

on the more complex and better-drawn characters in the novel—the women. As Mary Cadogan says, "It is very much what the women think that matters. However ineffectual they might *seem*, it is they who damn with faint praise or caustic reproach; who shred reputations and relationships; who decide when their husbands or brothers are ready for retirement."[54]

In her account of the origins of *Anderby Wold* Holtby describes both its public and its personal themes. She claims that the intellectual heart of the novel had its birth in a shared tutorial in economic history by A. L. Smith, who "had directed our attention to the ruthlessness of economic processes, new phases driving out old; the good of yesterday becoming the evil of today."[55] It was this information that helped Holtby understand why her father had given up the family farm and that provided the public background for the private story of the novel. After listening to Smith, "I forced myself to read histories of agriculture, of trade unionism, of socialism. I tried to set the drama of rural Yorkshire as I knew it . . . against the background of historical change and progress, and gradually, reading and thinking, I comforted myself, and invented a story of a young woman . . . married to a much older farmer, and confronted by circumstances similar to those which proved too much for my frail and gentle father."[56] The novel was written, then, to "comfort" herself, on the surface for her father's loss of the family farm, but on a perhaps less conscious level for her own need to abandon all that the family farm represented.

The extent to which the novel's main characters are based upon Holtby's own relatives suggests the importance of the personal reading. Holtby was born June 23, 1898, in the village of Rudston in Yorkshire, Anderby Wold in the novel. The setting is the Yorkshire of Holtby's youth, and the land itself—"the curves of the hills, the outline of the wolds,"[57] to which, Holtby told Brittain, her whole life was bound—is as important as any of the human characters. In *Testament of Friendship* Brittain points out that "Mary Robson's kinsfolk and friends are Winifred's Yorkshire relatives; her agricultural labourers are the beloved villagers whose dialect she often rendered for the delight of her companions. The scene throughout is that of the familiar East Riding."[58] Her father, David Holtby, farmer and estate manager, was the model for the cautious John Robson who has married his cousin Mary, inheritor

of a heavily mortgaged farm. Her mother, Alice, was a strong, controlling Yorkshire woman of the mold from which both Sarah Bannister, John's sister, and the protagonist, his wife, Mary, were created.

The strong women of Holtby's youth, as she portrays them in *Anderby Wold* and later novels, may be images of female power, but they are also power-hungry, controlling as wives, dominating as mothers. It was perhaps their example that determined Holtby in contrast to let each one of her "beloveds be completely free." Holtby's powerful women are the sisters of the possessive mothers who appear frequently in other novels by women of this period: May Sinclair's *Mary Olivier: A Life* (1919), Radclyffe Hall's *The Unlit Lamp* (1924), or Rebecca West's *The Judge* (1922). These novels, which Brittain and Holtby knew well, portray maternal control as an obstacle to female autonomy.

Sarah Bannister, who opens *Anderby Wold* riding toward her brother's house for a family gathering to celebrate the discharge of the mortgage on his farm, is a strong woman of this type. In her satiric portrait of Sarah Bannister, Holtby deals most harshly with her mother's possessiveness, though even her treatment of Sarah is at times almost affectionate. Holtby has transformed the mother-daughter conflict into one between sisters-in-law, though Sarah Bannister is old enough to be Mary Robson's mother. By making these powerful women sisters-in-law, Holtby liberates herself through fiction from the severest element of her own conflict. Mary Robson is not tied emotionally to her sister-in-law as Holtby is to her mother.

Sarah Bannister advances toward her sister-in-law's farm watched by "several pairs of eyes" (p. 11); her neighbors in Market Burton pay homage to her position in the town through their curiosity about her life and provide a chorus to this novel much like those used by Thomas Hardy and George Eliot. Sarah's first thought is of her independence. Although she has not retained her own surname, as she might well have done fifty years later, she congratulates herself in an almost contemporary way on not being known as Mrs. Donald or Mrs. Richard as her sisters are, "as though their only claim to recognition lay in the identity of their lord and possessor" (p. 12). It is Sarah herself who is the "possessor," proud of the cloth of her coat and her Robson family background. She owns her husband, Tom, who never questions

her judgments, and she bitterly regrets the control she has lost over her brother John since his marriage.

Holtby's attitude to the controlling aspects of Sarah Bannister is revealed in the language she uses to describe Sarah's relationship to her brother. She took "complete charge" (p. 14) of his upbringing; she "steered" (p. 15) him; his "orderly mind was like a familiar room, of which she held the key" (pp. 14–15). Holtby's irony shows Sarah blaming Mary Robson for faults that are also her own. "Anyway it was no use criticizing Mary since she was so obviously convinced of her own perfection" (p. 19), thinks Sarah, who has been described six pages earlier as having too much respect for her own judgment to acknowledge an error. *Anderby Wold* has glimpses of the ironist who will later write *Poor Caroline* and *Mandoa, Mandoa!* but it is not primarily a satire. The ironic doubling of Sarah and Mary allows Holtby to satirize the negative aspects of their strength more harshly in Sarah while treating Mary, in whom she has invested more of herself, more gently. The doubling also paradigmatically reflects the split in Holtby's own mind over the conservative attitude these women share.

Holtby represents herself in *Anderby Wold* in two characters, which in itself suggests the ambivalence she was feeling at this time.[59] The part of herself still bound to her mother, to her home, and to her mother's conservative values she inscribes in the protagonist, Mary Robson, to whom she has given many of her mother's qualities. The autonomous, intellectual part of Holtby, the ambitious writer, becomes the socialist author David Rossitur. It is significant that Holtby represents her independent side at this stage in a male figure; she is still feeling her way toward an acceptable version of female power.

Brittain points out the parts of Mary Robson that resemble Alice Holtby. "Her mother," writes Brittain, "looked after the village as assiduously as Mary Robson cared for Anderby and far more judiciously."[60] She carefully qualifies this later, probably out of a desire not to offend Alice Holtby: "though she fills at Anderby the same philanthropic, feudal role as Alice Holtby fulfilled at Rudston," Mary Robson "bears no real resemblance to Winifred's mother; she is a younger, less positive type, owning many of the uncertainties and half-blind good intentions of which Winifred was conscious in herself."[61] Physically Mary Robson resem-

bles Holtby: "Every easy motion of her arms or body suggested that behind it lay a reserve of strength. Her gentleness seemed to be compounded of restricted energy rather than weak emotion. All the qualities which John had admired in Sarah he found softened by youth in Mary" (pp. 23–24).

At the beginning of the novel Mary has organized the party to celebrate the discharging of the mortgage on the farm. In order to pay off this inheritance from her father, Mary has contracted a loveless marriage with a man "whose presence roused in her alternate irritation and disappointment" (p. 35). In traditional female fashion, then, Mary has seen marriage as the only route to independence, the only way of breaking with the negative aspects of the past. Despite now having control of the land—"Land was after all the thing that mattered most" (p. 31)—she is not at peace nor truly independent.

She is still restless in the presence of Sarah Bannister, who does not know "that when she was not present Mary rarely fidgeted" (p. 18). In the struggle for power between the two women, Mary is at first the loser. At the end of the party she is haunted by an inappropriate comment made by an elderly uncle about her failure to produce children. Since motherhood is used by Holtby throughout the novel to represent an essential aspect of an opposition whose alternative is individual autonomy and powerful energy, Mary's regret at her inability to produce children suggests her ambivalence toward her own power.

Mary attempts to compensate for her lack of children by making the whole village her family, for her failure in one female activity by her success in another, a traditional form of the service ideal. Holtby's attitude to Mary's benevolent dictatorship, which provides her employees with extravagant Christmas dinners but no say in their own working conditions, is revealed in the imagery of monarchy Holtby uses to describe her activities. In a chapter entitled "Full Suzerainty" Mary is described by Sarah, who fails to see the similarity in her own behavior, as "a queen holding a court . . . [T]he villagers . . . were said to make an absurd fuss of her" (p. 21).

Holtby's suspicions of the service ideal and her recognition that it often disguises an unacknowledged desire for power become apparent as she exposes Mary Robson's self-congratulation. The schoolmaster, Mr. Coast, one of Holtby's unlikable truth-tellers,

asks her to sell a piece of land for a children's playground. When she refuses, he turns on her: " 'I know that you are always willing to lend your land or your presence or your pony-cart . . . But when you are asked to part with something that means a small sacrifice, but which will be of great service to the village, then it's a different matter altogether, isn't it?' " Full of "outraged virtue," Mary rehearses her own good deeds in her head: "It was common talk how she sat up all night when old Mrs. Watts had bronchitis, and how she drove every sick child to hospital" (p. 57). The weakness in Mary's position is seen also in her inability to deal with her peers, whether they represent a different set of values, like Mr. Coast, or, like her worldly relative Ursula, undermine her authority by seeing her as someone to be helped. Mary succeeds only with those willing to adopt a feudal subservience, her servant Violet or the loyal farm worker Mike O'Flynn.

It is also clear, however, that if philosophically Holtby is not Mary, she understands her character so well partly because she shares some of her qualities, in particular her love of the land. She also admires her courage. In August 1921 Holtby wrote to her friend Jean McWilliam, with whom she had served during the war anu who was then in South Africa: "One hears so much of the courage of the pioneer, that it seems not out of place to talk for a little of the courage of those, who seeing the things they have given their lives to passing, raise no hand to prevent the coming of the new." [62] This exactly describes Mary Robson's actions in *Anderby Wold*.

Like many of Holtby's other female protagonists, Mary Robson, for all her practical common sense, has that streak of romanticism that Holtby recognized in herself. Mary Cadogan calls it a recognition of "the magic . . . just below the commonplace surface of life" (p. xviii). For Mary Robson this magic is the key to her love of the land and is offered as an explanation of her refusal to sell her field for the playground. The field was the place where John proposed, but she realizes the absurdity of romanticizing a proposal from a man she has never loved. "Still," Mary explains, "she liked to pretend she had once welcomed her lover like other women. The dream was so elusive that, without the field, it might vanish altogether" (p. 58).

The key words here are "like other women," for Mary's romantic streak pushes her toward a relationship with David Ros-

situr and an attempt to solve her problems through a familiar route, a lover who represents the freedom and autonomy she wants for herself. The convention of the contemporary novel in which the female protagonist seeks escape from a dead marriage through a lover is recognizable here.[63] The pattern is, of course, more than a literary convention; it is one aspect of the continuing practice of women to seek to solve their own identity problems through men.

If Holtby is ambivalent about the rootbound conservatism of the Mary Robson in herself, she is perhaps only slightly less ambivalent about the independent intellectual side represented by David Rossitur. This side, too, is far from flawless. When David Rossitur is introduced in the novel, Holtby suggests that the romantic solution to Mary's problems is unlikely to succeed by making their meeting a parody of the English sentimental novel tradition. Like Willoughby in Austen's *Sense and Sensibility* and Rochester in Brontë's *Jane Eyre,* Rossitur appears in *Anderby Wold* in a rescue scene concerning a horse. But roles have been reversed: David is the stranger at the crossroads and Mary is the one with the horse; though David removes the stone from the horse's hoof, he is the one in need of help. David has an unromantic bad cold and Mary, adopting him like an orphan child, takes him home to nurse.

Holtby has prepared us for Mary's attraction to Rossitur by embodying in him those qualities Mary misses in her life. They are philosophical antagonists, but we know Mary likes an argument and is bored with John's unwillingness to disagree. Unlike John, David is lively and full of vitality, a quality we have seen Mary admire in her cousin Ursula. Most significantly, David is willing to play the child at first because he is ill, and thus he allows Mary to satisfy the childless part of herself through adoption of a caring role.

The intellectual heart of the novel in terms of the public theme is in the central chapter where Mary's benevolent despotism is challenged by David's socialism. David is already known to the Robsons as the author of a book on farming called *The Salvation of Society* in which he argues for the right of land workers to determine their own working conditions through unionization. Mary adduces the well-being of her own farm workers and presents herself as the salvation of society. David asks, "What hope

is there for social stability when the happiness of men is a matter of philanthropy, not of right?" (p. 127). Like Holtby herself, Rossitur thinks the Robsons are "charming as people but iniquitous as an institution" (p. 129). Ironically, of course, David is currently taking advantage of Mary's benevolent despotism himself, as he comes to realize. Nevertheless, Holtby allows David the final word on the imagery of royalty that has surrounded Mary throughout the novel: "You think you're a queen because you govern this village and your subjects seem to like you. The only real kings and queens are those who stand above their generation and rule circumstance" (p. 127).

In terms of the personal level of the novel, David, the spokesman for individual autonomy, becomes the means by which Mary increases her separation from Sarah Bannister and thus symbolically from the mother figure. While David is staying at the Robson farm, Sarah arrives unexpectedly, having heard rumors in the village about David's political views. Mary hopes to avoid a confrontation between the two but Sarah finally goads David into speech. "And David spoke. For ten minutes not even Sarah was able to utter a word" (p. 136). After David's attack on her whole way of life, Sarah leaves and David, collapsing, apologizes to Mary.

Mary's response to David's energy and idealism at this moment is on the borderline of eroticism. She compares David to John: "If David had been like John she would have watched and protected him" (p. 142), turning the unsafe erotic impulse into the safer maternal one. Mary has seen herself in David: "Life was never kind to people who cared as much as that. If it was land they cared for, it denied them heirs; if it was ideas, it proved them false" (p. 142). But she cannot at this stage accept him intellectually or emotionally, and though she has temporarily broken with the mother, she returns at the end of the chapter to the female values of caring and nursing. "There were some things," she decides, "that it was wiser not to think about" (p. 142).

Given some knowledge of Holtby's political beliefs, it is easy to assume that David Rossitur is her representative in *Anderby Wold*. Brittain says in *Testament of Friendship* that "Winifred's outlook is approximately reflected in that of the eloquent red-haired young Socialist, David Rossitur."[64] And the side of Holtby struggling toward autonomy and self-empowerment is represented by

David. But Holtby treats David Rossitur with the same mixture of sympathy and irony as she does Mary Robson. Her independent self is, like David, still a child with a runny nose.

The charge Mary makes against David's position, a lack of practical experience of farming, is one that Holtby herself was likely to credit. David has no experience upon which to test the practical application of his theories. Holtby's suspicion of general theory separated from individual cases, which is clear here, later becomes recognition of the tendency of any institution to oppress the individual. David's ideas spark a farm workers' strike and Holtby undermines the reader's sympathy for his position by il-lustrating the personal basis for political belief. Each of his allies is motivated by a desire for personal revenge. Waite, whom the Robsons fired for mistreating a farm boy, joins their enemies; Coast, who has long engaged in a power battle with Mary, seeks victory by supporting the union organizers. Though certainly Holtby was more supportive ideologically of David Rossitur than of the Robsons, she was not a committed socialist when she was writing *Anderby Wold*. She wrote to Jean McWilliam in February of 1924: "I wish that I understood more about economics. I might be able to understand better then what socialism means. But whatever of it I do understand seems to me to be good in parts, but bad if it swallows up all individual ownership."[65]

It is just such a loss of individual control that endangers David's growing union movement in the areas around Anderby, as he recognizes when he sees that the men are merely being manip-ulated by new masters like the ruthless union organizer Hunting. " 'Oh, we'll just have to go on doing the best we can,' " he says, " 'organising first, educating after. It's the wrong way round of course, but it seems the only way at present' " (p. 212). It is not a way Holtby would have approved, for it does not allow for true self-empowerment, which is dependent on educated choice.

Mary tries to sublimate her growing infatuation with David in maternal gestures. At a gathering of Robson women, Mary is told of a report of David's activities in the *North Clarion*. She cuddles Ursula's baby, Thomas, and claims, " 'I came to look at the baby, not to read the newspaper' " (p. 169); in other words, she asserts her position in the female community, rejecting all interest in the public world. Yet as she drives home from Ursula's house with John, Mary's impulse toward David and toward a

future in which she can express the energy within her is at its strongest. "Why could she not relinquish this—the dim hills before her, the bearded figure beside her, the responsibilities that preyed upon her? Why not escape to the other side? . . . The rebellion culminated in one need—David, David Rossitur" (p. 176). Mary is to learn, as Holtby herself had learned, that to relinquish what the hills and the dull husband represent, the attachment to roots and the bondage of female values, is not an easy matter. Such relinquishment may indeed feel like an adulterous act.

After a brief absence David returns to Anderby and Mary meets him unexpectedly in the fields. Once more she needs rescuing; her sleeve is caught in the hawthorn bush, though, of course, she is actually trapped more significantly than this. They talk, are drawn together, and kiss. It is a scene with a long history in the English novel, perhaps used more frequently by E. M. Forster than anyone else. It is the kiss in the pastoral setting that invokes the life-affirming, joyous, vital aspects of the natural world. For the first time Mary is seen as part of the land, in David's arms "between the wheat and the hedgerow" (p. 214), rather than as its possessor. The associations with vegetation and fertility myths are made even clearer a few pages later when Mary fantasizes David as Master of the Harvest in the harvest ritual.

In drawing as she does here on fictional conventions associated with sexuality, Holtby seems at first to be at some risk of muddling her statement. Mary's sexual energy is clearly a positive force, part of what could offer her self-empowerment and link her with David, its representative. But fertility in the form of motherhood has already been established as part of that restricting world from which Mary seeks escape.

In the end it is the kiss that proves Mary's undoing. In a rather melodramatic moment of the novel, Mary, lying in David's arms, sees John ride by the hedge bordering the field. She hurries home to find that John has had a stroke and that she is trapped for ever by her own guilt, never to know whether the stroke is the result of John's seeing her with David. The attempt to express her own real emotions has ended in disaster and made her more rather than less bound to the mother's world. There are some indications that Holtby is gently mocking the fictional conventions she employs, just as earlier she had parodied the sentimental novel. As

Mary nurses John, trying to avoid anything that might remind him of the scene in the fields, she acknowledges the melodramatic nature of her situation. "This was too absurd," she thinks. "Like a scene out of a novel" (p. 223).

In subsequent scenes Holtby suggests that Mary's energy is not specifically sexual; her desire for David has been merely a sexual expression of the same force that drives her to control her neighbors. When the men ask for more money, Mary takes "her husband's place" (p. 244) and mocks and challenges them until they go on strike. Mary is excited by the confrontation; "she only knew that this was really thrilling and dramatic" (p. 246). Holtby describes her as "thoroughly enjoying herself" because she has finally found a use for her energy: "She felt mistress of the situation at last. Having found an outlet for the pent-up emotions of the summer, she determined to utilize it to the uttermost extent" (p. 246).

Imbued with a sense of her own power, Mary stands up to Sarah Bannister at last, rejecting the suggestion that she and John should retire for the sake of John's health and go and live in Market Burton. At her most maternal—"Mary had never heard her voice so gentle" (p. 263)—Sarah argues for giving up, for restricting her energies: " 'You're young and vigorous, and you want to use your youth. It seems dull to you to come and live among a lot of old maids and worn out men and women in Market Burton. Well, it is dull. But it's what we've all got to face sooner or later' " (p. 264). Mary refuses to give in, but Sarah's final comment is prophetic, " 'If you won't give way on your own, things will make you' " (p. 265).

Holtby can see no outlet for Mary's energy that has equal validity with the claims of female duty. Mary is eventually forced to surrender as Sarah has prophesied and through events that she has brought upon herself. Mary's angry treatment of the men is the begetter of the violence that follows. The strike peters out but those who supported it are left embittered. The schoolmaster, Coast, encourages the Robsons' disgruntled farmhand, Waite, to set fire to the Robson's hayricks. David, heading toward the farm, sees the fire and turns back to fetch the fire engine. A drunken Mike O'Flynn mistakenly assumes that David has set the fire and, out of misguided loyalty to Mary Robson, shoots him. As readers we learn all this, as Mary does, late and secondhand, a

method by which Holtby manages to tone down some of the melodrama.

David Rossitur, the representative of that part of Holtby that stands for self-empowerment, is, then, finally destroyed by his own impulse to return to Mary, to the traditional ways, and by Mike O'Flynn, who throughout the novel has demonstrated the blindness of feudal loyalty. Brittain points out that David is the first of many characters destined for premature death in Holtby's novels, as, of course, was Holtby herself.[66]

At the end of *Anderby Wold* Mary is forced to give up the farm and retire as Sarah has prophesied. She cannot escape from the world as Sarah defines it. The most she can do is "raise no hand to prevent the coming of the new"; "by going away quietly she was doing the only thing she could do" (p. 309). Mary appears to have learned the lesson David taught her. "She looked after people too much. They needed to be taught how to look after themselves" (p. 308), she admits. But what are we intended to make of the fact that she still sees herself as the controlling agent in everything that has happened and still looks forward to a future of good works in "a girls' club or a nursing association or something" (p. 308)?

As Mary Cadogan says, *Anderby Wold* is "a study of power and its various guises" (p. ix). As a study of public power, it is limited in comparison with what Holtby was to write later. It shows the dangers of false power, particularly control over others' lives in the name of charity, but gives only a hint through David Rossitur and Mary Robson at the end of what self-empowerment might mean. Nevertheless, Holtby's understanding of the connections, between the desire for personal power and the service ideal, between the oppression of workers and the oppression of women, is clearly indicated.

As a paradigm of Holtby's own struggle between her need for autonomy, the opportunity to exercise her own power, her own talents, and the pull of that internalized maternal power toward the sacrifice of those energies in the name of female values, the novel is rich and complex. It is a fascinating illustration of the daughter's ambivalence that Chodorow and others describe. At the end autonomy is dead and traditional values triumphant. But Holtby, of course, has a power Mary Robson, being merely Holtby's creation, does not, the power to read it all differently and to

rewrite it in the next novel. Mary Robson's defeat need not be Winifred Holtby's.

Anderby Wold received good reviews and was not remaindered until 1930. In *Testament of Friendship* Brittain quotes Mary Agnes Hamilton's review in *Time and Tide,* which praised Holtby for "a degree of mastery . . . rare even in the hands of much more practised writers."[67] Brittain herself is somewhat less generous about the novel, calling the dialogue "too often self-consciously epigrammitical" and accusing David Rossitur of talking like the editor of an Oxford literary magazine.[68]

Brittain's faint praise for *Anderby Wold* may be the residue of a very difficult period in her life, which was not helped by the problems she had in getting her own first novel, *The Dark Tide,* published. The freedom of life in London with Holtby may have been "Paradise" but Brittain's inner life was understandably in turmoil during these years. In the years following the war, she writes, "Every minor set-back, criticism or disappointment upset me at least twice as much as any sane person."[69] This she attributes to "nervous irritable ancestors, combined with the loss of every person for whose life I feared during the war."[70]

The building of their friendship, according to Brittain, was Holtby's "achievement rather than mine."[71] Letters of the early twenties support this statement. Initially it is Holtby who encourages, protects, authorizes. "My dear," she writes to Brittain in an unpublished letter of November 1921, "you are absolutely forbidden by your friend and guardian and critic to talk about your petty, parochial talent . . . I admire it, I look up to it so much that discourtesy to it sounds like sacrilege . . . Your particular kind of talent attains perfection through experience. You must write of what you know."

The Dark Tide is based on what Brittain knew and is much more directly autobiographical than *Anderby Wold.* Brittain tells us in the preface to the new edition of the novel in 1935, when it was reissued after the success of *Testament of Youth,* that the original notes for her first novel were made between 1919 and 1921 while she was still at Oxford. It is in fact an Oxford novel. Its first two chapters, Brittain said twelve years later, "described conditions at the women's colleges as they then both were and were not."[72] In 1953 she still thought the novel was fairly accurate, "notwithstanding the crude violence of its methods and the un-

modified black and whiteness of its values."[73] She might have
added: notwithstanding the overreaction of Somerville College,
which banned the novel, and the *Manchester Guardian,* which
threatened to sue because of a scene in which Mrs. Lethbridge
bribes one its reporters with champagne.

The Dark Tide, with its background of Oxford in 1919, was a
more direct response to Brittain's and Holtby's shared experience
than *Anderby Wold.* Somerville College has become Drayton and
the two central female characters, Daphne Lethbridge and Vir-
ginia Dennison, are history students who closely resemble Holtby
and Brittain in appearance and in some aspects of their person-
alities. The tall, fair-haired protagonist of *The Dark Tide,* Daphne
Lethbridge, borrows her physical appearance and some aspects
of her character from Holtby; her fellow student, Virginia Den-
nison, has much in common with Brittain. Two events, their
first meeting in a Somerville tutorial and the debate organized by
Holtby in which Brittain felt herself humiliated, are used in the
novel with little apparent change from the "nonfiction" versions
in *Testament of Youth.*

Since *The Dark Tide* was written concurrently with *Anderby
Wold* it cannot be described as a response to it, although, like
Holtby's novel, it reflects the ideas the two women were discuss-
ing at the time. The novels have very different backgrounds and
are written in two different languages; Holtby's is the language
of social and political theory, Brittain's that of religion. Brittain
claims the subject of *The Dark Tide* is "the conquest of 'that
despair which lies waiting to storm the defenses of every human
soul,'"[74] a description not really applicable to Holtby's novel,
which is also much less overtly pacifist and feminist in its con-
cerns. But both novels illustrate the importance of self-empow-
erment and the danger of institutions as oppressive of individual
freedom. And Brittain's technique—"the relation of an individual
story against a larger background of political and social events"
(p. 4)—is, of course, the same as Holtby's.

The Dark Tide represents, I believe, not Brittain's reading of
Anderby Wold so much as her reading of the relationship with
Holtby during the period when she depended heavily upon her
friend to rescue her from those postwar states of despair. Com-
petitive by nature and accustomed to being Holtby's leader and
teacher, Brittain moves the relationship back toward an even bal-

ance by rewriting it in the novel. The relationship between the two chief female characters is clearly based on that between Brittain and Holtby but is changed to give all the maturity and control to Virginia Dennison, the character most resembling Brittain. In this way the subject of the novel and the act of writing it become the conquest of despair.

Like Holtby in *Anderby Wold,* Brittain expressed her personal ambivalence toward female values and her own ambitions in her first novel. In some ways Brittain appears clearer about where she stands than Holtby. It is Daphne Lethbridge, the Holtby figure, to whom Brittain attributes the difficulty of separating from the mother's values, and the narrator's position on this is obviously and unwaveringly critical from the beginning. Yet there is ambivalence in her attitude to the notions of the service ideal and self-sacrifice, and Virginia Dennison is a rather contradictory combination of cynic and martyr.

"It was generally assumed," Brittain says in her preface, "when *The Dark Tide* was first published that one of its two 'heroines,' Virginia Dennison, was intended as a portrait of myself" (p. 3). Clearly that is, on the surface, a credible assumption. Brittain has given Virginia her own war history: she left Oxford after one year to nurse the wounded in France; her fiancé was killed just before Christmas leave; she is still haunted by "those black years" (p. 41). Virginia looks like Brittain: "She was small and dark-eyed and pale" (p. 31).

Daphne Lethbridge, on the other hand, looks like Holtby. She is tall, with a slim waist and hips; she has blue eyes and "thick, slightly waving fair hair, not flaxen, but gold with the reddish tinge of ripe corn" (p. 24). She dresses with Holtby's flamboyant love of bright contrasting colors. Like Holtby, who played Celia to Jean McWilliams's Rosalind, Daphne quotes *As You Like It;* like Holtby, she is generally popular, possessing, the narrator tells us, "that uninspired popularity which is usually accorded to good-natured unselfishness" (p. 43).

In the two scenes that are drawn directly from their own experience Virginia plays Brittain's role and Daphne Holtby's. Virginia arrives early for the first coaching with their male history tutor and is chatting with him about Europe when Daphne arrives late. They dislike each other on sight. Daphne has done none of the assigned preliminary reading; Virginia has done it all. In

the novel Daphne is an officer of Drayton's debating society and invites Virginia to propose the motion that four years' travel are a better education than four years at a university. Virginia takes the opportunity to rebuke her fellow students and they respond in kind. Daphne brings down the house with the words Holtby used: "'I had rather have a fool to make me merry, than experience to make me sad; and to travel for it, too!'" (p. 48). The version of these scenes in the novel closely resembles the "non-fiction" version in *Testament of Youth*.

The relationship between Brittain and Holtby and their apparent fictional counterparts is, however, more complex than this suggests. Brittain tells us how to read it in her preface to the novel. If Virginia Dennison was a portrait of herself, she says, "she was one of those 'wish-fulfillment' portraits by means of which the young are apt to compensate for their own failures and humiliations. Between the brilliant, priggish Virginia with her easy First in History and her dogmatic control of difficult situations and myself with my hallucination-haunted university career and calamitous second, there was all too grievously little in common" (p. 3). Brittain then has remade herself into a person she prefers to her "real" self. In other words, she has purged Virginia of those qualities she saw as her weaknesses, her competitiveness and mean-spiritedness—Virginia does not enjoy Daphne's failures as a student—and her debilitating insecurity. And she has given her added strengths, a more successful academic career and a satirical novel published before graduation.

More significant, though, is what Brittain has made of Daphne. She has not served in France as Holtby had; she has merely been a driver in England for male officers because her parents would not allow anything riskier. Daphne has failed to do the prescribed reading as Holtby did but for different reasons: Holtby was still in the service the summer before returning to Oxford; Daphne has been occupied by "those tennis teas and garden parties at Thornbury Park, to which her mother, anxious to display a de-mobilised daughter, had continually persuaded her to go" (p. 33). To Daphne, Brittain has ascribed the vices she purged from Virginia, her own mean-spiritedness—Daphne relishes mocking Virginia to her friends—and competitiveness. She has also given her a provincial middle-class background and a mother who much more resembles her own than Holtby's. The Daphne we see at

Oxford is supposedly intelligent but rarely behaves in a way that is anything but gauche and naive, dropping her hairpin in the soup of a famous historian and dropping her essay out of her muff at a tea party given by her tutor. She suffers from constant insecurity.

The ways in which Brittain has altered the facts, or rather has presented them differently from the way she has presented them elsewhere, suggests that several not necessarily contradictory impulses may be at work here. The portrait of Daphne is a cruel one, at least at the beginning of the novel; and to the extent that Daphne is Holtby, it can be read as an expression of Brittain's resentment of her. The most obvious source of this anger is the debate, of which she wrote as late as 1933 in *Testament of Youth* that the memory was "still able to awaken the bitter sense of having outlived my day which possessed me when it was over. For years I believed it had been deliberately planned with a view to my humiliation."[75] In *A Dark Tide* the debate is planned with just such malicious intent and Virginia tells Daphne years later how long her resentment lasted. Less obvious but equally potent is Brittain's need to rectify the balance of her relationship with Holtby, upon whose friendship she has become dependent and whom she fears losing as she has lost everyone she has ever loved: "I needed it [Holtby's friendship] with the starving need of an individual whose earlier loves had been prematurely and violently shattered."[76]

Either of these motives would explain why Daphne is a much weaker person than any other portrayal of Holtby, but they do not explain why Brittain has given her her own weaknesses nor why the novel is seen essentially from Daphne's point of view. It seems clear that Daphne is also in some way Brittain herself. What Brittain seems to have done is to represent two different sides of herself in her two female characters. The side she approves of, the more autonomous, intellectual, stronger side, she portrays in Virginia. Her insecurity, her need to adhere to the mother's values, to a conventional female role, she attributes to Daphne. In other words she gives her weaknesses to her second self, to Holtby, whom she can help to cure them as Virginia does Daphne. "In literature," as Meredith Skura says in her description of the psychic function of literature as fantasy, "we fight out our trial battles between our divided selves."[77]

When *The Dark Tide* opens, Daphne Lethbridge is returning to Oxford, like Brittain and Holtby, after an absence for war work. Her parents' restrictions upon her war service are only one of the ways in which Brittain illustrates Daphne's lack of separation from her mother and from the values of Thorbury Park. Although Mrs. Lethbridge resembles Brittain's more than Holtby's mother, like Alice Holtby she gives her daughter mixed messages. Encouraging her to go to Oxford, she makes it very difficult for her to do the necessary work. " 'You see, we entertain a great deal at home, and my mother goes out a lot and likes to have me with her' " (p. 36), explains Daphne to Virginia as a reason for not reading the preliminary texts. Daphne cannot understand why Virginia is so attractive to men when she "seemed to have none of the graceful gentleness, the soft deference, the subtle admiration, which Mrs. Lethbridge had taught Daphne that she must always show to men even when she despised them because they would never like her unless she did" (p. 102). Daphne prays to "a Deity in whom she herself only believed remotely, but whom Thorbury Park would not have considered it quite respectable to abandon altogether" (p. 121). Since Daphne does not question the values of Thorbury Park or the values of Oxford, she quickly finds herself in an impossible situation, trying to keep up a reputation as a social butterfly while attempting "to learn everything, and get the best degree in History that woman ever had, and then to write things which would make the name of Daphne Lethbridge a household word in English Literature" (p. 10).

Brittain's own continued ambivalence over the conflict between conventional female values and intellectual independence is seen less in Daphne than in the intellectually successful women of the novel, Virginia and the female lecturer, Patricia O'Neill. Virginia treats most men with contempt and claims they " 'do everything at women's expense from their first day to their last' " (p. 71). She devotes all her time to her work and is even successful as a poet. Nevertheless, Brittain also makes Virginia socially successful, popular and well dressed, and still romantic enough to reread continually the last letter from her dead fiancé.

Patricia O'Neill is not forced into a choice of values either. Pat O'Neill, the ideal female don Brittain complained she never met at Oxford, is both brilliant and humble, concerned with the emo-

tional as well as the intellectual lives of her students; after criticizing marriage as an institution for years, she finally marries a male colleague, Stephanoff, with whom, Brittain suggests, she will have a happy marriage. Here Brittain is beginning to explore the possibility of compromise between the two worlds, an exploration that she was to continue throughout her fiction and her life. She rejects both the notion of marriage as an answer to a woman's questions about her identity, as a means of achieving separation from the mother, and the notion of a marriage that deprives the wife of her own work, but she cannot represent as positive a life without heterosexual love. In a 1925 unpublished letter to George Catlin, Holtby wrote that five years before, she had thought Brittain naively, almost childishly, accepting of conventional ideas.

In Daphne Lethbridge Brittain punished that part of herself still bound by conventional ideas of a woman's role. The action of *The Dark Tide* hinges on a rather improbable event. Daphne and Virginia have been studying international relations with Raymond Sylvester, a melodramatic villain with whom Daphne falls in love. Virginia knows that he is not to be trusted. She knows this because he looks " 'rather dissipated' " (p. 73), will only coach women for an hour a week, and praises her brain as " 'more like a man's than a woman's' " (p. 89), reminding him in many ways of his own. Brittain realized that Raymond Sylvester was the weak point of her novel. In the 1935 preface she says, "Where *The Dark Tide* did, of course, emphatically depart from university experience"—and, she might have added, her own—"was in the amorous adventures of its five chief characters. It is hardly necessary to add that Raymond Sylvester, the wicked don who subsequently became a 'diplomatist' and with whom marriage, as Mr. H. C. Harwood pertinently remarked in *The Outlook,* resembled 'being run over by a motor-bus,' was a hyperbolic figment of my too-inventive brain" (p. 3).

In love with Virginia, Sylvester proposes to her and is rejected with what Brittain calls "intolerably self-righteous" (p. 111) criticism about his double moral standard and his assumption that every woman wants to marry. Clearly announcing her separation from traditional female values, Virginia claims, " 'I enjoy being what I'm sure you'd call a superfluous woman' " (p. 109). When he attempts to kiss her, she hits him in the face with a symbol of

her intellectual achievement, her essay. Later that day Sylvester proposes to Daphne, in order, he thinks egotistically, to humble Virginia's pride, and is accepted. In contrast to Virginia, Daphne sees marriage, particularly marriage to an intellectual and social superior, as a badge of achievement. She is marrying academic success rather than claiming it for herself. In this she is still clearly the mother's daughter.

Even if the proposal scene itself is not entirely probable, the scenes in Thorbury Park preparing for the marriage and the Italian honeymoon are uncomfortably credible. As Brittain mounts an increasingly bitter attack on the irreconcilability of society's expectations for women such as Daphne and, of course, herself, she writes of a way of life she knew firsthand. Attempting to succeed in her Oxford exams to please Sylvester, Daphne works herself into a state of exhaustion as she tries to meet both social and intellectual demands and almost fails. Oxford has become Thorbury Park. Underlining this point, Brittain sends Daphne back home to be nursed "with exasperating fervour by her voluminous female parent" (p. 139).

Secure in the knowledge that she has finally satisfied her mother's expectations by this engagement—nothing "could so firmly establish the prestige of the family" (p. 124)—Daphne gives herself up to her mother's world, allowing her to plan the wedding and even the honeymoon in the more popular parts of France and Italy that Sylvester has no desire to revisit. "Mrs. Lethbridge's friends understood Italy" (p. 141). As Daphne daydreams the morning of her marriage, Brittain shows by means of clichés the extent to which Daphne has bought an illusory, conventional dream of female happiness. She dreams of "that love into which she was about to enter with the joy of every woman who comes to her natural heritage." She no longer needs the victories of a Virginia Dennison, with her "feverish narrowness" and "exclusive, intellectual circles," because to her "were whispered the great elemental secrets of love and marriage and birth" (pp. 151–52).

The background information for Daphne and Raymond Sylvester's honeymoon trip to Italy, a trip reminiscent of Dorothea Brooke's Italian honeymoon in *Middlemarch,* was acquired in a six-week vacation with Holtby in the fall of 1921. Brittain describes this trip in *Testament of Youth* as "a treasured memory of

warmth and beauty and perfect companionship, deepened and intensified by two days of poignant sorrow."[78] The sorrow was related to the purpose of the trip, a visit to her brother Edward's grave in Asiago, but despite this and a recurrence of a wartime illness upon her return, Brittain felt that this trip had cured "the acutest soreness of the War's deep hurt."[79]

The middle chapters of *The Dark Tide* were written, she tells us, while suffering from jaundice "in saffron-hued contentment."[80] War ghosts laid to rest, having made the physical break from her parents, now living independently, empowered and enriched by Holtby's friendship, Brittain writes the harshest yet strongest part of *The Dark Tide*. In the sections describing Daphne's marriage to Sylvester, Brittain rejects all aspects of that female masochism her mother's world has taught Daphne and in doing so gives us one of the clearest illustrations in fiction of how it works.

Daphne's submissiveness to men tolerates even Sylvester's abandonment of her on their honeymoon. Left to amuse herself while Sylvester joins an old friend, Daphne experiences a hallucination in a cathedral in Siena that symbolizes her current state. Drifting into illusion, she feels herself wandering along dark roads and imagines that the statues in the cathedral are her examiners at Oxford. Daphne sees an image of her own self-sacrifice in the Christian imagery of Calvary in which the cathedral abounds.

Brittain suggests that Daphne's ignorance is more disastrous than any academic failure, for it is a chosen state and becomes a neurotic need to believe all is well with her marriage despite overwhelming evidence to the contrary. Blaming herself for her failure to satisfy her husband, Daphne makes pathetic attempts to please him, chattering to him about his work, showing him her own efforts at writing. She believes everything will be solved when she bestows "upon him the greatest gift that any wife can give" (p. 175), but when this illusion is shattered also, she is even willing to take the blame for Sylvester's lack of interest in her pregnancy. Daphne hopes the child will provide her with the human contact that her husband has denied her. In contrast to Brittain's ideal, Pat O'Neill, who does not need children for completion, Daphne, like the heterosexual women Chodorow describes, believes that "once she held her child in her arms all her loneliness would be forgotten" (p. 186).

Brittain rewards Daphne's submissiveness with the severest of punishments. Involved in an affair with an opera singer, Lucia, who reminds him of Virginia, Sylvester leaves Daphne, rejecting her with a violent, angry shove. Daphne falls heavily and their child, Jack, is born crippled. Lying on the floor semiconscious, Daphne drifts into a hallucinatory state as she had once before in the cathedral in Siena. She thinks she sees again that symbol of her self-sacrifice, the shadow of the cross on the cathedral wall.

Brittain's use of Christian language and symbolism is only one of the problematic aspects of the final section of the novel. The last chapters chronicle Daphne's recovery from despair, her rising above the dark tide, which Brittain claimed was the true subject of her novel. They also concern themselves with a renewed relationship between Daphne and Virginia Dennison, who meets Daphne by chance in a London street shortly before Sylvester leaves her. Unlike Holtby's first novel, Brittain's is resolved through a female friendship, but the terms of that resolution reveal more than anything else in the novel the extent to which Brittain remains attached to the conventional female values of her mother's world despite her condemnation of Daphne and her attempt at compromise in Pat O'Neill.

The chief problem with the ending of *The Dark Tide* is that it reads most easily as a glorification of female self-sacrifice justified in Christian terms. Virginia Dennison arrives in time to pick Daphne up from the floor and stays to nurse her back to health. Virginia makes it clear that she is motivated by guilt, guilt over her failure to tell Daphne the truth before her marriage: "'I couldn't do much less than try to mend what had been broken because of me, could I?'" (p. 257). So Virginia gives her time and energy to Daphne, who depends upon her entirely for a while since her mother is only too anxious not to advertise Daphne's failed marriage in Thorbury Park.

Virginia's life after Drayton has, however, taken the shape of self-sacrifice in another way. Believing that she has "'only one great enemy, and that's my own intellect'" (p. 217), Virginia has given up the academic life and trained to be a nurse. She now plans to work for the League of Nations on an antityphus campaign in Russia. It is a choice that demands of her a constant willingness to put aside her intellectual pride as she struggles to-

ward what she calls " 'an ideal of service.' " (p. 287). When Pat O'Neill tempts her to change her mind with the offer of a position at Drayton, Virginia rejects it in biblical terms. " 'Get thee behind me, Satan!' " she replies to Pat. " 'I've put my hand to the plough and I'm not going to look back' " (p. 208).

Although Brittain expressed some reservations about Virginia after the novel was published, suggesting that she probably threw away her life in a typhus camp quite needlessly, the novel itself indicates little but assent for Virginia's position at the time. Daphne, we are to believe, will find some satisfaction in her writing and in her refusal to take revenge on Sylvester by ruining his political career with a divorce. She has become quieter, more independent, more mature. Virginia says good-bye to her with the longest speech of the novel, a speech full of admiration for a Christian notion of sacrificing oneself for others, particularly the undeserving. She compares the new Daphne, who has matured through suffering, to saints and martyrs, to all those " 'who thought that their supreme effort was in vain, but still went on' " (p. 315).

At the end of *The Dark Tide* both women have changed. Brittain has restored the balance between them and, insofar as Daphne is Holtby, between Holtby and herself. Daphne is allowed a measure of intellectual success in her writing and a measure of autonomy but must pay for it with life service to a crippled son and legal bondage to a dreadful husband. In Virginia Brittain allows herself personal freedom and the use of her energies in work, but the cost is the fulfillment of those ambitions she desires the most. Brittain cannot allow herself at this point complete separation from the traditional view of good womanhood her mother taught her. Female self-empowerment in *The Dark Tide* is the strength to continue alone, but it can only be justified through the service ideal.

The Dark Tide received some surprisingly favorable reviews, surprising considering Brittain's difficulties in getting it accepted for publication. But she was also immediately threatened with a lawsuit by the *Manchester Guardian* over the champagne-bribery issue and deeply hurt by the attitude of the Oxford authorities, from whom she "encountered acid disapproval and a ban by my own college upon the circulation of the book" (p. 6). Incapable

of taking this lightly, Brittain closed the London flat and took temporary refuge in the country, "convinced that my career as a writer and my reputation as an individual were alike at an end" (p. 7).

Chapter 2

"Your life is your own, Muriel"

The Crowded Street;
Not without Honour;
The Land of Green Ginger

lthough the publication of *The Dark Tide* was to bring George Catlin into their lives and create a temporary separation because of Brittain's marriage, Holtby and Brittain were still living together on Doughty Street at the time of writing their second novels. It was a period of increasing success as journalists and growing confidence in the possibility of their own independence. Holtby, who never took the trouble with her articles that she did with her novels, was not so immediately successful a nonfiction writer as Brittain, but by 1923 she had already won the approval of Lady Rhondda and made the connection with *Time and Tide* that was ultimately to earn her the description "the most brilliant journalist in London."[1]

In their lack of ambivalence and forceful rejection of most traditional female values, Brittain's and Holtby's second novels, *Not without Honour* and *The Crowded Street,* reflect the new confidence a second self had authorized in each of them. Both novels take as their subject a female protagonist successfully battling the restrictions of provincial life; both, together with Holtby's third novel, *The Land of Green Ginger,* leave the protagonist facing life without

55

a husband. Brittain's *Not without Honour* picks up the flawed-prophet theme that Holtby claimed was her concern in *Anderby Wold*. And all three novels wrestle with the question of female self-sacrifice and the service ideal, a problem discussed in many novels by women in the period, as, for example, in May Sinclair's *Harriet Frean* (1922).

The rhetoric of the final pages of *The Dark Tide* asks for approval. There is no ironic distance and no hint of the reservations about both Daphne and Virginia that Brittain was to express in an unpublished November 1923 letter to George Catlin, who had written to her from the United States praising the novel. Daphne no longer interests her, she says, since she regards resignation as one of the seven deadly sins. Brittain is still interested in Virginia Dennison but is herself now further away from "that sense one had so strongly during the war of the colossal unimportance of intellectual things." Seeing Virginia as fundamentally damaged by the war, obsessed by it against her will and drawn from "the vocation she was best fitted for," Brittain now talks about the possibility of "a better completer Virginia," one who might "accept the new responsibilities of women instead of contemptuously rejecting them." Brittain claims for Virginia what she claims for herself at this period, that she will not marry.[2]

What changed Brittain's view of her characters and altered her view of intellectual ambition and self-sacrifice? *The Crowded Street* suggests that Holtby's reading of Brittain's *The Dark Tide* might be among the most significant influences. In an unpublished 1925 letter to Catlin, now at McMaster, Holtby calls *The Dark Tide* "crude and immature" but talks also of "a perception and creative genius" that Brittain has not yet shown fully in her work. She claims that Brittain could be Delia of her own second novel but not Virginia Dennison.

By the time this letter was written, Holtby had already expressed her reading of *The Dark Tide* in *The Crowded Street*, which she had begun in 1923 and published in the autumn of 1924. She had great difficulty writing the book and indeed tore the manuscript up once and started again.[3] "It's like a jelly that won't 'jell'—cold, flabby, formless,"[4] she wrote to Jean Mc-William. "The minor characters simply refuse to stay minor. The major ones insist upon telling me everything about their perfectly ordinary pasts."[5] Holtby felt "overcrowded" by her material,

"smothered in a bewildering crowd of people and things."[6] This is not the source of the novel's title, as Claire Hardisty suggests in her introduction to the Virago reprint. The title clearly comes from the poem by Brittain that serves as an epigraph to the novel and refers to being abandoned in a crowd of people. Hardisty is probably right, though, when she claims that the amount of autobiographical material and "the obvious frustration experienced by the author lead us to suspect a very great personal involvement in the story."[7]

The Crowded Street suggests that Holtby's main disagreement with Brittain's *The Dark Tide* lay in the harshness of her portrayal of both Daphne and Virginia. Like *The Dark Tide,* Holtby's novel has two female characters who are at least partial portrayals of herself and Brittain. The Daphne Lethbridge of *The Crowded Street* is Muriel Hammond, a Daphne made more sympathetic and less foolish by a thorough examination of the social pressures of her upbringing. Holtby answers Brittain's harsh criticism of Daphne's naiveté by laying the blame more heavily upon these social pressures. Holtby described the novel in its early stages as "a social study of a northern provincial town."[8]

The Virginia Dennison of this novel is Delia Vaughan, a social activist and feminist, motivated in her friendship for Muriel less by religious guilt than by a healthy self-interest and by human compassion. Virginia's vanity and coldness are gone, but her intellectual power is retained and valued. So Holtby excuses the Daphne aspect of herself and Brittain and softens the portrayal of Brittain as Virginia. She asks for a redefinition of the service ideal and for recognition of the value of female intelligence and education.

Brittain recognized Delia Vaughan as a partial "reconstruction of my war-time self."[9] The provincial social life at Marshington, Brittain claims, was based on Holtby's own upbringing. It was also, as Claire Hardisty suggests, based on Brittain's history and background (p. xi); Brittain's hometown, Buxton, is in fact mentioned in the novel as an adjacent town (p. 96). Holtby acknowledges her own participation in Muriel Hammond. Looking back after the novel's publication, she writes, "My Muriel is myself— part of me only—the stupid, frightened part. I know so well her sentimentalities, her pitiful, shrinking ideals, her cowardlinesses, and I have even a little tender affection for them, as one has in

one's softer moments for one's own delinquencies."[10] Just as in *The Dark Tide,* however, the relationship of Brittain and Holtby to their fictional counterparts in *The Crowded Street* is a complex one. Holtby also claims participation in Delia's "occasional ruthlessness, and restless pursuit of an unknown goal."[11]

The action of *The Crowded Street* in some significant ways echoes the action of *The Dark Tide.* Each traces the progress of its female protagonist toward self-definition and empowerment. Both Muriel Hammond and Daphne Lethbridge learn to reject what they have been taught by "the best traditional tales."[12] Both are guided in their decision to do this by wiser feminist friends, Delia Vaughan and Virginia Dennison, each of whom has a lover who dies in the war. *The Dark Tide* could be described in the words Holtby used in a letter to Jean McWilliam about *The Crowded Street*: "a book about a girl who never found romance," which ends not in marriage but in "a kind of coming to terms with life."[13] And Brittain's description of the spiritual theme of *The Crowded Street,* "the search of the burdened, frustrated soul for some magic experience lying just beyond the confines of daily life,"[14] could apply equally well to her own character, Daphne Lethbridge. Indeed, although most commentators on Holtby recognize this as a dominant theme in her work,[15] few note that it is as clearly present in Brittain's first two novels.

One could argue, of course, that these rather general descriptions apply to a great number of English novels with female protagonists. And it is certainly true that Brittain and Holtby both write in that tradition of English fiction in which a moral decision is the turning point of the action. As Hardisty claims, "Muriel's definition of her duty and her difficulty in selecting the right choice, or action, place her as a direct successor to some of the heroines of Jane Austen, Charlotte Brontë and George Eliot" (p. xi).

But the relationship between *The Crowded Street* and *The Dark Tide* is more specific than these general statements of theme suggest. Holtby's reading of *The Dark Tide* puts most emphasis upon the sections of the novel that take place in provincial England. She takes the chapter in which Daphne prepares for her wedding in Marshington and opens it up to a more detailed examination. How did Daphne become Daphne? Holtby asks. Her answer is a confirmation of Brittain's suggestions in *The Dark Tide* but much

more overt and much harsher in tone. The strongest political statement Holtby was to make in her fiction, *The Crowded Street* is a cutting indictment of society's oppression of women and of mothers as the primary agents of that oppression. Holtby affirms what she was ambivalent about in *Anderby Wold,* the need to reject the mother's values and insist upon the superior claim of one's own autonomy. If Brittain taught Holtby the necessity for feminism, as Holtby claims, she was clearly a good instructor.

The Crowded Street opens with a prologue, a children's party that is emblematic of the rest of Muriel Hammond's life. Muriel joyfully anticipates the party and, still childishly undamaged by society, knows herself to be "more beautiful than anyone in the world" (p. 10). At the party few agree with her self-description; she dances badly and has few partners in a world where "the unforgivable sin" was "to have no partners" (p. 16). Mrs. Hammond and the other mothers compete over the relative popularity of their daughters, and Muriel is "vaguely aware of duty unfulfilled" (p. 13) toward her mother. She solves this problem by filling in boys' names on her dance program and hiding in the dining room. There she takes one candy from the laden supper table, is accused of stealing, and goes home in disgrace. Muriel has taken the initiative and violated the unwritten rules for females; on this occasion, as on all others, she should have waited. The prologue ends with the words "Muriel had never found the party" (p. 19), and she never does. Like Daphne Lethbridge, she has to learn that "the party" as traditionally defined has no magic for her nor, perhaps Holtby is saying, for many women.

In the provincial society of Marshington that Holtby exposes so ruthlessly in *The Crowded Street* the only goal for women is marriage; "there is only one thing that counts for a girl in Marshington," explains Delia Vaughan to Muriel, "and that is sex success" (p. 88). Even marriage is not desired for its own sake but as a mark of triumph, often triumph over those seen as socially superior. The problem of marriage seen as a social affair rather than a personal matter is the concern of many women's novels of the twenties and thirties; Margaret Kennedy's *The Ladies of Lyndon* (1923) is a good example. In *The Crowded Street* Mrs. Hammond desires her daughter's marriage to the local young squire, Godfrey Neale, primarily because it represents victory over Mrs. Marshall Gurney, whose daughter is interested in God-

frey. Throughout the novel Holtby emphasizes the role of mothers in reinforcing this social game "so hedged with rules . . . which women played for contentment or despair" (p. 100).

Such education as women receive, Holtby shows, only tends to reinforce society's goals. So Heathcroft, the school to which Muriel is sent in order to cultivate suitable friendships, a school not unlike those that Holtby and Brittain themselves attended, teaches her that "goodness," that is, obeying her parents, is to be preferred over "cleverness." Mrs. Hancock, Heathcroft's principal, recognizes that "for most of her parents, the unacknowledged aim of education was to teach their children to be a comfort to them" (p. 28). Holtby brilliantly reveals the motivations of such educators as Mrs. Hancock, who is too intelligent not to question the wisdom of the school motto, "Happy in my lot" (p. 42). Mrs. Hancock is a businesswoman and knows that since the parents are the customers who pay the bills, they are the ones to satisfy. And they will not be comforted by daughters who make them uncomfortable.

Muriel is at first pleased to go to school, since she has ambitions very much like Daphne Lethbridge's: "She wanted to draw, to paint, to play the piano as no one before had played it" (p. 27). She wants to study mathematics and astronomy and, significantly, fill "her beautiful mother's heart with pride" by succeeding at two incompatible aims: making "wonderful friendships" and "winning all the prizes" (p. 28). Her ambition to be a great mathematician has been influenced by a biography entitled *The Life of Mary Somerville,* but instead of mathematics Muriel is encouraged to study dressmaking. Vainly fighting for lessons in astronomy that her mother has not requested, she asserts her own autonomy against her mother's control: "'It wasn't Mother. It's me'" (p. 29). It is to be a long time before she asserts herself again.

Muriel is not popular at school and the friendship she does make is not considered suitable. Muriel "gave her heart to Clare Duquesne" (p. 31), a foreign student who has all the confidence Muriel lacks. Unlike Muriel, she can climb without falling, laughs when she makes mistakes, and wears clothes that defy all the conventional rules for young girls. Muriel's passion for this idealized second self is the closest thing to intensity she is to experience in the novel, but it is strongly discouraged by Mrs.

Hancock, who believes that passionate friendships between girls could wreck "all hope of matrimony without offering any satisfaction in return" (p. 41). Holtby's portrayal of girls' schools dramatizes much of what Carol Dyhouse and Martha Vicinus say about female education at this time. It also has some strong similarities, though it is less harsh, to Antonia White's autobiographical school story *Frost in May* (1933).

Although Holtby stresses the importance of female friendship in many of her novels, only in *The Crowded Street*—unless one counts Lydia Holly's schoolgirl crush on Sarah Burton in *South Riding*—does she suggest a lesbian feeling. When Clare visits Muriel's family in Marshington, Muriel's involvement with her friend is compared to the infatuation of Godfrey Neale; Muriel spends a whole dinner party telling Godfrey about Clare at school while Mrs. Hammond ironically looks on with satisfaction. Interestingly, Holtby represents this friendship as antagonistic to Muriel's relationship with her mother, as the friendship of a woman's second self so often is. "Why," wonders Muriel, "did she feel this silent force of her mother's will coming between her and the most glorious friendship that she could ever know?" (p. 79). Brittain tells us that Clare Duquesne is a portrait of Holtby's school friend Osyth Harvey.[16]

Clare is the only female character in the novel who apparently makes society's expectations for women work for her, but she is able to do so only because she has been blessed with beauty, wealth, and well-connected relations. Quite willing to accept that women are considered merely sex objects, Clare simply aims at being the sexiest of objects. She appears to break many social rules but adheres strongly to the most important one, that marriage is the aim of a woman's life. Self-centered and rather unimaginative, Clare marries young and seems set to marry many times. In the meantime her promising talent as a singer goes undeveloped.

Holtby provides two powerful portraits of women whose attempts to follow the expected path for females destroy their lives. Muriel's Aunt Beatrice is the "home daughter," the one who stayed at home to nurse her mother and whose wretched existence Holtby herself dreaded experiencing full time. Beatrice moves from one sister or brother to another, "paying for their hospitality by registering approval" (p. 24). Unlike Sylvia Townsend War-

ner's protagonist, who in *Lolly Willowes* (1926) solves the problem by becoming a witch, Beatrice sees only marriage, any marriage, as an alternative to her situation: "Marriage is . . . what we were born for—to have a husband and children, and a little home of your own" (p. 223). All Beatrice has left to pray for is "that I can die before every one gets tired of me" (p. 224).

Muriel's sister Connie, growing up with Aunt Beatrice as a graphic warning, is desperate to marry and willing to break some of the rules to do so. Like Clare she flirts privately at dances, takes risks when she rides horses, and associates easily with men. But Connie is no Clare Duquesne. Having failed to capture a likely prospect, a local doctor, and believing herself abandoned by a man with whom she has been having an affair, Connie traps a husband she does not want by getting pregnant. The scenes of Connie's miserable marriage, which her mother has insisted upon, take place on a desolate farm. The Todd family and the moor farm at Thwaite are reminiscent of *Wuthering Heights,* as Brittain and other critics have pointed out. Holtby uses the echoes, however, to offer a very different view from Emily Brontë's. Holtby evokes the world of religiosity, a puritan self-righteousness, which is used to punish those who violate the sexual code, as a way of illustrating its destructiveness. Her sympathies are all with Connie, who eventually dies of pneumonia brought about by running away. Although Connie actually dies because an oxygen tank fails to arrive, Holtby blames her death as much on the romantic view of passion Connie has learned from reading such novels as *The Romance of Emmeline* and, perhaps, *Wuthering Heights.* There are no grand passions, no Heathcliffs, here, only unwanted pregnancy and death.

Muriel's story is played out against a background provided by these negative role models. She has learned society's lessons all too well. She is totally obedient to her mother, but Holtby understands that this obedience is based not only on a sense of duty but also on that bond from which Muriel cannot separate. She sees her mother—falsely, for "Mrs. Hammond was not a hurt child" (p. 99)—as in need of protection. For a moment caught in that confusion of roles characteristic of the mother-daughter relationship as Chodorow defines it, Muriel wants to take her mother home "and kiss her better" (p. 99). She experiences her mother's suffering: "Muriel felt the tension in the room to be

unendurable. Somehow they were torturing that gentle little lady on the sofa" (p. 149).

The first part of the novel is structured on a series of social occasions that essentially replicate the children's party of the prologue. Like the Edwardian young women Woolf describes so brilliantly in *Three Guineas* (1939), Muriel spends her time waiting, waiting to be asked to play tennis, to go for a walk at a picnic, to dance, to get married. Life is a party to which she must wait to be invited; she takes no initiative. As the years go by, Muriel thinks of herself as the heroine of the novel no one—except Holtby—writes, the novel in which nothing happens. Ironically, the one kiss Muriel receives, from Godfrey Neale as he is about to leave for battle, is unknowingly interrupted by her mother, whose summons the well-trained Muriel immediately obeys. At this point in her life, Muriel, like Daphne Lethbridge, would have married Raymond Sylvester or anyone else who could provide an invitation to the party. But Holtby is to offer Muriel a more hopeful future than Daphne's, just as she will make her rejection of the traditional female values more complete.

The first change in Muriel's life comes about as a result of World War I, as it did for so many women. Through Muriel's response to the war, Holtby answers Brittain's contempt for those who survived it emotionally unscathed. Using a variation of a motif that both she and Brittain repeat many times in their work, Holtby claims that "the war came to Marshington with the bewildering irrelevance of all great catastrophes" (p. 110). Just as Daphne in *The Dark Tide* considers it merely "an unwelcome interruption" (p. 9), Muriel sees it as an interruption in the tennis tournament.

For the young women of Marshington, though, the war is to provide a dramatic role for the first time. The Daisy Weathergays, whose husbands go off to fight, become the "symbol of womanhood, patient and heroic" (p. 115). Muriel envies those women "with that envy of suffering which can burn most potently of all" (p. 115); when Delia's fiancé is killed, she describes herself as "hungry for her pain" (p. 143). For women like Muriel, Holtby explains to Brittain, the war highlights their own empty lives so that any feeling, however painful, becomes the evidence of involvement and therefore the occasion of envy.

Although the war is to change the world, even Marshington,

sufficiently so that Muriel will eventually be able to find an outlet for her energies, for the time being she can only volunteer at the local hospital and watch other women become nurses. Nevertheless, the war forces Muriel to assess her own situation at last, and that assessment is the beginning of change: "She had wanted to be clever, but had sacrificed her intellect to her mother's need. She had meant to be like Delia and had grown like Rosie Harpur, because her duty had lain at home . . . She could not stir herself to effort for her own sake" (p. 141).

Muriel learns the rewards and terrors of independent action for the first time in an attempt to rescue her sister Connie from the consequences of her foolish marriage. Writing home as she is about to confront Connie's fanatical father-in-law, Muriel refuses her mother's request to return to help with a luncheon; she feels "as soldiers feel about letters written on the eve of an advance" (p. 180). Holtby's association of military imagery with female independent action underscores Sandra Gilbert's point that for many women World War I represented liberation.[17] After Muriel fails in this first attempt, her decline in spirit and increasing resentment of her mother are obvious even to the vicar of Marshington, Delia Vaughan's father. He observes Muriel's attitude to her mother as "that scornful yet submissive aversion, which lacked spirit even to be violent" (p. 218). On the verge of being able to separate herself at last from her mother's view of the world, Muriel realizes, " 'the only thing Marshington cares about is sex-success.' Delia Vaughan had said that. Muriel did not believe her. It was true enough, quite true" (p. 227).

The relationship between Muriel and Delia Vaughan occupies the final section of the novel, in which Holtby offers an alternative to Brittain's concluding sentiments in *The Dark Tide*. A more human Virginia Dennison, Delia, like Brittain and Virginia, has had to create a life for herself after the death of her fiancé. But Delia is able to do this more easily than Virginia, for although she loved Martin Elliott, with whom she shared her intellectual as well as her emotional life, she had never viewed marriage itself as a goal. " 'It isn't marriage I object to,' " Delia explains to her father in words that echo sentiments Brittain expressed many times,[18] " 'only marriage as an end of life in itself, as the ultimate goal of the female soul's development' " (p. 230). Through the possibility of Delia and Martin, Holtby suggests the integration

of work and marriage that Brittain had suggested in Pat O'Neill and Stephanoff and that was to remain an ideal for Brittain, although never very successfully portrayed in her fiction. Holtby leaves moot the question of the advantages of the right marriage; in an unpublished 1925 letter to Catlin, she wrote that when Martin Elliott died Delia probably realized that "she had less power to carry out the work for which his death perhaps gave her the more liberty."

Urged by her father to help Muriel, Delia breaks through the polite veneer of social relationships in Marshington to point out Muriel's mistake and to talk to her of the necessity for self-empowerment. "'And you thought that by helping your mother you would escape the possibility of having to help yourself, didn't you?'" Delia says to Muriel. "'Your life is your own, Muriel, nobody can take it from you . . . But the thing that matters is to take your life into your own hands and live it'" (p. 232). Muriel tells Delia that she is "'living like—like a person that I'm not'" (p. 237),[19] and finally decides to leave Marshington and her mother.

Like Daphne Lethbrige, Muriel is rescued in the end by a female friend, but there are some very significant differences between the two relationships. Delia offers Muriel a home in London, but unlike Virginia Dennison, she is motivated not by guilt or by a general impulse toward self-sacrifice but by a healthy selfishness. Delia needs a housekeeper so that she can eat and sleep while she works for the Twentieth Century Reform League; Muriel needs to use her energies and feel useful. It is a fair exchange.

Holtby has not, however, abandoned the justification of women's work through the idea of public service that Brittain offered in *The Dark Tide*. Delia's work is, after all, to reform society, and Muriel is left at the end of the novel with "'an idea of service—not just vague and sentimental, but translated into quite practical things'" (p. 270). But the definition of public service is different from Brittain's. Gone is the masochistic stress on suffering and self-sacrifice. Muriel's work, although an offshoot of Delia's, involves using her intellect, not turning her back on it; it demands the stretching of her energies, not their repression; and it makes her happy. In the name of this work and "'of every new thing that has made me a person'" (p. 270), Muriel is able to

reject Godfrey Neale's eventual proposal of marriage and the traditional values of her upbringing. In contrast to *The Dark Tide, The Crowded Street* leaves the two women friends together, like Brittain and Holtby, sharing a flat in London.

Muriel Hammond, like Daphne Lethbridge, has triumphed over despair and learned to make the choices that affect her own life. But in rewriting Brittain, Holtby has clarified motivations and influences and redefined ideas of independence, choice, and public service. The traditional values of the mother's world have, temporarily at least, been forcefully rejected. Holtby has recreated Brittain's characters in stronger and more human figures of her own and, in empowering them, has authorized both Brittain and herself.

No two novels by Brittain and Holtby share more similarities than *The Crowded Street* and *Not without Honour.* Both begin with prologues that take place at an earlier stage of the protagonist's life; both have young female protagonists trapped in prewar provincial England; both protagonists eventually break out of their prisons to establish themselves in other worlds familiar to Brittain and Holtby, London and Oxford. The intellectual and emotional closeness the two friends shared at this time is evident in the thematic and attitudinal similarities of the novels, not only in the general sense of their common antipathy to life in provincial England but in specific points of their analyses of it.

Begun before *The Dark Tide* was accepted for publication, *Not without Honour* was written mostly in 1923, when Brittain and Holtby had been living together for almost two years. It seems clear that this was a novel Brittain was willing to discuss with Holtby as she wrote it; in *Testament of Friendship,* for example, she describes an argument they had in a London restaurant over "the probable conduct in a crisis of the exhibitionist clerical hero in my second novel, *Not without Honour.*"[20] The willingness to share ideas during the writing process—something they abandoned later—testifies to the degree of their mutual trust at this period.

Nevertheless, despite—or perhaps because of—the importance to her of the friendship with Holtby, Brittain's relationship with George Catlin was steadily intensifying, at first through a transatlantic correspondence and later through weekend visits. Catlin had read *The Dark Tide* and later told Brittain that " 'I determined that I would win Virginia Dennison, and that if you were Vir-

ginia I would win you.'"[21] "Behind all my work that year,"
Brittain says, "—the General Election, the conclusion of *Not with-
out Honour,* my lectures and articles and the Scottish Border
Tour—the music of his letters had sounded like the rolling of
some distant organ, the tones of which became gradually deeper
and the melody more sweet."[22] Although she had determined by
this time that she would not marry, she allowed Catlin to visit
her, comparing the thought of cutting off "this profound and
intimate correspondence" to death terminating "the dear and in-
timate correspondence of the war."[23] On July 5, 1924, shortly
after the publication of *Not without Honour,* she agreed to marry
him.

Described in this fashion, the relationship between Brittain and
Catlin seems to come about abruptly and for insufficient reason.
In part this is because I am seeing it from the vantage point of
the friendship between Brittain and Holtby, as the focus of this
book dictates, and initially, it was indeed a sudden interruption
to the friendship. It is also true that since Catlin objected to
Brittain's inclusion of him in *Testament of Youth,* with the result
that he is referred to merely as G. and barely described as a
character, it is difficult to get much sense of the origins of their
relationship.

Jane Marcus has called this marriage "a marriage of conve-
nience,"[24] a label that Alan Bishop rejects.[25] In the most obvious
meaning of that term, the marriage was more than merely con-
venient; Brittain's letters and diaries reveal an emotional interest
in Gordon, as she and Holtby always called him, that the term
convenient, with its suggestion of lack of feeling, precludes. But if
Brittain was indeed threatened by the accusations of lesbianism
made by others[26] and perhaps also by fears about her own feelings
for Holtby, then the marriage to Catlin was, of course, conve-
nient.

Not without Honour picks up the flawed-prophet theme from
Anderby Wold, reworks Brittain's own ideas about self-sacrifice,
and like Holtby's *The Crowded Street* marks its author's separation
from the female world of the mother. But in her choice of how
to bring about this separation, Brittain reveals quite clearly both
her ambivalence about and her need for the marriage with Catlin.

Brittain's protagonist, Christine Merivale, is first shown in a
prologue as an intelligent, rather unpopular schoolgirl who is

much like Brittain herself in appearance and character. About to leave school and return home to her parents and Torborough, she is encouraged by her mentor, Miss Lansdowne, to think about studying journalism in London. This image of Christine as a young woman of ambition turning for guidance and affection to another woman never appears in the novel again, though the final sequence reconstitutes everything but the female friend.

Brittain's attack on the narrowness and snobbery of life in the provinces closely resembles Holtby's in *The Crowded Street.* In the early part of *Testament of Youth,* where she describes her home-town, Brittain says, "None of my books have had large sales and the least successful of them all was my second novel, *Not without Honour,* but I have never enjoyed any experience more than the process of decanting my hatred [for Buxton] into that story of the social life of a small provincial town."[27] Torborough, like Holtby's Marshington and *The Dark Tide*'s Thorbury Park, is concerned with only two things for women, marriage and social success. Mrs. Hastings, the dentist's wife, is ignored in Torborough until her father is discovered to be Sir Richard Carpenter, a member of Parliament and well-known lawyer. Mrs. Merivale measures her daughter's conduct by the opinions of her socially superior friends. Like Muriel Hammond, Christine is judged successful to the extent that she is seen as popular with young men. *Not without Honour* also has the scene of the unfilled dance program, though Christine is much more heterosexually successful than Muriel—as Brittain was than Holtby—and is rescued from hiding in the cloakroom by the self-conscious Ronald Anderson. Nevertheless, from the moment of her return to Torborough, Christine feels like "a doll being turned over and priced by other people . . . A doll put up to auction in the market place, waiting to be flung at the head of the highest bidder."[28]

As in *The Crowded Street* the guardian of these traditional female values is the mother. To Mrs. Merivale Christine is an extension of herself, there to fulfill her role in her absence and, of course, to perpetuate it in the future. She writes her daughter a letter that consists entirely of instructions about shopping, cleaning the house, and ordering the servants. She is delighted when Christine goes off on a bicycle ride with Ronald Anderson because they are likely to be seen by her friends. When Christine expresses reluctance to deliver magazines for her, Mrs. Merivale feels that

it "was a cruel shame that she, who had spent her whole life making sacrifices for other people, should have a difficult, selfish girl like Christine for a daughter" (p. 31). Like Mrs. Hammond, Mrs. Merivale derives pleasure from the notion of her own self-sacrifice, which she sees as a measure of female virtue.

In spite of the similarities, however, Brittain's attack on the traditional expectations for women is not as powerful as Holtby's. Muriel Hammond is a figure in conflict over these expectations, even though her creator no longer is, and through her it is possible to see their pull as well as their limitations. As such she is a richer character than the Christine Merivale of the book's beginning, who has already rejected these expectations and has an older Brittain's understanding of their flaws. When she attacks her mother verbally, Christine is well aware that her mother is "the only person in the world who makes me want to behave like that" (p. 35). She is already planning to write a book "to prove that Family Life is the Curse of Civilisation" (p. 118). There is no conflict and very little appeal in the rather arrogant, condescending Christine Merivale.

But although Christine has rejected the world of traditional female values, she has little idea what to put in its place. The Christine who searches for a viable alternative is indeed a conflicted human being, and gradually she becomes a more interesting character. Denied the opportunity to study journalism in London by her parents, she recognizes that "there was to be no escape from Torborough through work" (p. 63). Like Muriel, she has a romantic notion of the power of "Love." Love, "a vision of splendour and light, . . . would lift her from the little prosaic circle of every day" (p. 63). She rejects Torborough's version of love—"a safe young man, a good income, and a comfortable home"—but substitutes for it a "snow-white bird of the soul . . . the love of artists and poets" (p. 63).

Brittain carefully prepares the trap that will ensnare Christine, that confusion of the spiritual and the erotic characteristic of many young girls. Eventually Christine thinks she has found the answer to her desire for "the real true Thing that lies behind everything in Life" (p. 36),[29] which she has glimpsed briefly before, in the curate of Garthington, the Reverend Albert Clark. Walking home from listening to one of his sermons, she is suddenly seized by "that sense of an Infinite Beauty behind all life" (p. 207).

The novel had two provisional titles, "The Prophet" and "Man on the Crucifix," and Brittain's treatment of the false prophet, Mr. Clark, is certainly the most fascinating part of *Not without Honour.* She reveals in *Testament of Youth* that she had recorded in her diary the appearance of "a rationalistic curate, whose unorthodox dissertations on the Higher Criticism I took for the profoundest learning."[30] In his notes to the diaries, Alan Bishop points out that this curate was Joseph Harry Ward of Fairfield, a town just to the east of Buxton, and that "Vera Brittain's *Not without Honour* (1924) presents a fictional version of Mr. Ward and his struggles in Fairfield."[31]

What neither Bishop nor anyone else has noted is that in the novel Brittain not only has retained the main outlines of her encounters with Mr. Ward but has used several long sections of her diary verbatim with extraordinarily little editing. Christine's first acquaintance with Mr. Clark, like Brittain's with Mr. Ward, comes through a series of letters in the local newspaper that make him the center of a religious controversy over the higher criticism of the Bible. Christine's argument with her father over the issue closely follows the diary. Mr. Merivale's words are Mr. Brittain's: "a little slip of a girl like you, laying down the law to her *father* about something she doesn't understand" (p. 118).[32] Brittain's summation of the event is given without alteration to Christine: "Of course I have always known really, but it is no longer doubtful to me that it is as a plaything or a pretty toy that my father sometimes spoils and pets me, not as a sensible human being who *counts*—and that he has nothing but contempt for me and my knowledge, just as he has at heart for all women, because he believes them, for some unknown reason, to be inferior to him" (p. 119).[33] Immediately afterward (pp. 119–20) Christine discusses her own religious views, her "glimmer" of truth, again in words taken directly from Brittain's diary.[34]

Brittain's first glimpse of Mr. Ward, like Christine's of Mr. Clark, is in a nearby town one morning; both men are described as pale, thin, with remarkably firm jaws. Brittain transfers Ward's one unlikely supporter, the elderly Mrs. Bennett, into the novel with only a change of name; she becomes Mrs. Crook. As Christine does in *Not without Honour,* Brittain goes every Sunday to hear the curate preach, notes the crowds of working people now in

the congregation, is inspired by his passionate sermons, and eventually is rewarded with a handshake when leaving the church one evening. The outlines of Mr. Ward's experience at Fairfield are repeated in Mr. Clark's: he decides to leave and is persuaded not to; he gives one very depressed sermon; he finally says farewell to his congregation. Brittain, like Christine, visits the curate's home and comments on the inferior social class of his wife. Mr. Ward visits Brittain's home as Mr. Clark visit's Christine's. In January of 1914 Brittain writes in her diary, "I thought of an idea to-day for a plot of another novel, also dealing with Buxton, in which Mr. Ward will play an important part as the original of one of the characters."[35]

What are the implications of such exact use by a writer of material from her own diary? Most obviously it confirms Christine Merivale as a representative of Brittain herself, a Brittain who is punished for her arrogant confidence in her misguided judgments. Brittain indicates her suspicion of her own intellectual pride in Christine Merivale, just as she had in Virginia Dennison, but in *Not without Honour* she makes it clear that spiritual pride is a much greater weakness.

The most significant implications, however, can be best assessed by looking at the changes Brittain makes in turning the story of Mr. Ward into a novel, for there are changes despite the verbatim use of whole sections of the diary. This is the first sign of that rewriting of one's own material which is a more significant feature of the third stage of Holtby's and Brittain's development.

In the diary Brittain defends what she calls "playing to the gallery," and wonders "how far that trait is really the weakness it is always considered." In "natural leaders" she feels it is excusable, claiming that "the love of making an impression" may be indicative of the "fitness to make it."[36] In *Not without Honour,* however, Mr. Clark's overdramatization is shown to be a major flaw, a spiritual pride that makes him cast himself as Christ in the drama of his own life. Clark accuses his congregation of crucifying "Him again to-day in the minds and souls of His prophets who come to save you!" (p. 183). He writes parables in which he makes analogous Christ's experience and his own and finally rejects Christine in order to protect his self-image as a Christ figure. "To-night the last of the cruel nails completed the

crucifixion of his soul," he thinks with some satisfaction. "But the victory was his; he had conquered the world and the flesh" (p. 284).

Brittain underlines the similarities between Christine and Clark. Both see themselves as writers; both are afflicted with what Clark calls "the imaginative mind" (p. 218); both have a passion for Olive Schreiner's work; both feel themselves alone and unappreciated; and most significantly, they have "a mutual aspiration after martyrdom" (p. 224). In book 4 of the novel, entitled "The Shadow of the Cross," Christine's experience is described in terms of a crucifixion. Brittain has represented herself in her two major characters here, just as Holtby did in *Anderby Wold*. In fictionalizing herself as Clark as well as Christine, Brittain links spiritual pride to a male self and condemns it even more harshly. I see Clark as Brittain's attempt to clarify her portrait of Virginia Dennison in *The Dark Tide* and amend it, though not along the lines of Holtby's reclamation of Virginia in Delia Vaughan. This can be supported by the final section of *Not without Honour*, in which Christine, now a student at Drayton College, actually meets Virginia Dennison several years before her appearance in *The Dark Tide*. Christine sees her as wearing "a pose of hidden depths of heroism" and is reminded "vaguely of one or two of Mr. Clark's sermons at Garthington" (p. 295). Brittain is conceding to Holtby Virginia's mistake in rejecting her intellectual strengths, and she points out even more forcefully than Holtby the spiritual pride attendant on self-sacrifice.

The second change that Brittain made in transposing the story of Mr. Ward into her novel concerns the meetings between Christine and Clark. In the diary Mrs. Brittain accompanies her daughter to Fairfield church, is present on the occasion of Brittain's first visit to Mr. and Mrs. Ward, and entertains when the Wards return the call. In the novel all the meetings between Christine and Clark take place while they are alone. Brittain has removed her mother from the scenes, thus fictionally obliterating her. In this way Brittain demonstrates that she sees Christine's relationship with Clark as her way of separating from her mother. As she draws closer to Clark, Christine emphasizes the distance between her and her mother's world: "'And you needn't trouble about what my parents think. They and I are poles asunder; we have nothing in common, nothing'" (p. 218). There is another reason for the

removal of parental supervision; it would have precluded the development of the love affair between Christine and Clark.

The major change that Brittain has made between diary and novel is the introduction of an erotic element into the relationship. In the diary Brittain's romantic interest is centered on Bertram Spafford, abbreviated to B.S.; her intellectual energy and idealistic spirit are focused on Ward. The plot of *Not without Honour* is a love affair between Christine and Clark. Their similarities draw them together; they confess their attraction for one another in a scene that culminates in a kiss—the convention Holtby had used in *Anderby Wold*—and agree to sublimate their passion in shared work in Clark's parish. Increasingly they become the subject of gossip in Torborough, though Christine believes they have achieved a "perfect spiritual communion" (p. 253), one that has effectively separated her from Torborough. When her parents hear the gossip and lock her in the house, physically as well as symbolically tying her to the world of traditional female values, she escapes and goes to Clark, suggesting he take her away with him. His rejection of her sends her running wildly in the night across the common as Clark envisions her "engulfed" by Torborough.

As she wrote *Not without Honour,* Brittain was involved in the early stages of her relationship with Catlin and once again was considering the possibility of marriage, a possibility she had dismissed since the death of Roland Leighton and the friendship with Holtby. The love affair between Christine and Clark indicates, I suggest, the ambivalence Brittain felt toward the relationship with Catlin. First of all, unlike Holtby, who liberated Muriel Hammond from Marshington through the intervention of a female friend, Brittain explores the possibility of liberation through heterosexual love. She follows Chodorow's prescription for the daughter's separation from the mother. It is significant, perhaps, that Catlin had entertained the idea of a religious life at one point. As a religious teacher Clark is given the capacity to offer Christine the spiritual and intellectual companionship Brittain had found with Holtby, as well as the possibility of acceptable sexual passion.

But Christine's trust in heterosexual love is not rewarded. She does not escape Torborough through Clark; at the high point of her relationship with him, she is merely his assistant, performing

the traditional female visits to the sick as she had earlier with her mother. And when she needs him most, Clark proves to be self-aggrandizing and cowardly. Brittain's mistrust of once again putting her faith in a relationship with a male is clear enough.

It is equally clear, however, that she has a strong need to make this route viable for herself. In the final section of the novel Christine is at Oxford in 1914, where "for the first time, her eager intellect was satisfied" (p. 300). Brittain has reclaimed the intellectual life she rejected in Virginia Dennison. But although Christine does not marry him, Brittain also reclaims Albert Clark. On the day war is declared, Clark volunteers as a chaplain. At Oxford Christine learns of his heroic death in battle and recognizes that he had, after all, "the courage to face crucifixion" (p. 313). She compares him in her mind to Lycurgus, to Joan of Arc, to Savonarola, "vanished martyrs" who "could only live their lives as actors on a larger stage" (p. 314). Christine realizes that a flawed prophet may teach the truth, "that a man can be full of human follies and yet see the light" (p. 315). Mr. Ward, who disappears inconspicuously from the diary when he leaves Fairfield, has been transformed into a martyr who sacrifices himself for the possibility that "some remnant of beauty might remain" (p. 316). He has also been cast in the role of Brittain's fiancé, Roland Leighton, who died in similar circumstances early in World War I.

In reclaiming Clark in this particular fashion, Brittain is also proclaiming her heterosexual self. She has no question about her feelings for Roland; they are evidence enough of her normality. Christine does not marry at the end of the novel, but the possibility of her marriage at some future date is much greater than that of Muriel Hammond. There are no female friends of importance in her life. Christine has rejected many aspects of the mother's world; she is less ambivalent about Torborough than Muriel is initially about Marshington. But she has not rejected the idea of a primary heterosexual relationship. It is not yet clear how Christine or Brittain could marry and sustain the intellectual fulfillment each has found without being drawn back into some equivalent of Torborough, but it is clear that Brittain has not rejected that possibility.

Perhaps because Brittain was still uncertain of the future she envisioned for herself as she finished *Not without Honour,* the final section of the novel seems seriously flawed. Brittain essentially

repeats the ending of *The Dark Tide,* although *Not without Honour* has throughout argued a different case. In several pages of lyrical contemplation, comparable to Virginia's speech to Daphne at the end of *The Dark Tide,* Christine readopts the martyr's role. She believes that "the Pale Galilean still waited for her with His message" (p. 316), and that "as long as His disciples, . . . were ready to live and die for humanity in its darkest hour, His kingdom would not fail" (p. 316). She, too, must give up "her inheritance of youth and joy" (p. 316). The virtue Brittain finally affirms, then, is self-sacrifice, which seems far too much a part of those traditional female values *Not without Honour* has forcefully attacked.

Despite the reservations she expressed in *Not without Honour* and despite her stated certainty that she did not want to marry, that she loved her "uninterrupted independence" and "had achieved the way of living that I had always desired,"[37] on July 5, 1924, three weeks after he had landed in England and taken her to a performance of Shaw's *St. Joan,* Brittain agreed to marry George Catlin. Since Catlin had an academic appointment at Cornell, this meant for Brittain not only the usual disruptions of marriage but a major geographical upheaval. She knew him only through letters, letters that had convinced her he was a feminist, would respect her need to do her own work, and shared her view that marriage was not the aim of a woman's life but merely one of the possible ways of enriching it.

Why did Brittain marry? To read her thoughts at this time as she expressed them in *Testament of Youth* is to believe that she was making a political gesture, demonstrating the possibility of a new kind of marriage: "I felt that I must not shrink from that fight, nor abandon in cowardice the attempt to prove, as no theories could ever satisfactorily prove without examples, that marriage and motherhood need never tame the mind."[38] The demonstration would not be easy, she realized, because "our old enemies—the Victorian tradition of womanhood, a carefully trained conscience, a sheltered youth, an imperfect education, lost time, blasted years—were still there and always would be."[39] Was Brittain's marriage really undertaken in opposition to "the old enemies" or was it perhaps, at least in part, the result of a modernized version of them, the desire to be or to appear "normal," a liberated, ambitious, but entirely heterosexual woman?

Brittain claims that "with the characteristic selfishness of lovers," she forgot that her marriage and departure for America would mean "a period of loneliness and heartache for Winifred."[40] Part of Holtby's heartache, Brittain writes, would be a comparison between Catlin's devotion to her and Holtby's treatment by the shadowy figure of her longtime childhood sweetheart, "Bill," actually Harry Pearson. Whatever the truth about Holtby's feelings for this unsatisfactory suitor, Brittain's mentioning him in this context seems rather to be further blurring of her relationship with Holtby. There is little doubt that Holtby's main heartache would be the loss of her life with Brittain.

With characteristic generosity of spirit, that desire to leave each of her beloveds absolutely free, Holtby never attempted to influence Brittain's decision.[41] It was only when she went through Holtby's library the week after her death that Brittain discovered the words written on the flyleaf of Holtby's copy of St. Joan, words that Holtby had concealed from her "with so loving and self-forgetful a magnanimity," "Ave atque Vale. July 5th, 1924. W.H."[42] The relationship was not, of course, dead, though perhaps one stage of it was. The two friends were not even immediately parted, because Brittain postponed her marriage for a year, a year that Catlin spent in America. Brittain and Holtby completed the plan they had made before Brittain's engagement and spent three months in Europe gaining firsthand information for their political speeches on behalf of the League of Nations Union.

Catlin returned as planned from America and Holtby's letters to her friend Jean McWilliam show her attempting to celebrate rather than resent "this richer life"[43] for Brittain. "G. is back," Holtby wrote. "When I saw him yesterday, slim, charming, brilliant, with his blue eyes ablaze with happiness, and his arm across the shoulders of his little love, I almost believed that the romance of fiction was less perniciously untruthful than I had thought. Even if marriage proves catastrophic, this parting and meeting has at least been lovely."[44] This comment is hardly in itself a strong statement of Holtby's faith in the marriage, and it is surely undercut by the knowledge of Holtby's nickname for Brittain, "my V.S.V.D.L.," my very small, very dear love. "My little love" has become "his little love," hardly an observation Holtby could make without pain.

Indeed, Holtby's pain is evident in her letters of this period and

in the, for her, curiously sentimental poem she wrote when she returned to their flat after Brittain's wedding:

> Oh, foolish clocks, who had not wit for hoarding
> The precious moments when my love was here,
> Be silent now, and cease this vain recording
> Of worthless hours, since she is not near.[45]

Even the new pen Brittain gave her just before leaving for America created "blots and things." Pens, Holtby writes, "don't like my writing or something, and are false to me just when I most need them."[46]

Most significant of all is a long letter in which she discusses how she will live when "Vera will go, and I shall be on my own again."[47] It is a letter that tries to climb out of despair into some sort of affirmation that "life is a lovely thing." Holtby speculates on the possibility of a life of Christian service in which she subordinates her "own intellectual training to the needs of those who have had no opportunities," an idea she finds attractive because it might mean an "end to this heart-tearing sense of separation— the end to this pleasure that turns only to bitterness."[49] Although she abandons this idea in favor of using her intellect for "sound thinking and unprejudiced work,"[50] as she does in her fiction, she denies herself the excuse of refraining "from doing things because one is not worthy."[51] The relationship between the worth of the professor and the truth of what is professed, or the value of the services performed in the name of this truth, is the overt subject of the novel Holtby was writing during 1924 and 1925, just as it was the ostensible subject of Brittain's *Not without Honour.*

Neither Brittain nor Holtby found publishers for the books they wrote during Brittain's engagement and the early days of her marriage. The sense of mutual empowerment temporarily suspended, neither could work as she had before. Brittain's "Honeymoon in Two Worlds" later provided material for *Testament of Experience* (1957), but Holtby's "The Runners" was eventually shelved. Holtby claimed that she enjoyed writing it "as she had never enjoyed a book in her life,"[52] but it seems to have been the total absorption in work she appreciated most, an escape from personal turmoil. "I am fierce for work," she wrote to Jean McWilliam. "Without work I am nothing."[53] She writes in more detail about this work to Jean McWilliam than about any other,

perhaps reflecting a need to find alternatives to Brittain as her only working partner.

"The Runners," a fourteenth-century romance, is based on the story of Wyclif, "a man torn by intellectual doubts, physical cowardice, moral cowardice . . . who saw farther than any man of his time—and dared not go."[54] Holtby was excited by the dramatic possibility of certain scenes—the peasants' revolt, the translation of the Bible, the germs of English elementary education—and by the opportunity to write in a different genre. Rereading *The Crowded Street,* she found she disliked it and swore never to "try *vie de province* again."[55] "A pox upon your niggardly realism!" she wrote to Jean McWilliam. "I'll write a romance, high tragedy, real galloping stuff, or die for it."[56]

But although she had been planning for over a year to write "a non-realistic novel,"[57] encouraged by such experiments in technique as Woolf's *Jacob's Room* (1922), which she was reading at the time, her style refused to cooperate: "It's my style that is damnable—too heavy and somehow artificial. . . . I'm off romance."[58] Reading the manuscript I was struck less by problems in style than by the problem the publisher's reader, another Yorkshire novelist, J. B. Priestley, had with the work. He recommended rejection of the manuscript because it was half love story, half chronicle, and did not "hang together."[59] The difficulty lies, I think, in the fact that though the style works well for the chronicle aspect of the novel and indeed provides some rich and powerful scenes like that of the revolt, the love story and its subtext touch on Holtby's primary sociolgial themes, which are much better served by the realistic tradition of a George Eliot novel.

In *Testament of Friendship* Brittain claimed that "The Runners" "illuminates Winifred's mind more clearly than any of her writings except *South Riding,* for in the contrasting personalities of those whom she called 'runners' and 'leaders' it embodies her own conflict between the claims of art and the claims of social service."[60] It is significant that although "The Runners" is in many ways Holtby's reading of *Not without Honour* and explores, as Brittain does, the worth of a flawed prophet and the relationship between religious and erotic emotion, for the first time no major character in it is representative of Brittain herself. The debate takes place between two male protagonists, Wyclif, the runner, a priest and a scholar, and Will Fielde, the leader, son of a woman

Wyclif had loved. As Brittain suggests, Holtby shows us the battle between her divided selves, the imaginative artist and the social worker, both given the authority, which Holtby must have felt she needed at this time, of historical validity and male identity.

Wyclif preaches equality. He wants to "free the people,"[61] promises land at fourpence an acre and language accessibility. He preaches in English rather than Latin. Will Fielde, in search of "a noble cause," is drawn to Wyclif, but when the people revolt, Wyclif lacks the courage to support the rebellion. Fielde is the fighter who supports the rebellion and, disappointed in Wyclif, breaks with him. Holtby later reconciles the two men, the two sides of herself, through Fielde's realization about the nature of freedom: "Freedom was the thing needed then. That was what Wyclif had said. Was it possible that all the time they had been fighting on the same side and not knowing it? Were their goals perhaps one? The bondage which they had sought to break was different, that was all."

As Brittain had in *Not without Honour,* Holtby redeems her flawed prophet, but she resists the temptation of martyrdom. "The Runners" may be in places "real galloping stuff," but it is not "high tragedy." Will does not die a hero's death; he is murdered. Wyclif, who lives on wondering whether those who preach change are responsible for the violence that brings it about, suffers a stroke and is sent into forced retirement. Holtby clearly saw the problem with the ending of *Not without Honour* and attempted affirmation without high drama. Writing a romance seems to have taught her the value of realism and in the work to follow she was more likely to stress the dangers of the romantic imagination than its joys. Also in contrast to Brittain, Holtby redeems same-sex friendship and stresses the plurality of truth. Fielde's recognition of the commonality of all forms of oppression reflects the position both Holtby and Brittain were to stress increasingly in their work, the fight for equal humanity, whether against racism, antifeminism, or militarism.

"The Runners" is also a love story, one through which Holtby reveals some of her response to Brittain's marriage. The novel's representation of marriage is almost entirely negative; the strongest bonds are not those sanctioned by legal ties. The duke of Gaunt loves his mistress, Katherine Swynford; Sir Guy marries Alice Fielde though he really loves Lady Isabelle. In this, of

course, Holtby is accurately reflecting the fourteenth century. Could it have been one of her reasons for choosing this subject? Wyclif, a priest bound by vows of celibacy, finds sexual abstinence hard. Has Holtby perhaps encoded lesbian taboos as religious ones? Wyclif is attracted to Alice Fielde, whose lover, like Brittain's, has been killed in the French wars, and who is now engaged, as Brittain is, to someone else. Like Brittain, Alice is a feminist: "'O, we are fated, we women,' she cried suddenly, 'we have minds and souls as strong as any men, yet because of this strange frailty of our bodies we have become instruments of man's grosser pleasures till abstinence from our company is a virtue."

Alice flirts with Wyclif at her wedding to Sir Guy, but he is uncertain of the true nature of her feeling for him: "Wyclif never knew whether she had loved or mocked him and this was, of all the pain she brought him, the most hard to bear." In a similar fashion Holtby may have been uncertain at this time of Brittain's feeling for her. Certainly the letters Brittain wrote to Holtby immediately after her marriage are full of reassurances on this subject. After running away from Sir Guy, Alice dies in a ditch giving birth to a son, and Holtby restores her world by replacing the unsatisfactory heterosexual bond with an enriching same-sex friendship between Wyclif and Alice's son, Will. Although Holtby never portrays women rejecting male suitors in the name of female friendships, as, for example, Joan Ogden rejects Richard Benson in Radclyffe Hall's *The Unlit Lamp* (1924) or Sally rejects Glen in Sylvia Stevenson's *Surplus* (1924), from now on in her work the single state is almost always preferable to marriage. And "The Runners" is in many ways a celebration of a same-sex friendship. The epigraph from Saint Jerome, the preeminent anti-matrimonialist, that opens the novel, "If an offence come from the truth, better were it that the offence should come than that the truth be hidden," applies to more than Wyclif's political beliefs.

At the end of 1923 Holtby's friend Jean McWilliam, with whom she had served in France and who was now a headmistress in Pretoria, made a visit to England. Holtby and Brittain were thrilled by her descriptions of South Africa and planned a trip there together. When Brittain's marriage put a stop to her visit, Holtby determined to make the trip alone. She had intended to

go when Brittain left for America in the fall of 1925, but the need to earn money prevented her departure till January 1926. Brittain sent her a blue and yellow painted bird as a mascot for the trip. Holtby called it "Vsvdyl," the initials of her nickname for Brittain, and took it on every trip with her from then on. Although it was to be many more months before Brittain again shared her life with Holtby on a daily basis, the letters she wrote to her from America make it clear that she had realized how necessary the relationship with Holtby still was to her. "You are more necessary to me than he is," she wrote in February of 1926, "because you further my work." The presence of Vsvdyl on the trip to South Africa seems symbolic of that realization.

As well as a visit to an old friend, Holtby's six-month trip to South Africa was also work. She gave a series of lectures for the League of Nations Union, which guaranteed her traveling throughout the country and also made her something of a celebrity. It was a very significant trip for Holtby's development. It provided material for two subsequent novels, *The Land of Green Ginger* (1927) and *Mandoa, Mandoa!* (1933), and gave her one of the great causes of her life, the fight for racial justice. Brittain explains that Holtby's devotion to this cause began when she realized that all the arguments offered by white South Africans for the suppression of blacks were those she had heard in England to justify the suppression of women: "They told her that higher education was bad for natives and gave them ideas and undermined their loyalty; that political power was unsuited to natives, since they were not ready for it."[62] Holtby merely substituted *women* for *natives*. "She went to preach the gospel of peace to white South Africa," wrote Brittain; "she returned to plead, with passion and pertinacity, the cause of black South Africa to an indifferent England."[63]

South Africa did not only provide Holtby with new activities. It gave her "poise and self-confidence"; "it helped her to grow up."[64] Brittain's comments on the effect of this trip on Holtby suggest that it was the bridge between what I have called stages one and two in her development. Before the trip Holtby was either still ambivalent about the authority of the traditional female values or dependent upon her friendship with Brittain, her second self, to resist it. After the trip, though still enriched by Brittain, she moved into some new directions of her own. Brittain puts it

this way: "Hitherto she had always been in tutelage to authority or constantly associated with some intimate companion; now she was launched, an independent, questing personality, without supervision upon an unfamiliar world."[65]

The Land of Green Ginger, the novel inspired by South Africa, which Holtby began to write there, is in many ways a transitional work. Like *The Crowded Street* and *Not without Honour,* it rejects traditional female values, but the presentation of the relationship between mothers and daughters is more complex than in those bitter attacks on provincial life. Like them, it takes place in a small area but, through the protagonist's fantasy life, also roams a world of exotic places. Writing to Brittain from South Africa in May of 1926, Holtby said, "It all takes place at East Witton on the Wensleydale moors, but its vitality is to come from Hungary, Finland, South Africa and China!"[66]

The Land of Green Ginger is also a transitional work in that it foreshadows what Holtby will do in a richer and more dramatic fashion in *South Riding*: rework some aspects of her own earlier material. Here she returns to the rural Yorkshire setting of *Anderby Wold* and also to some of its plot devices. Once again there is an emotional triangle, but this time the protagonist's husband dies of tuberculosis and she rejects the lover. Holtby no longer feels the ambivalence she revealed in *Anderby Wold.* Repudiating the melodrama of her earlier novel, Holtby even reworks the incident of the fire; this one kills none of her characters and has little direct effect upon her protagonist's life.

Although its vitality may come from the exotic, *The Land of Green Ginger* is finally anti-romance, a rejection of the mode of "The Runners" and of "the romance of fiction" that Holtby had always thought so "perniciously untruthful."[67] In style it moves toward the satirical tone Holtby will adopt for her next novel, *Poor Caroline,* though it does not attempt to sustain it throughout. "When the Reverend Ambrose Entwhistle had been for six months in his grave," Holtby begins, "his widow besought an Eternal Father in Heaven to substitute His providence for that of a mortal father upon earth, and to assist Nature and Society in the provision of husbands for her girls."[68] Echoing Jane Austen once more, Holtby describes Mrs. Marshall as enjoying "the unquenchable optimism produced by an assured income, good health and small imagination" (p. 58).

Holtby's overt subject in this novel is that magic lying below the surface of everyday life which both Muriel Hammond and Christine Merivale had longed for. The title says it all. The Land of Green Ginger, an exotic sixteenth-century name, is an actual street in the most prosaic of cities, Hull. Holtby suggests, then, from the outset what her protagonist, Joanna Leigh, is to learn, that magic is to be found in the real world rather than through fantasy. As a child Joanna, walking with her aunts in Hull, comes across the street name and is immediately enthralled: "to see Commercial Lane and to find . . . The Land of Green Ginger, dark, narrow, mysterious road to Heaven, to Fairy Land, to everywhere, anywhere, even to South Africa, which was the goal of all men's longing" (p. 20).

The religious implications of The Land of Green Ginger are also mentioned in Holtby's notebooks: " 'The Land of Green Ginger is about us and within us like the kingdom of God.' "[69] For Holtby spiritual experience seems to be less specifically Christian than it is for Brittain. It is more a matter of Blake's "Imagination, the real and eternal world of which this vegetable Universe is but a faint shadow,"[70] than it is of the Pale Galilean. Holtby's god, far more than Brittain's, is, like the imagination, "within us," inseparable from the self. The two clergymen in *The Land of Green Ginger,* Joanna's father and her pastor, Mr. Boyse, are figures of fun, with a strong tendency to confuse the spiritual and the erotic. Joanna's imagination, once anchored in reality, becomes the means of her liberation that Holtby, finally, affirms.

Like "The Runners," *The Land of Green Ginger,* in its negative representation of heterosexual relationships and its affirmation of same-sex friendships, appears to reflect Holtby's otherwise unstated response to Brittain's marriage to Catlin. Joanna's husband, Teddy Leigh, whom Holtby told Brittain she hated,[71] dies after he endangers his own life by forcing Joanna to have sexual intercourse. Like Catlin, Teddy intended to become a priest; like Catlin, he served in World War I; like Catlin, he proposes marriage and is accepted after a very short acquaintance. Holtby fulfills her own conscious or unconscious wishes by undoing Brittain's marriage, by envisioning it as just as restrictive as that of her own sister Grace,[72] by showing it deteriorate into marital rape, and by conveniently removing the husband from the scene.

The first chapter of the novel, a prologue about Joanna's

mother, suggests Holtby's concern with mother-daughter relationships and with the transmission of values and attitudes from one generation to the next. Edith Entwhistle, a young woman trapped in Victorian England, enlivens her narrow existence by imagining herself to be such male adventurers as Saint Paul and Sir Walter Raleigh. Travel to exotic places becomes both the means and the symbol of female liberation. Meeting a missionary on leave from South Africa, Edith understandably believes she loves him, marries in haste, and returns with him to South Africa in a cloud of romantic excitement. Although the countryside delights her, her illusions are rapidly shattered. Colonial life is as snobbish as E. M. Forster portrayed it; housekeeping upon chickens, rice, goat's milk, and yams is difficult; and a missionary's life is a battle with official prejudice rather than "moments of spiritual radiance" (p. 16).

Her marriage is a disappointment, the first of many in the novel. Edith has seen marriage as a way out of her mother's world, as an exotic, romantic adventure, but finds she has merely married her father and replicated her past: "Her husband, a kind, affectionate and preoccupied priest, hardly showed more concern for her than had her father, who had also been a kind, affectionate and preoccupied priest" (p. 16). Finding herself pregnant, Edith turns to the idea of the child as a substitute for the husband, exactly in the fashion Chodorow describes, but she dies in childbirth because of her husband's ineptitude. So Holtby established marriage as the antithesis to the life of the imagination and to the spatial metaphor of distant lands, although it may at first seem a woman's means to achieve them.

Unlike Muriel Hammond and Christine Merivale, Joanna, Edith's daughter, has no living mother from whom she must separate. She has, however, inherited her mother's outlook on the world and, naturally enough, repeats her pattern. Like her mother, Joanna is a dreamer. She loves exotic places and, once she goes to England to be brought up by her aunts, comes to believe South Africa the most exotic of all. Sir Walter Raleigh is a key figure in Joanna's fantasies as he had been in her mother's; she summons him into her mind whenever faced with such unpleasant realities of life as sickness or monotonous work. Holtby emphasizes Joanna's separation from the world of public events with a motif both she and Brittain had used before and would use again.

Taking the beginning of World War I as a symbol of the public world, Holtby points out Joanna's absorption in her personal life. The "misfortune" that "came upon Joanna" in 1914 was the death of her father and her failure to matriculate in mathematics and Latin (p. 21).

Unlike her mother, Joanna comes to associate travel to distant lands with her female friends, Rachel and Agnes. Rachel, a Jewish feminist, was modeled on Brittain, and Agnes, who lives in China, was based on Holtby's novelist friend Stella Benson. As she talks with her friends at school, Joanna becomes intoxicated with the idea of a world "enriched with so many curious and coloured creatures" (p. 24). Foreshadowing Joanna's realization that magic lies in the ordinary world, Holtby undercuts her protagonist's fantasies with the final sentence of this chapter: "The daisies opened their eyes wide in wonder that anyone, having seen them, should desire more abundant pleasures" (p. 24). As her life continues and she has less and less time to keep up her correspondence with Rachel and Agnes, Joanna makes her friends characters in her imaginary world. In a reversal that serves to restore Brittain's affection to her and erase her own need, Holtby attributes the clock poem she wrote on the occasion of Brittain's wedding to Agnes, whom she imagines sending it to her from China. In the same imaginary letter, Agnes describes the discovery of a way they can spend weekends together despite the distance between them and announces very casually a new husband: "Did you know that I had a husband? I forget when I found mine, but I expect that he is much the same as yours, so really there is little need to bother you with the details" (p. 124).

The Land of Green Ginger is structured by contrasting scenes in which Joanna's optimistic fantasies of the exotic are alternated with the harsh realities of life on an isolated Yorkshire farm with a sick husband and no money. Joanna marries Teddy Leigh during the First World War, believing him to be a romantic "nonsensical young man" (p. 29) who can make her fantasies reality. Even without an actual mother's presence, Joanna repeats her mother's mistake and buys into the familiar female illusion of marriage as a solution to the problem of her own identity. "'Our marriage,'" she tells Rachel, "'will be one long voyage of discovery'" (p. 31). Holtby recasts the roles she and Brittain were actually playing and has Brittain, through Rachel, speak out against marriage. "'The

only sort of voyage you'll ever make then,' prophesied Rachel gloomily" (pp. 31–32).

Rachel is right, for the marriage is an almost immediate failure. Teddy, sick with the tuberculosis that he never mentioned to Joanna before the marriage, cannot work and becomes increasingly egotistical and morose. Holtby makes the point that Teddy's sickness is not the result of the war, an answer to Brittain's inclination to blame the war for all the problems of their generation. "Not war alone menaced the loveliness and worth of life" (p. 35), realizes Joanna. In many later books Holtby was to repeat synonymous comments, which are easily, but perhaps wrongly, attributable to her awareness of her own terminal illness. *The Land of Green Ginger* precedes by at least two years the first signs of her illness.

Despite Teddy's faults, Holtby blames Joanna's problems at least as much on her own attitude to heterosexual relationships. Having only an incomplete sense of herself, Joanna is bound to the service of others: "She could not make up her mind who needed her most, Teddy or the children" (pp. 84–85). She responds entirely to his moods but never feels able to please him: "She had failed him again, of course. She was always failing him" (p. 38). She feels guilty about not living up to Teddy's idealized notions of mothers, "which made the presence of their children essential to their happiness, even if it involved continual work and supervision" (p. 96). Joanna worries about preferring her elder daughter, Pamela, who resembles herself, to the younger, Patricia, who has inherited Teddy's weak lungs. She also feels guilty about pleasing herself. Invited to the Marshalls' party, she "measured her iniquity in going to the party by the extent of her desire to go" (p. 56).

The party is one of the rare moments of actual happiness for Joanna, but this too is connected to her fantasy world of travel and to female friendship. She falls in love with the well-traveled Lorna Lavine, a guest at the party, and talks to her of Rachel and Agnes and of her own desire for distant lands. Joanna's happiness does not last. The party ends and she returns home to find their prize-winning pig dead, her daughter sick with pleurisy, and Teddy's illness exacerbated by the stress of going out. His sickness disgusts Joanna and when he asks for a sexual expression of her love, she pulls away from him. Joanna longs for female friends.

"Did friendship only belong to schooldays?" she wonders. She wishes she knew "how people ought to feel" and is afraid that she is wrong "to wish that I sometimes had a woman friend to talk to when I've got Teddy" (p. 119). Here Holtby echoes and reinforces what Brittain was beginning to write to her in her letters from America: that marriage was not enough and that she still needed the relationship with Holtby.

Joanna's lack of a sense of herself as an autonomous human being is apparent even to those who hardly know her. Holtby gives to Mr. Boyse the realization that Joanna behaves "as though her business of being a wife and mother were somehow not quite real to her. Almost it seemed as though she were playing at being herself, and not quite serious" (p. 171). As the major problems with her marriage impinge more demandingly upon her attempts to escape them, Joanna only reaches out to an alternative fantasy. Still believing in the myth of the romantic male rescuer, like Mary Robson in *Anderby Wold,* she merely substitutes a new, more exciting, man for the husband who has become dull. The new man is Paul Szermai, a Hungarian aristocrat uprooted by the war, who is employed by a local landowner to supervise some Finnish peasants on a forestry project. Meeting him on the moor, Joanna sees him as "the eldritch knight," as Young Tam Lin, a character from a romantic ballad (p. 93). Joanna is attracted by all the places he has traveled and claims that he makes her "feel like a princess" (p. 94). Szermai is the first of Holtby's attractive conservatives, men whom she presents sympathetically despite her dislike of their political beliefs. Szermai disapproves of the League of Nations and thinks men look dignified only when they are fighting. Holtby links Joanna's romanticism to Szermai's conservatism as she points out the reason for their attraction: "She was eager for life; Szermai disdained it; yet somehow both shared this aristocratic indifference to its fortune. They made their own world. They were akin, and now, perhaps they knew it" (p. 107).

From the moment when Szermai enters the novel, the two men, Teddy and Paul, come to represent the split in Joanna's mind between the real and the fantasized. Holtby chooses this moment halfway through the novel, to describe Teddy's background, reminiscent of Catlin's in his loneliness as a sickly child, his affection for a mother who dies, his isolation from a cold father, his turning for consolation to the church. In this way Teddy takes on a com-

plexity he has not had before. Holtby also enriches our sense of Joanna's real world through scenes of people talking in pubs and brief portraits of villagers like the promiscuous Bessie Bottomley. This palpable sense of a world, which Holtby learned to convey from George Eliot, foreshadows the richness of *South Riding*.

As the public world behind Joanna is drawn into the forefront of the novel, it becomes impossible for Joanna to escape it. Joanna's revelation comes in a scene in which Paul tells her the story of his life, not a happy fairy-tale after all but a dreadful story of death and the loss of love through war. Left with no illusions, Joanna rails against all men: "'Must you take my dream? Will you leave me nothing, not even the untouched privacy of my imagination?'" (p. 190). Joanna awakens to the realization that in the real world her fantasies of "battles and executions and great, terrific betrayals," "of heroes like Sir Walter Raleigh" (p. 190), involved misery and pain. "But when in real life we meet this wild, devastating fury," she sees, ". . . all the elusive fabric of vision vanishes. Their realism robs us of fantasy and we don't like it" (p. 190). This is a theme Brittain was to develop in far more graphic detail in *Testament of Youth*, the idea for which she had already conceived when Holtby wrote *The Land of Green Ginger*.

The last section of the novel echoes the conflict between fantasy and reality in the experience of the other characters. Paul, desperately trying to hold onto the idealized memory of his dead fiancé, is increasingly attracted by Joanna, whose actual presence destroys his dreams. Teddy, trapped in the painful, restricted world of his sickness and his jealousy of Paul, attempts to escape through religious detachment. After a soliloquy in which Holtby skillfully mingles Teddy's desire for Joanna with his desire for God, Teddy is forced back into reality: "As though to greet Him, Teddy turned too quickly. The pain caught his chest. His heart knocked angrily. He began to cough" (p. 198). Joanna's lesson is reinforced by the villagers' rejection of her and Paul at a local dance, by the sickness of Patricia, by Teddy's rape of her and her subsequent pregnancy, and finally by Teddy's death. "Fool, fool," she says to herself, "to feed upon fantasy till the life of the flesh betrayed you. Fool, to think in your vanity that you could conquer disease and poverty by a dream" (p. 241). As she watches,

the hearse carrying Teddy's body turns into "the dark by-road called The Land of Green Ginger" (p. 265).

At this point in the novel Holtby is faced with the same problem that she had faced at the end of *The Crowded Street* and that Brittain had faced at the end of *Not without Honour.* Her protagonist has separated herself from illusions, rejected "the traditional tales" of the mother's world, but still has to find a way to live. Joanna, like Holtby herself, wishes to affirm that " 'life's a good bargain" (p. 300), but with little education, no money, and two children to raise there are no obvious directions for her to pursue. At the end of the novel, Joanna leaves for South Africa to join Rachel, who is a lecturer in a university there. Rachel, like Delia in *The Crowded Street,* needs a comfortable place to live in order to do her work and Joanna plans to set up a boarding house. There is even the possibility of meeting with Agnes again, since she is also en route for South Africa. *The Land of Green Ginger* ends with Joanna aboard ship headed for South Africa talking to her daughter Pamela, who is as excited as her mother ever was about the exotic land she is to visit. It seems to Joanna "impossible that she could have found so perfect a companion in her pilgrimage" (p. 311).

The implications of this ending are manifold. In terms of the thematic content of the novel, Joanna, who has learned that fantasy cannot protect one from the pain of the real world, comes to realize that reality is not all pain, that it really does contain magic moments. Standing on deck, she says to her daughter in the penultimate sentence of the novel, " 'If nothing nice ever happens again, this is true' " (p. 311). So Holtby affirms the world of the imagination while warning against using it to escape reality. In the final sentence of *The Land of Green Ginger* Joanna takes her daughter's hand in hers, suggesting surely that what was given to her by her mother is now to be passed on to another generation. It is hard to grasp quite what Holtby intends here. It is clearly in one sense an illustration of Chodorow's point. Joanna will find in her child the emotional bond she never found with her husband. But isn't it also the beginning of a reclaiming of part of the mother's world, something which both Holtby and Brittain will do far more significantly in what I have called stage three? At this point, however, it is difficult to see what will pre-

vent Pamela from repeating her mother's mistakes. And indeed, it would be possible to argue that this entire ending is ironic and that our memories of the first chapter should tell us that Joanna will be as disillusioned as her mother was by the realities of South Africa. As if to emphasize this connection, Holtby has given the first and last chapters the same title, "The Adventurer's Child."

The reason I do not interpret it in that fashion is because of the personal content of the novel. Reading the ending, in Meredith Skura's terms, as wish-fulfillment, Holtby has rejected marriage and restored the community of women; in particular she has reunited the two characters most closely resembling Brittain and herself, Rachel and Joanna.[74] She has fulfilled her own dreams by making Joanna's most exotic fantasies reality.

By the time she was writing the ending of *The Land of Green Ginger*, Holtby's world had in many ways been restored. Unable to find outlets for her articles in the United States, Brittain was near despair over her work. She and Catlin agreed upon what they called a "semi-detached" marriage, in which Brittain would live and work in England and Catlin spend half the year with her and the other half at Cornell. Winifred was to share the household. In September of 1927 they moved into a flat in Nevern Place off the Earl's Court Road, Brittain already pregnant with her first child, John Edward. It was the beginning of the second stage of their working partnership and of their development as writers.

Chapter 3

"Perhaps laughter is the first gift of freedom"

Poor Caroline and Mandoa, Mandoa!

The reestablishment of their life together in London provided the base from which Brittain could attempt to reclaim her writing career in England and Holtby could experiment with new kinds of fiction. "Friendship," as Janice Raymond says, "provides women with a common world that becomes a reference point for location in a larger world."[1] The friendship had survived separation and Brittain's marriage and was now recognized by both of them as an essential foundation for creative work. But although it drew its strength from the empowerment of the relationship, the work they wrote in the second stage was less obviously a result of their interaction. It was also very different in style. Holtby's work in this period shows an apparent detachment from her own experience, a need for the impersonal that was reflected in her choice of a satirical mode, as in *Poor Caroline* (1931) and *Mandoa, Mandoa!* (1933). Brittain, on the other hand, began work on what appears to be her most personal document, her autobiography *Testament of Youth*.

The friendship had certainly become less exclusive; it could encompass and be enriched by the presence of Catlin, of other

friends, and eventually of Brittain's children, John Edward and
Shirley. Looking back to 1929, when they all moved to a larger
house in Chelsea, Brittain wrote, "With its babies, its books, its
toys, its friends, and the companionship of both G. and Winifred,
the household in Glebe Place was the nearest thing to complete
happiness that I have ever known or ever hope to know. I believe
that Winifred felt the same."[2] Nevertheless, it was their partner-
ship that was most necessary to both Brittain and Holtby in terms
of their work. As soon as Brittain had reestablished her life with
Holtby, even before Catlin's return to England, she wrote to him,
" 'Never before . . . have I felt so alive.' "[3] She explains in *Testa-
ment of Experience,* "For the first time I was living the life which
I had most desired from my earliest youth; the life of the profes-
sional writer who undertakes other activities mainly as a source
of ideas for her work."[4] The problems of trying to work in Amer-
ica had been practical as well as psychological, but it seems clear
that a major one had been the separation from Holtby.

Thrice a Stranger (1938), Brittain's description of her relation-
ship with America, is the best source for understanding what
happened during the early days with Catlin in Ithaca, New York,
an account that explains her subsequent published works, two
short nonfiction pieces, *Women's Work in Modern England* (1928)
and *Halcyon, or The Future of Monogamy* (1929). Although she had
already begun work on *Testament of Youth,* then thought of as a
novel entitled "The Incidental Adam," it would not be published
until 1933. Not until 1936 did Brittain publish another work of
fiction.

Brittain's problems with marriage began even before leaving
England. With some difficulty she obtained a passport in her
maiden name, but interviews with immigration personnel showed
her that her only status was as Catlin's wife: "So long as a woman
remains unmarried, she continues to be known as Mary Jones,
lecturer, or Jane Brown, barrister, or Vera Brittain, author; but
let her once agree to live with some man as his lawful spouse,
and everyone conspires to rob her of that unbecoming individu-
alism."[5] The loss of her "unbecoming individualism" was rein-
forced upon their arrival at Cornell, where Brittain's position as
faculty wife meant endless social obligations but no intellectual
stimulation and no time to work. As a woman in this society,
which she saw as hopelessly provincial, she was automatically

inferior. Her position in Ithaca was compounded by her total fail-
ure as a journalist in America. She was unable to place articles in
American periodicals and unable to find a publisher for "Hon-
eymoon in Two Worlds." "Residence in Ithaca," she wrote in
Testament of Experience, "meant full stop to a writer's progress."[6]
She hated the "burden of domesticity";[7] the subordination of her
work to Catlin's book, which she was "typing, revising and cor-
recting";[8] and the weather, which, together with influenza, she
came to associate with marriage.

Despite the miseries of this existence, Brittain, like the rest of
her generation of women, had been "so ruthlessly trained in
childhood to put persons before convictions"[9] that she might well
have tolerated it, if it had not seemed so familiar. Ithaca was
Buxton; Brittain had returned to the mother's world: "I had
thought Buxton remote owing to its four hours' rail journey from
London, but Ithaca, four hundred miles from New York, made
escape even more difficult."[10] The faculty wives reminded her of
"the provincial Englishwomen whom I had known in my intol-
erant adolescence,"[11] "the embodiment of all false values."[12]

The memory of Buxton accounts, I suspect, for the intensity
of Brittain's dislike of life in Ithaca, an overreaction she was to
recognize later, but it also helped her to escape. Looking back,
she realized that she had "had constantly to choose between being
disagreeable and being ineffective,"[13] and that life's "most valu-
able turning-points" had "always followed some refusal to ac-
commodate myself to circumstances which I found hampering,
uncongenial or oppressive."[14] Once again at a turning point, Brit-
tain accepted Catlin's "generous offer" to remain in Ithaca alone
while she returned to England for the fall and spring. "If I did
not," she wrote, "I knew that I should have to make, without
hope of revocation, that final surrender of the claims of the human
intelligence which I had always felt that no woman, as no man,
should be required to offer on the altar of marriage."[15] Brittain's
Buxton training did not allow her to leave without some qualms
of conscience, but they were unmatched by the joy of going home:
"A sense of guilt lingered uneasily in my mind all the way across
the Atlantic, but nothing else mitigated the profound relief with
which I returned to England."[16]

It is easy enough to see why Brittain's first project upon her
return to England should have been a book on women's employ-

ment. *Women's Work in Modern England* originated as a series of essays entitled "Prospects in Women's Employment" that she had written for the *Outlook* in April and May of 1927. It is primarily a guide to women about opportunities in various fields of employment—industry, business, the professions, the services, and volunteer work—but it also analyzes the social, political, and economic climate in which women make their choices.

Brittain's second stage of development, then, begins with a clear focus on the public sphere but, equally clearly, springs from a very personal experience, her own inability to work in America. Her premise is that work is essential for everyone: "An aimless, parasitic existence is the most deplorable legacy of the old and bad tradition of feminine limitations and . . . the most reliable happiness which life offers is to be claimed by means of a chosen profession."[17] What Brittain is fighting for here is "equality feminism," women's right to compete on equal terms with men in the public sphere. She places no value upon traditional women's employment in the home; there are no arguments made, for example, for paid housework. There is even some naiveté about her own profession, which she assumes has no sex bias. The rewards in art, literature, and music are "based upon merit rather than upon sex,"[18] and "in the world of creative literature there are no sex distinctions."[19] Her own particular experience is reflected, too, in her comments on the difficulties of becoming a journalist and upon the high qualifications needed for volunteer political work.

The political and economic context in which Brittain was writing explains her emphasis, I think. The Sex Qualification Removal Act of 1919 had indeed theoretically opened up new professions to women, but the optimistic situation forecast for women's employment after the war had not materialized. Returning soldiers had claimed jobs performed by women during the war; unions were still exclusionary; the overall economic situation was depressed and thus the climate for adding new members to the work force was negative.

Nevertheless, Brittain encourages women to fight these barriers as well as all the traditional psychological ones. She points out fields in which there are new opportunities for women, as in electrical engineering, where the demand for new household products has made female participation desirable. She provides role

models for her women readers in each area she discusses, naming those like Gertrude Bell, oriental secretary to the high commissioner for Iraq, who have been particularly successful in dominantly male fields. (It is true that the degree of their success is sometimes unique, but Brittain also quotes the overall figures for women's employment in individual areas.) In a final chapter she skillfully answers the familiar objections to women's work, pointing out that women's lack of physical strength is belied by the heavy work involved in nursing, that the statistics on women's dependents refute the notion that women work for pin money, and that male propaganda is responsible for the lie that married women do not wish to work and that others are only marking time before marriage.

Brittain's arguments are persuasive because she does not underestimate the difficulties involved for women even in those professions like nursing and teaching that employ far more women than men. She is particularly opposed to the firing of women teachers upon marriage and makes her usual argument that children should be exposed to "normal" women, that is, married women "with children of their own."[20] She points out that administrative jobs in teaching invariably go to men and quotes the Schoolmasters' Association, which in 1926 "passed, amid cheering, a resolution declaring opposition to any assistant master serving under a headmistress."[21] Although Brittain makes it the responsibility of women to fight for change, her conclusion is not very encouraging, especially to a reader in the 1980s. No doubt Brittain would have been depressed to know how contemporary her words sound today. "A woman," she writes, "has still to be considerably better qualified than a man in order to obtain a post for which she is contending with male competitors."[22]

The short book that Brittain published in 1929, *Halcyon, or The Future of Monogamy,* is a utopian fantasy closer in style to Holtby's satiric works than anything else Brittain wrote. Like the frame story of so many other fantasies, *Halcyon's* is a dream vision in which Brittain discovers a book written by Professor Minerva Huxterwin of the mid-twenty-first century. The book is a history of English moral institutions from the nineteenth to the twenty-first centuries, but Brittain is only able to read, and thus retell, the section on monogamy.

The title refers to the story of the devoted wife Alcyone, who

threw herself into the sea when her husband drowned. The gods rewarded her devotion by reuniting them both in the form of kingfishers (halcyons). This is not, however, the sort of wifely behavior Brittain is arguing for in *Halcyon,* where she links monogamy to female independence rather than to self-sacrifice, to freedom of choice rather than to external restraints. Like *Women's Work, Halcyon* derives from Brittain's own experience; it makes the case for her choice of a "semi-detached marriage," and assuages her guilt at putting her own needs before her marriage by arguing that a monogamous relationship is strengthened by "the union of two careers and two sets of values."[23]

Writing from a utopian society more than a hundred years in the future, Minerva Huxterwin can interpret history as she wishes, and, of course, she describes as positive causes of her society those social, political, and scientific movements Brittain approves, while seeing as obstacles the forces Brittain opposes. The only section of the book that refers to a period Brittain had actually lived through is the first, a time she sees characterized by the reimposition of sexual restrictions after their relaxation during World War I. Opposing these restrictions and the equation of virtue with ignorance, Brittain argues for sex education as a means of avoiding sexual maladjustment and thus divorce, and for contraception as a means of avoiding multiple pregnancies, which, she claims, tend to drive husbands to other women. Women, she believes, should be encouraged to work before and after marriage and should receive equal pay with men. Monogamy benefits from female economic independence by encouraging earlier marriage and allowing women to select husbands for love rather than income.

Brittain envisions an enlightened government that has legislated, by the 1940s, sexual instruction and independence for married women; by the 1950s, divorce by consent; by the 1960s, companionate and other forms of experimental sexual union; and by the 1970s, the state guardianship of children and her most problematic proposal, the Second Contracts Act. This act allows for permanent or temporary marriage to a second partner, in times of prolonged separation, without divorce from the first. Speedy air travel, however, eventually makes this law unnecessary. Semi-detached marriage is not only tolerated but recommended, as is a rational attitude to homosexuality.

Monogamy has benefited between 1950 and 2000 from a number of scientific advances. Air travel has made distance irrelevant; home entertainment—radio, television, and "home talkies" (VCRs) —has made monogamy less boring; and biological advances have extended the age of physical well-being and attractiveness for both men and women. War has been abolished, so that the loss of large numbers of males in one generation has been prevented, and science now enables the planning of equal numbers of both sexes in all families.

In her final section, Brittain describes a world in which voluntary monogamy is the rule and is seen as the result primarily of equality between men and women. Her own choice to pursue her career, even at the cost of leaving her husband temporarily, is justified by the argument that "waste of training and the thwarting of legitimate ambition have long been recognized as serious threats to the success of even the most promising union."[24] The sexual aspect of marriage is in one sense not made the most important issue in *Halcyon*; for example, the utopian twenty-first century sees as permissible "an occasional and frankly acknowledged extra-marital experience," if it has "some cogent reason such as that of honour to an old obligation."[25] But *Halcyon* is, nevertheless, curiously clinical, in a way reminiscent of Huxley's *Brave New World*. It springs from that post-Freudian view of sexuality as a biological need whose expression keeps us "normal" and whose frustration leads to divorce if not to madness. It was a view that Brittain never challenged, perhaps because she recognized the extent to which it had informed her own life choices, but that Holtby knew was, in its way, as narrow as the Victorian restrictions it supplanted.

Despite *Women's Work* and *Halcyon,* Brittain continued to feel the need to justify her concentration on her own career. In one sense, *Testament of Youth* finally became that justification. Looking back on the days in Ithaca in *Testament of Experience,* Brittain claims that if her problem had been only intellectual frustration, she would probably have settled for domesticity; what she was experiencing, though, was "spiritual frustration." "After seeing civilisation wrecked and the brilliant loves of my early youth destroyed, I had dedicated myself in the months following the Armistice to a future that was less a 'career' than a devotional crusade . . . Could it really be my duty, I asked myself now, to

sacrifice the attempt to convey a redemptive faith . . . to the personal needs of a husband and later a family?"[26] Whether or not this sounds a little like self-defense, Brittain's attempt to explain her position produced the work that made her name, *Testament of Youth*. It was, however, to take her another four years to write it.

In the same years as Brittain published *Women's Work* and *Halcyon*, Holtby also published two nonfiction works, in the same genres as Brittain's although in reverse order. *Eutychus, or The Future of the Pulpit* (1928) is a fantasy in which Holtby, like Brittain in *Halcyon*, discusses the values of contemporary society. Like *Halcyon* it was written for a monograph series on current social issues entitled To-day and Tomorrow. *A New Voter's Guide to Party Programmes* (1929) was, as its title suggests, designed as a self-help book for the recently enfranchised female voter. While superficially resembling Brittain's *Women's Work* in its stance as a serious guidebook, it is far more satirical in tone and takes aim in turn at each of the political parties. The four essays share a concern with the same issues—sexuality, women's work, and war—and illustrate how close Brittain and Holtby had come in their attitudes to these topics. Although their work at this stage is still clearly a conversation, with some exceptions it is beginning to resemble the sort of conversation in which the participants can finish each other's sentences.

Eutychus is not set in the future like *Halcyon*; rather, Holtby brings a historical character into the present to achieve the same purpose, an investigation of contemporary social attitudes. The French philosopher Fenelon is visiting England to collect material for his new work on the future of the pulpit. He meets Anthony, a young man about Bloomsbury, who tells him that religion has no future and therefore neither does the pulpit. In the contemporary world people have too many other distractions on Sundays, argues Anthony—sports, cars, and racy Sunday newspapers. Fenelon retorts that preachers may be disregarded but not divine authority, to which assertion Anthony replies that science has proved that there are no "ultimate realities."[27] Fenelon cleverly wins the first round and sets up Holtby's main line of argument by forcing Anthony to admit that he does not understand the scientific arguments against the existence of God but has accepted them on faith. " 'Show me the man whose sentence is received

by people who cannot follow all his reasoning,'" says Fenelon,
"'and I will show you the modern preacher.'"[28]

At this point Eutychus, the young man who slept through Saint
Paul's sermon, appears and tells them that in their concentration
on preachers and their authority, they have forgotten the sermon's
audience. Fenelon agrees that eloquence is to be judged by its
capacity to move the souls of the congregation. Through Euty-
chus, the ordinary man, Holtby introduces what is to be one of
her major concerns in this period, the audience, listener or reader,
of a literary text. In part 2 of *Eutychus* all three set out separately
to study contemporary mores and when they return, each claims
that his view is correct. What becomes clear as each makes his
argument is that although they have read the same text, because
of their individual biases they have read it differently. Holtby's
position here is that of a reader-response critic, though, of course,
she would not have known the term.

Fenelon claims that preachers are still in command though they
preach through posters, cheap books, and newspapers, rather
than in churches. They even preach on the same topics. He has
observed an article on "The He-Woman, the She-Woman, and the
Girl Voter of Twenty-Five," and has recognized it as a theme
"'frequently chosen by the Doctors of the Early Church, namely
the instability and intellectual weakness of women.'"[29] Like Brit-
tain in *Halcyon,* Holtby stresses the antifeminist backlash to the
apparent advances women have made since the war. Fenelon has
also identified some modern saints: Paine, Marx, Godwin, Lenin,
and Freud.

Anthony is primarily interested in Saint Freud and uses his
discussion of modern attitudes to sexuality to illustrate the num-
ber of differing authorities and new religions in contemporary
society. Holtby is, as usual, much readier than Brittain to criticize
post-Freudian attitudes to sexuality. Anthony points out that fear
of sex frustration and fear of unmarried women has created a
religion of fertility. "'We may find it,'" he claims, "'in the de-
mands for greater freedom of intercourse between men and
women in society, in the interest in companionate marriage, in
the protests against celibacy of teachers, in the contempt for vir-
gins, the interest manifested in Eugenics, and the veneration of
maternity.'"[30] Here Holtby finds fault with some causes close to
Brittain's heart, but she is equally willing to condemn their op-

position, the School of Moralists, who oppose anything to do with the public discussion of sexuality. As Anthony continues to explore both political and artistic "religions," Holtby maintains the same sort of balance, harsher perhaps on the conservatives than the liberals, but clear-sighted enough to see faults in both. In tone, at least, Brittain is the more polemical of the two, more willing to argue a particular case.

Fenelon and Anthony discover that Eutychus has once again fallen asleep, thereby underlining Holtby's point that society only appears to change while the underlying structure of human attitudes remains much the same. Eutychus returns to his concern with the audience. Ordinary people need religion because they want " 'to be made safe—saved, you know,' "[31] but it is irrelevant to them whether that religion is Christianity or psychoanalysis. So despite reading the text of contemporary society from different perspectives, Fenelon, Anthony, and Eutychus finally agree on two matters: the pulpit is still important in modern society though its preachers, its authority, and its congregation have changed; and it takes all three to make a sermon.

Like *Eutychus, A New Voter's Guide to Party Programmes* is a series of dialogues, a form the dramatist in Holtby was comfortable with in a way that Brittain never was. In other respects, however, *A New Voter's Guide* shares much with *Women's Work* and, like Brittain's essay, is based upon some very thorough research. The dialogues contain numerous quotations from party position papers and other political documents that are footnoted in the text. In some places these quotations are so dense that the dialogue seems to be a carefully constructed patchwork of other people's words. In this way Holtby implies an objectivity that she only partially has. Although Holtby, like Brittain, had left the Liberal party for the Labour party four years earlier and was supporting the Labour candidate, Monica Whately, in the upcoming 1929 general election, it would often be hard to tell this from the essay. Her criticism does not fall equally on all three political parties, but all at some time feel the cut of her satire. As in *Eutychus*, it is Holtby's clear vision that strikes a reader most strongly. She does, however, speak out more forcefully here than in *Eutychus* for those causes closest to her heart.

The fiction of *New Voter's Guide* is that a naive voter, Juvenis, is visited at home by canvassers from the three political parties,

Conservative, Liberal, and Labour. The first part of the guide has each canvasser discuss party principles; they then debate their positions on foreign policy, economics, education, health, feminism, and agriculture. The final two discussions are aided by a visiting feminist and a visiting farmer, who alone can be said to win their arguments. Labor's stress on economic help for poor children's education and on the importance of educating every citizen clearly has Holtby's support. And the Conservatives are clearly the villains when it comes to foreign policy. Holtby quotes Mander's description of Lord Cashenden, the Conservative delegate to the League of Nations, as " 'malice tempered by intolerance,' "[32] but even here she allows the Conservative candidate to make the persuasive point that since the Conservatives are the party in power, they are the only ones whose foreign policy is tested. She finds them all inadequate on the issue of birth control.

Holtby's method when she really wishes to win her case is indicated in the section on the feminist issue. Her visiting feminist begins by surprising her audience with her positive remarks about men. Her position, an argument for equality feminism and internationalism, is unassailably simple. While she argues, as Brittain does, for such specific issues as the married woman's right to work, her fundamental demand is for " 'a change in attitude.' "[33] " 'If only you could see all adult men and women as human beings together, the rest would come quite simply,' " she says. For the first time Juvenis is convinced and responds, " 'So that's what it means—only that grown up women should be treated as grown up and allowed to judge for themselves. Well, really you know.' "[34]

The guide ends with an investigation of the issues of the future and introduces a communist, a fascist, an open conspirator, and a cultured stranger, each of whom is as problematic as the party canvassers. They indicate the increasingly international scope of Holtby's political concerns at this time, a direction that points toward *Mandoa, Mandoa!* (1933) and her anti-dictator play *Take Back Your Freedom* (1939). But they do not help Juvenis decide whom to vote for, and at the end she asks for time to think it over.

Before *Voter's Guide* was published, Holtby had returned to writing fiction and was at work on *Poor Caroline* (1931), a novel that continues both the satirical method of the two nonfiction

pieces and their dramatic structure. *Poor Caroline* was Holtby's first commercially successful novel, and in this respect, as George Davidson says, it "represented a watershed"[35] in her career. It was a new venture in other ways too; more consistently satirical in tone than her earlier novels, it differed from them also in its dramatic structure. *Poor Caroline* introduces us in a series of short chapters to a variety of characters, who are then brought together in an interconnected web of events in a manner reminiscent, in this respect though not in others, of George Eliot's *Middlemarch*. For the first time Holtby is not writing a novel of education. None of the characters learns much; the only people persuaded to change their views are her readers. Holtby attempts to reverse our perspective on her elderly protagonist, Caroline Denton-Smyth, as the novel progresses. Holtby's transition into the second stage of development is marked by this shift from being a recorder of her own experience to being a satirist with a clear position she wishes to teach others. Both the fiction and the nonfiction of this period demonstrate Holtby's emphasis on the reader or listener, as, for example, in *Eutychus* and *Virginia Woolf.*

Although Holtby experienced during this period the first serious signs of Bright's disease, the kidney disease that was soon to kill her, *Poor Caroline* was written at what Brittain describes as "the very peak of Winifred's triumphant vitality."[36] This meant that it was also written while Holtby was attempting to do a great number of other things. Holtby began writing the novel after a vacation in Monte Carlo where she had been amused by the "most hair-raising gossipers"[37] she had ever heard. This brittle society finds its way into *Poor Caroline,* as does the London world Holtby had come to know well. The hated provincial world of her earlier novels makes an appearance only in the "Opening Chorus," in which Caroline's shallow nieces return to Marshington after her funeral to make the ironic statement that there can never have been " 'anyone whose life was much less important, or who had less influence on anybody else' " (p. 16).

Holtby's work on *Poor Caroline* was combined with nursing her father, now seriously ill in Yorkshire; this involved traveling several hours every Saturday, sitting up all night with her father, and returning early Monday in time to write the lead article for *Time and Tide* before it went to press. Brittain was pregnant with her second child, which meant that even in London Holtby had

domestic responsibilities to add to those of *Time and Tide,* her political work for South African blacks, and her own writing. She wrote to Phyllis Bentley on July 22, 1930, that she was " 'working till about 1.0 every morning with masses of correspondence about native affairs, trying to draft a new play, and expecting Vera's baby hourly!' "[38]

Holtby was never to have any success as a dramatist, although she attempted three plays between 1929 and 1934: "Judgment Voice," which she eventually turned into a short story, "The Voice of God"; "Efficiency First," a comedy about women in business; and *Take Back Your Freedom,* which was published posthumously in 1939. "The Voice of God" is similar to *Poor Caroline* in its concern with modern inventions—in the short story the radio rather than film—and in its critical commentary on the human inability to be motivated by anything except personal gain. Although her plays were never produced, Holtby's ability to write witty dialogue and create comic scenes, so evident in *Poor Caroline,* may well have been a useful by-product of her efforts in this direction.

Brittain states that both Catlin and Lady Rhondda very much disliked *Poor Caroline* because they believed it showed Holtby engaging in self-pity. This assumption was based both on an identification between Holtby and her elderly spinster protagonist and on an evaluation of this character as pathetic and worthless. Holtby rejected both these ideas, telling Lady Rhondda, " 'Caroline is not a symbol of me . . . but an expression of herself . . . I meant to leave the impression of someone silly but vital, directly futile but indirectly triumphant, a person who . . . had in the end been able to give to those she wished to benefit their heart's desire.' "[39] Brittain, who recognized that Catlin and Lady Rhondda were wrong to identify Holtby with Caroline, is herself guilty of misjudging Holtby's view of this character, whom she calls "grotesque."[40]

Holtby's novel is an argument against just such prejudice and stereotyping, in fundamental opposition to Brittain's view of marriage as the "normal" and therefore "healthy" situation for women. The *Yorkshire Post* critic, Alice Herbert, quoted in George Davidson's introduction to the novel, claimed that in *Poor Caroline* Holtby had " 'pulled the comic spinster out of her rut' " and that her gift lay " 'in taking a type that many novelists accept as ready-

made, and in showing its enormously varied and complicated humanity'" (pp. xi–xii). Caroline Denton-Smyth was based upon someone Holtby knew, the aunt of one of her early governesses, who, like Caroline, lived on hope and other people's generosity, a sort of female Mr. Micawber. Mary Horne had apparently treated Holtby as Caroline treated Eleanor de la Roux in the novel, taking her money—though not to support a Christian cinema company—and demanding her attention. Like Caroline, she died after a street accident in a pauper's bed in a public hospital. And just as Caroline finally, if unknowingly, benefits her friends, so Mary Horne earned the dedication to *Poor Caroline* by providing Holtby with "the missing theme for her new novel."[41]

Although personal motives and a particular acquaintance obviously influenced Holtby in her presentation of a sympathetic spinster, she was also affected by contemporary fiction by other women writers. Her friend Stella Benson had published a novel entitled *Living Alone* in 1922, and in 1926 Sylvia Townsend Warner published *Lolly Willowes,* an account of an unmarried woman who rebels against dependence on an elder brother and his wife and goes to live in the country, where she becomes a happy and successful witch. In December of 1926 Holtby wrote to Jean McWilliam describing a "delightful lunch" that Sylvia Warner had attended and asked, "Have you read *Lolly Willowes?*"[42] Three months later Holtby went to "an entrancing lecture by Sylvia Townsend Warner about witches."[43] Holtby was entranced by Warner's celebration of witches as guilt-free women "really letting themselves go,"[44] and by her connection of witches to the old fertility god. Holtby ironically associates Caroline Denton-Smyth, a Christian social reformer, with these positive aspects of old pagan religions by describing her as a witch: "Caroline was a witch," thinks Eleanor. "She believed in magic" (p. 84).[45]

The novel works to gradually shift the reader's perception of Caroline. She is introduced first through the prejudices of her relatives in Marshington. One of her nieces describes her as "'our prize cadger, prize idiot, prize bore, and prize affliction'" (p. 60). Her early history is reported with blatant but familiar prejudices. Caroline's appearance was inadequate; she was too short, too plump, and wore "prehistoric" clothes. When she was rejected by a young officer, she became a teacher in a private school, where she had "'one of those silly friendships with the head-mistress.'"

When the school " 'failed, as of course it would,' " Caroline took the headmistress to her mother's house, where her friend had a nervous breakdown " 'very comfortably, though it killed Caroline's mother,' " and eventually " 'got engaged to the local doctor, though Caroline had rather fancied him for herself' " (p. 61).

When Holtby shows us Caroline in action, she is indeed a cadger, using other people for their money, living on the illusion that her newly founded Christian Cinema Company will make huge profits, and writing a will in which she leaves money she does not have. But Caroline's naiveté is infectious rather than pathetic, even when she takes her niece Eleanor's inheritance to buy a color film process of dubious worth. She is not knowingly a fraud—neither she nor many of the other characters in this novel have much self-knowledge—but her passion, Holtby makes clear, is for using her energy rather than for the purity of films. " 'She's in love with the work, with enterprise, with getting something done' " (p. 49). Caroline's view of herself as a conservative social reformer with traditional ideas of female roles hides a modern woman as anxious to use her talents as her feminist niece Eleanor. And as an unmarried woman, Holtby points out, she has more opportunity to do this than her married sisters.

Early in the novel Holtby provides a scene that, while comic in tone, is a subtle lesson in what feeds and what modifies prejudice. Joseph Isenbaum is waiting in a restaurant to have lunch with an acquaintance, Basil St. Denis, who has promised to introduce him to the honorary secretary of the Christian Cinema Company. When he sees Caroline enter the restaurant, Isenbaum, as guilty of prejudice as the anti-Semites who have made his life miserable, expects her to be thrown out. Her clothes are "like the trappings of an oriental dancer at a cheap music hall," her hat is "preposterous," her shoes "shameful." "Her poverty, her oddity, her jaunty air of unintimidated resolution were abominable" (pp. 41–42). When he realizes who she is, however, and watches St. Denis, whom he considers his social superior, treat her "as though her oddity were an asset," Isenbaum finds his view of Caroline changing. She was "not insignificant. Seen more closely, her shabbiness wore an air of picturesque and debonair eccentricity" (p. 43). Prejudice, Holtby makes clear, is learned, and we can be reeducated.

Holtby reeducates us about Caroline in two ways. As she lies

dying in the hospital, Caroline meditates upon her life, and her history seen from her own point of view becomes, like that of anybody else, composed of both intense joys and unjust suffering. Her friendship with Adelaide Thurlby, the headmistress, was composed of "bliss and art and companionship" (p. 238), and Caroline is still glad to have known intimate friendship despite the suffering it brought. "Her mother had died in debt, and she had lost her lover, her friend, her mother, her home and her profession in one brief season" (p. 239), but she has seen Italy and Paris and is in the end "sorry for the sheltered, wealthy women who had never experienced the chill rapture of travelling alone" (p. 240). As well as ensuring our sympathy for Caroline by taking us inside her mind, Holtby also ends the novel by reversing our expectations of the outcome of Caroline's ventures. Her hope of benefiting those around her is not finally an idle one. "She had wanted the Christian Cinema Company to benefit mankind, and had it not done so? Mr. St. Denis had had his diversion from it, Hugh his advertisement, Johnson his romance, Guerdon the gratification of his conscience" (p. 250). When the novel ends, the title has become ironic; the protagonist is not, much to our surprise, poor Caroline after all.

The other characters in the novel all become directors of Caroline's Christian Cinema Company, and each in turn, with the exception of Eleanor, is shown to have a selfish reason for using Caroline. Holtby presents them first as stereotypes: the rich Jew, Joseph Isenbaum; the aristocratic, effeminate dilettante, Basil St. Denis; the comic curate, Roger Mortimer; the unscrupulous womanizer, Clifton Johnson. As she does with Caroline, Holtby shatters the stereotypes and makes almost all of the characters sympathetic. Johnson's contention that " 'Jews buy up Old Masters once they've been approved of for about five hundred years' " (p. 115) is refuted by Isenbaum's knowledgeable and risky art purchases. Isenbaum's love for his son makes him vulnerable and sympathetic, even while his pursuit of St. Denis, whose poverty he exploits in order to get the boy into Eton, is used to create one of the funniest scenes in the novel. Meeting by chance at the showroom of the most expensive and most snobbish tailor in London, St. Denis, who has been insulted because he cannot pay his bill, and Isenbaum, who is treated as inferior because he is a Jew, get revenge on the owner, Mitchell, by leaving in a friendly

fashion together. St. Denis "knew that Augustus Mitchell did not introduce his Jews. He knew that Mitchell sought to make himself unpleasant. He quietly spiked the tailor's guns" (p. 39).

Basil's effeminacy is undercut by his passion for Gloria, who becomes his wife, and his attempt to escape all social responsibility is made understandable by his experiences in the war. Playing roulette in Monte Carlo, "he began to forget the harsh, shattering explosion of the shells. In that enchanted palace, where life is so remote from all other reality, he lost his sense of the imminent menace of death" (p. 21). The horrors of the First World War are also used to redeem Roger Mortimer, who at first seems to be what he dreads being considered, "the comic curate, living on milk and buns" (p. 141). Holtby describes Mortimer's postwar horror of finding "a corpse under the daffodils," his expectation of "the stench of putrifying flesh" (p. 131), his survivor's guilt. Holtby is more specific in *Poor Caroline* about the horrors of the war than she has been in her earlier fiction, probably a reflection of the fact that at this time Brittain was planning *Testament of Youth*. Holtby also reverses the stereotypical view of the chaste clergyman tormented by sexual thoughts; Roger is vexed by "his wanton mind" rather than by the "desires of the flesh" (p. 129).

The only character whom Holtby does not rescue is the womanizer Johnson, the most prejudiced person in the novel. Anti-Semitic and antifeminist, he sees active women as "sex-starved," in need of being " 'raped by the butcher's boy' " (p. 113). Johnson is finally brought low by the most pathetic female character in the novel, Doreen Weller, a would-be novelist, whose inopportune arrival at Johnson's apartment in search of the money he has taken on false pretenses prevents his seduction of Gloria. He is finally left on a European tour with the one woman he cannot dominate, "wretched and fearful, a victim of his own temperament, of his upbringing, his tastes, and of the Christian Cinema Company" (p. 254).

Eleanor de la Roux, who like Joanna in *The Land of Green Ginger* comes to England from South Africa, is an amalgam of both Brittain and Holtby. She has Holtby's links to South Africa, and, like Holtby, she has recently lost her father under circumstances that leave her guilty about her failures as a daughter. As she wrote *Poor Caroline,* Holtby was struggling with the same conflict.

Eleanor turns down an opportunity to travel with her father on the car trip that kills him and afterward feels "it was all her fault" (p. 59). Her work as a scientist is her main reason for not going, and so, again like Holtby, she becomes involved in an inner struggle between her right to independence and work and her personal responsibilities. Eleanor also shares Holtby's acute awareness of the extent to which money and education have rendered her immune from the suffering experienced by others and wonders, "How far was one justified in making use of one's immunity?" (p. 65).

Eleanor's independence is marked by her ownership of a car, which gives her the freedom Holtby and Brittain had to travel around London alone. She is both a feminist and a socialist and suffers for both of these positions. Attempting to get a minor problem in her car fixed quickly, Eleanor is told by a leering mechanic, " 'No 'Ladies First' now that you've got the vote. It's all Equality now' " (p. 64). But for all her strength, Eleanor is as susceptible as Brittain and Holtby to the appeal to social service. Moved by a sermon given by Roger Mortimer, Eleanor gives her inheritance to rescue the Christian Cinema Company.

In her treatment of Eleanor, Holtby is once again reversing stereotypes. Unconcerned with marriage, absorbed by her career, Eleanor is considered mannish not only in behavior but in appearance. "This Miss de la Roux, with her short boyish hair, and her boyish tweed coat, and her queer husky voice with the South African accent, might have been a small dandified young man" (p. 118). Nevertheless, it is Eleanor for whom Roger conceives the first real passion of his life, a love that Eleanor returns. Eleanor marries Roger because he is "the one man she had ever met who wanted his marriage to be an adventure not a refuge" (p. 250), because he accepts her right to her own career, and because she believes that " 'the present generation of feminists must marry . . . and if we fail, we can always separate' " (p. 250).

By attributing Brittain's view of her own marriage to Eleanor's view of hers with Roger, Holtby effects her reconciliation with Brittain's marriage. (Like Catlin, Roger is a religiously inclined, postwar New College graduate.) Simultaneously Holtby asks for equal acceptance of her own single state and for others who are by religion, profession, or personality marginalized. It is not clear to me to what extent Holtby makes this appeal to Brittain as well

as to society at large. In 1928 Brittain appeared in court, along with many other writers, to defend the publication of Radclyffe Hall's lesbian novel *The Well of Loneliness,* but she continued to talk, perhaps unthinkingly, about marriage as the "normal" and desirable state for women. It is hard to imagine that Holtby did not at times find Brittain's comments on this issue offensive.

The extent to which Holtby recognized and opposed the dangers of the post-Freudian attitude to sexuality is clear in her next book, *Virginia Woolf: A Critical Memoir* (1932). Describing Woolf's situation as a Georgian woman writer, Holtby mounts an angry attack on the way in which, just at the moment they had some hope of being considered as human beings, women were told that their "sex was all that really mattered." The Georgians "discovered sensibilities and intuitions, and memories, and the subconscious mind, and sex," writes Holtby. A woman "must enjoy the full cycle of sex-experience, or she would become riddled with complexes like a rotting fruit."[46] Once again Holtby voices the view that sexual "liberation" has merely set back women's claim to common humanity.

The occasion for Holtby's writing on Woolf was an invitation by Thomas Moult to contribute a volume on an author of her own choosing to a series he was editing, Modern Writers on Modern Writers. Brittain quotes a 1932 letter from Holtby to Sarah Millin in which Holtby describes her reasons for choosing Woolf. She " 'chose the writer whose art seemed most of all removed from anything I could ever attempt, and whose experience was most alien to my own.' " And she found writing about Woolf " 'the most enthralling adventure . . . as strange an exploration as it would have been for Virginia Woolf to sit beside my mother's pie and hear my uncles talk fat-stock prices and cub-hunting.' "[47] Although Holtby did not know Woolf personally and met with her only three times, she was helped in the biographical aspects of the study by the composer Dame Ethel Smyth, a friend of both women. Woolf later described Holtby's book as "wildly inaccurate."[48] Holtby herself, wrote Woolf to Violet Dickinson, was a "nice enthusiastic woman, but feather-pated . . . I couldn't help laughing to think what a story she could have told had she known the true Virginia."[49]

But if Holtby did not know "the true Virginia," she had a deep understanding of Woolf the writer. Indeed, Holtby's capacity to

understand and fully appreciate those aspects of Woolf's work unlike her own contributes to this memoir's being in some ways, as Brittain called it, "the profoundest of Winifred's books."[50] Holtby was writing before Woolf had published anything beyond *The Waves,* but even without a knowledge of the entire Woolf canon, she presents a version of her that would not be seen again until the seventies. Holtby shows us *Jacob's Room* as a war book, *To the Lighthouse* as a ghost story. She sees the political side of Woolf and describes how "the temptation to be rarefied . . . had far less power over her because one side of her mind was continually rubbing up against the minds of people engaged in securing pit-head baths for miners."[51] She recognizes Woolf's difficulties with portraying working-class characters in her fiction, but does not dismiss this as elitism. She knows that Woolf is far from prudish: "She is well aware that virility is attractive, but she estimated that attraction at a lower value than most."[52] Holtby appreciates a method and a style quite different from her own. She shows us how Woolf works not just with the cadences of poetry but with its methods, how she writes her novels "as a whole so that every detail of landscape, furniture or dialogue falls into its place in the design and assumes the double significance of story and of symbol."[53] Holtby communicates a sense of what it is like to read Woolf herself, a talent only the best critics have.

If it was the difference in Woolf that drew Holtby to her, it was their commonality that she discovered. Woolf was, after all, like Holtby, a twentieth-century woman novelist, part of a female tradition that, if unrecognized, was nevertheless potent in its influence. Holtby demonstrates Woolf's links with her mother, in whose *Notes from Sick Rooms* "there are more resemblances to Virginia's later literary style than in all her father's immense catalogue of published works."[54] As Holtby quotes delightfully Woolfian passages from Mrs. Stephen's work, her own style also becomes reminiscent of Woolf's essays, as if the lively variation in sentence length, the playful spirit, the insightful overstatement were infectious: "'The origin of most things has been decided on,'" quotes Holtby. "Is that not an almost perfect Virginia Woolf remark . . . The shadows of St. John Hirst, Charles Tansley, Ridley Ambrose and Mr. Ramsay creep from it across the page."[55] Holtby reclaims Woolf's mother for her here as she will begin to reclaim her own in the near future.

Holtby found other bonds with Woolf: her reaction to World War I, the conflict between the artistic and political life, her interest in adventurous women whose "Americas lay within themselves,"[56] and her emphasis upon the reader. Like Woolf, Holtby had struggled to free herself from limiting conventions and had reached a point in her life when she could say, "So she had got free. The old clumsy tools were out of the window."[57] Most of all Holtby is drawn to Woolf's androgynous vision of the human mind, to the image in *A Room of One's Own* of two in a taxi. "Her women may not all have been men once, as Orlando was, but they harbour a hidden man within their hearts."[58] Woolf sees the androgynous mind not merely as compatible with creativity but as essential to it, giving the artist the Tiresian ability to participate imaginatively in all aspects of human experience. Holtby's obvious attraction to this idea suggests perhaps that Woolf was right when she wrote years later to Ethel Smyth that Holtby was trying "to clear up her own muddles"[59] in this work. Woolf has, however, missed the fact that her identification with her subject has allowed Holtby to see their differences with clarity. Woolf did, after all, confess to Smyth that she "never did more than whip through it [Holtby's book] with one eye shut."[60]

In the fall of 1931 Holtby experienced the first serious signs of her illness, and she spent the rest of that year in an Earl's Court nursing home suffering from severe headaches, weakness, and abnormally high blood pressure. Doctors were unable to diagnose the disease and, attributing it to overwork, ordered a six-week rest. "It was then," writes Brittain, "that we discovered the value of a long and close friendship which had made our minds and outlooks virtually interchangeable."[61] Brittain found that she could answer Holtby's letters without consulting her and "correct the proofs of her articles and stories as though they were my own."[62] After six weeks the rest had superficially improved Holtby's health and she was sent to a convalescent home in South Devon, where Brittain visited her. Every afternoon they wrote together in Holtby's room, Brittain working on *Testament of Youth* and Holtby on her new novel *Mandoa, Mandoa!* Every evening when Brittain returned to her hotel, Holtby stood on the cliff lighting the path for Brittain with her flashlight, giving "me a sense of direction through the wood, just as the glow of her personality gave me a sense of direction through life."[63] As in-

creasing numbers of friends and well-wishers found their way to Holtby's convalescent retreat, she began to experience the same need to protect her time to write that Brittain had felt mired in the domestic bogs of house and children's needs. Affirming the uniqueness of their working partnership, Holtby wrote to Brittain, "'You are the only person I know in the world who does not prevent one working.'"[64]

In the spring of 1932 a specialist gave Holtby two years to live, a death sentence from which she protected Brittain until June 1935, three months before her death, when she claimed to have outwitted the doctors. In retrospect Brittain could describe a subtle change in Holtby after she had been told the truth about her condition, a tendency to withdraw and to keep her own counsel. On the surface, once a course of treatment had been established, Holtby appeared to be the same person she had been before the onset of the illness. She returned to her life at Glebe Place; renewed a friendship with Phyllis Bentley, whose Yorkshire novel *Inheritance* (1932) had just appeared to glowing reviews; continued her work for *Time and Tide*; completed *Mandoa, Mandoa!* and reestablished contact with Harry Pearson, who had recently returned from India after six years. Brittain describes Pearson as keeping Holtby on "emotional tenterhooks" by his surprise appearances and disappearances in her life. In recounting his reappearance in 1932, Brittain once again uses him as an argument against the "scandalmongers who invented for her a lurid series of homosexual relationships, usually associated with Lady Rhondda or myself."[65] Whatever the truth about Holtby's feelings for Pearson, she used his reappearance to provide a character for her novel. In *Mandoa, Mandoa!* Pearson is Bill Durrant, whom the protagonist has been attracted to for years but in the end rejects.

Mandoa, Mandoa! marks the culmination of Holtby's second stage of development. A political comedy, it is part a satire on British imperialism, part domestic realism. In her introduction to the Virago reprint, Marion Shaw suggests that the novel suffers from the split,[66] but if this is in some ways true, the two styles can also be read as a reflection of Holtby's theme, the relationship between the public and the private worlds, between commitment to people and commitment to conviction. It is her first exploration since *Anderby Wold* of our capacity to love where we disapprove and dislike where we share convictions. As Shaw points out,

Holtby claimed she was "'a passionate imperialist by instinct,' who found in enlightened colonialism a nostalgic parallel with the paternalistic farming community of her youth," although intellectually she knew that "the most hopeful future for South Africa lay in the constitutional advancement of the black population" (pp. x–xi).

Mandoa, Mandoa! subtitled "A Comedy of Irrelevance," is dedicated to Brittain, "V.S.V.D.L. irrelevantly," though the dedication is hardly irrelevant. Holtby had every reason to believe this book might be her last, and she wanted to make sure she dedicated one to Brittain. "But she knew too," said Brittain, "that I should agree with her ideas, sympathise with her conclusions, and perceive the significance of her leading characters."[67] What may have begun as an irrelevance, a jeu d'esprit much like the comic dystopia, *The Astonishing Island,* Holtby published the same year, became a profound examination of imperialism and a powerful attack on slavery of all kinds. It is a novel in the tradition of E. M. Forster's *A Passage to India* and Evelyn Waugh's *Black Mischief,* which was published three months before *Mandoa, Mandoa!* and to some extent preempted it. Holtby had said, "'I want to do something hard, muscular, compact, very little emotional, and then the emotion hammered into the style. Metal-work, not water-colour'";[68] and as Marion Shaw says, it is "an unusual novel for a woman to have written" (p. xviii). Holtby's fight for equality feminism and her personal struggle to establish a place for herself in a public world culminated, at the end of stage two, in her writing a very successful novel in a male genre.

Mandoa, Mandoa! was written in a time of national disillusionment during the aftermath of the 1931 general election. Already depressed by increasing unemployment, Britain was beginning to hear the threatening voice of fascism in Europe that was to culminate in the Second World War. Both these situations hover in the background of a novel whose most powerful scenes are set in the imaginary African kingdom of Mandoa. The immediate event that inspired the novel was the 1930 coronation of the emperor of Abyssinia, which was reported in colorful detail in British newspapers and described to Holtby by an acquaintance. Although Holtby had never been to Abyssinia, she chose this country as the scene of the novel, rather than the South African states with which she had more direct familiarity, because the

transitional status of Abyssinian culture made it appropriate for her theme. Nevertheless, it was the many years of work Holtby had given to the cause of black trade unionism in South Africa that informed the political consciousness of *Mandoa, Mandoa!* and provided the prototypes for some of its characters. In return, some of the money earned from the novel was used to wipe out the debts of her Africa fund.

In a manner highly reminiscent of Forster's *A Passage to India,* *Mandoa, Mandoa!* opens with a panoramic view of an exotic landscape, though in this case it is African rather than Indian. Holtby's omniscient narrator cheerfully describes colorful crowds gathered in the square of the Mandoan town of Lolagoba to watch a procession. Only in the final words of the chapter does the narrator reveal that they and we are watching "the annual slave-train from Mandoa to the Red Sea" (p. 16). In this way Holtby establishes from the beginning the two moods of the novel: the comic surface mood that is used to point out the similarities between the naive and inhumane Mandoan culture and the supposedly sophisticated, more humane British one; and the serious mood of her own social conscience that functions as an ironic subtext to the comedy.

Holtby links the institution of slavery to the treatment of women as the narrator describes the arrival of the Mandoans at their present location "with only a trifling loss of slaves and women" (p. 18). The constitution of Mandoa is a debased form of goddess power that, by means of secret male intervention, sustains a public illusion of virgin birth by a princess who only has daughters. Talal, the Aziz character of this novel, is based on Clements Kadalie, secretary of the union of South African black workers, with whom Holtby had worked for many years. Talal explains the reason for a princess rather than a king: "Women were easier to manage, being . . . only a sub-human (and he quoted lines from Alfred, Lord Tennyson to prove it). They must be respected; but they need not be obeyed" (p. 19).

The Mandoans are greatly intrigued by the recent importation of Hollywood movies and spend most evenings in a hut renamed Hollywood Hall, acquiring their ideas of Western culture from such films as *College Girls Must Love* and *Red Hot Momma*. So Talal dreams of a life with "puddings made from custard powder, exotic soups and vegetables out of tins, gas ovens that cooked the

meals unaided" (p. 22). The confusion between Catholicism and Hollywood has resulted in the worship of Mary Pickford and an inability to distinguish the Gloria from Gloria Swanson. Holtby's satire on England of the 1930s, with its obsessive interest in the new labor-saving devices and its veneration of glamorous public figures, is underlined in Bill Durrant's comparison of advertisements with Mandoan triumph-songs. "What were these testimonials but triumph-songs? Was there so much to choose between them" (p. 151)? Talal illustrates the equation of Britain with Mandoa in an account of his slave Kanackrie, a Kikuyu, who once lived under British rule in Kenya: " 'No Briton *owns* a Kikuyu. No, sir! Britons own government. They own roads. They own land. They levy taxes. If Kikuyu won't work for them, they take more land, levy more taxes' " (p. 140). The social irresponsibility of British imperialism is echoed in Talal himself, who, at the end of the first section of the novel, is shown ignoring a slave being driven to execution as he heads to Hollywood Hall to watch a movie. Despite the comedy Holtby creates from the inability of the Mandoans to understand the language and customs of the British—Talal believes a public house is a brothel and mixed doubles a sort of love dance—*Mandoa, Mandoa!* like other travel satires, finally exposes the weaknesses of the original culture by showing its similarity to an exaggerated fictional counterpart.

This comparison is echoed in the structure of the novel, which alternates between scenes set in Mandoa and scenes set in London. The London world is represented by Maurice and Bill Durrant and their mother, by Sir Joseph Prince of Prince's Tours, a prestigious travel agency for whom Maurice Durrant works, and by Jean Stanbury, the female protagonist, who is based on Holtby herself. At the beginning of the novel Maurice Durrant has just won the 1931 election as the Conservative member of Parliament for North Donnington. An imperialist and apologist for British nationalism, Maurice has been opposed by a Socialist who, like Holtby, believes that empire " 'divides—bosses from workers, white from black, Britons from the rest of the world' " (p. 30).

A scene in front of a labor exchange where the unemployed are seeking jobs suggests that England's social problems are the result of World War I and the subsequent "peace." Here Sid Granger, labor activist, confronts Bill Durrant, who, he claims, is taking

advantage of his class to deprive the more genuinely needy of employment. "Sid Granger looked at the tall young man beside him and then at the group straggling round the Labour Exchange. Old men with fumbling, toothless mouths and useless hands; self-respecting, highly-skilled artisans, loathing their new humiliation, shy, awkward, and suffering; young boys who had never done a week's work since leaving school, and on whom the deterioration of idleness and malnutrition had set its mark" (p. 62). Bill's unemployment is the result of the election; he had been working for a Labor MP who failed to get reelected. Maurice hopes to trade on Sir Joseph Prince's desire to take advantage of his new importance to the business and acquire a job for his brother. Prince plans to expand the range of his tours and proposes sending Bill to investigate Mandoa as a possible tourist destination. That racism is as fundamental to British culture as slavery is to the Mandoan is suggested by Prince's comment on this proposition to an unperturbed Maurice: " 'If I want to take a risk with a man, I send him to a native state where there are nothing but blacks . . . If I let him go where there were other white men, the reputation of the firm might get damaged' " (p. 57).

Maurice's motives in agreeing to Bill's departure for Mandoa are at least partly selfish. Envious since a child of his mother's preference for Bill, who, although a war hero, has been a conspicuous failure in adult life, Maurice feels guilty about his strong desire to get rid of his brother. Even on the night of his election victory, Maurice sees his mother's concentration on Bill's needs. Holtby's portrait of her longtime friend and perhaps lover, Harry Pearson, is sympathetic but finally very detached. She sees his charm and can describe it, but does not give the impression of feeling it any longer. She knows his weaknesses and defines them much too clearly for someone who is still enamored. "Bill has stopped caring intensely years ago" (p. 137); faced with the horrors of Mandoa, he shuts his eyes, vaguely aware that "if he really opened his eyes and looked at what was going on, he could not bear it" (p. 157). Bill has been afraid of flying since a plane accident in which he was responsible for the death of his friend Stephen, Jean Stanbury's brother, but Holtby knows that he is "not afraid of death. It was life he feared, life, and responsibility, and taking decisions upon himself" (p. 141). It is difficult to read

this portrait, as Brittain does, as a revelation of Holtby's "hidden love," as the explanation of "the secret history of her emotional life."[69]

Interesting though the portrayal of Bill Durrant may be as Holtby's clarification of her relationship to Pearson, probably more significant in terms of her development is her treatment of the metaphor of motherhood in this novel. Early on she strips motherhood of all illusory joys, drawing on Brittain's experience to describe Mrs. Durrant's unwillingness to acknowledge that she, "like many other women, was bored by babies" (p. 42). Just as in *Anderby Wold* and *The Crowded Street,* Holtby associates mother with traditional values, but now the values are broader in scope and encompass metaphorically not only conventional views of male and female roles but also ideas of empire and nationalism. So Sid Granger verbally accuses a mild-looking clerk of being " 'the good boy of the family, mother's little joy an' comfort . . . You salute the Union Jack, and sing the National Anthem, . . . and you vote Tory at every damned election just to spite the rest of us' " (p. 59). Maurice's longing for his mother's attention is both the result of her favoritism toward his brother and symbolic of his traditional political views: "When he spoke to the electors of North Donnington about the iniquity of a trade union caucus dictating to the British cabinet, he actually saw treason striking at the heart of the mother of parliaments" (p. 79). It is the conservatism of the political world, a traditionally male preserve, that concerns Holtby here, though by linking this as she had linked conventional female attitudes to the idea of mother, she underscores the connection between the private and public spheres.

Like Eleanor de La Roux, Jean Stanbury is a single woman perfectly satisfied with her life. She enjoys living alone, relishes the privacy of her own cottage. "No place in the world could possibly please her more" (p. 68), she thinks. Despite the warnings of modern psychologists against "the frustrations of an abnormal sex life" (p. 69), she cannot "honestly discern any inconveniences in her virgin state" (p. 69). Jean's job as assistant editor of the *Byeword,* an antiimperialist weekly review, is a satisfying one and she has resolved not to marry. Accused by a colleague, Evelyn Raye, of sublimating her "maternal instincts on offices" (p. 123), Jean defends Holtby's own position. Like Holtby, Jean has had years of experience tending other family members and is

"satiated by a career of altruism" (p. 69). " 'I've bathed, nursed, cuddled, and rocked babies until I never want to see a human creature under twenty-five again in my life,' " explains Jean. " 'I may be suffering from reaction against excessive vicarious maternity; but the fact remains that I actually enjoy this sort of life' " (p. 123).

With the introduction of Jean Stanbury in chapter 6, a late introduction for a protagonist, *Mandoa, Mandoa!* moves into the domestic realism characteristic of Holtby's earlier novels. Jean is older than Holtby's earlier female protagonists and has already made the choices we have watched such characters as Muriel Hammond make. She has rejected the traditional female values represented by the mother. She is the confident spokesperson for the Holtby of middle life, irritated by the postwar narrowness of sexual "liberation," by "the ancient school of feminine solicitude" (p. 70) that requires her to comfort Bill Durrant for the loss of her brother, strong willed enough, even after "a lifetime of control" (p. 95), to oppose her editor's publication of an article she considers libelous. Jean is also, like the mature Holtby, capable of realizing "that nothing in life is ever finally settled; that the dilemmas recur, and the decisions have to be remade again and again, and that only in death is finality" (p. 247).

Jean's objection to the publication of Arthur Rollett's article costs her her job with the *Byeword*. Rollett, the most radical humanitarian in the novel, is based in part, according to Brittain, on Holtby's friend Dr. Norman Leys, who "carried passionate integrity to the limit of fanaticism."[70] Convinced of the evil motives of Prince and aware of Mandoan slavery, Rollett finds his own way to Mandoa to expose the truth. Despite his unpolitic actions and his unpleasant personality, Rollett serves as the conscience of the novel, one of many examples of unattractive characters who nevertheless represent Holtby's views.

Jean Stanbury also goes to Mandoa, but as a representative of the International Humanitarian Association, part of a commission investigating alleged abuses by Princes Ltd. Rollett has been rejected as unsuitable for a commission appointment because he believes that effective reforms can only come about through unpleasantness. To a large extent Rollett's expectations of the failure of the investigation are confirmed. Each member of the commission is shown to have his or her own reasons for not pushing

the investigation too hard. Beaton, the Englishman, for example, "hated scandal. In his heart he longed to find his own countrymen incapable of the greater villainies of commercial exploitation" (p. 253).

Trapped in the African backcountry by tribal conflicts and the sudden arrival of a dying Rollett who must be cared for, the members of the IHA commission become examples for Holtby of a vision of apparent human isolation. "When it came to the point, they were all lonely, lonely," Jean believes. "Not one of them knew what the others were thinking" (p. 263). In an ironic vision of human unity through a shared sense of isolation, a vision comparable to Woolf's in *Mrs. Dalloway,* Holtby has each member of the commission in turn experience the loneliness Jean has talked of. Once more connecting the personal to the political, Holtby shows Beriot comparing his inability to know his dead wife with the commission's failures in Africa: "'If I never really knew my love, how can I know a Negro? How can I save these strangers of alien race when I could not save her'" (p. 264)? Bill Durrant's friendship with Talal serves the same function, reflecting in a personal mode a fragile bridge between two apparently very different cultures.

The political plot of *Mandoa, Mandoa!* ends with little changed. Rollett is dead; Prince's colonization of Mandoa is proceeding; slavery continues. But Prince does not have everything his own way and Maurice Durrant is to have the question of slavery raised in Parliament. As Jean Stanbury says at the final luncheon party, "'We have to work for the world we know as best we can . . . The reforms have been started, we are only waiting for the signal to go forward'" (p. 375). An unpublished 1933 letter to Catlin from Holtby makes clear what she intended here. Her "hero," she says, is the "Human Will." The luncheon party and final Mandoan vision may be "a poem of the continuity of that spirit— the grain of mustard seed growing after burial." The novel is not meant to be either "pessimistic" or "defeatist." The ending seems rather more prosaic than poetic, however, a realistic compromise rather than a heroic victory for the forces of good, a George Eliot vision of small gains and limited hopes.

The ending in the personal mode, the conclusion of Jean Stanbury's story, represents a far more radical change. Flying toward Mandoa, Jean had said, "'I have left Jean Stanbury somewhere

beyond Sennar . . . I left half a dozen selves . . . This won't last for ever. I shall go back to Victoria Street. I shall recover all my old selves again'" (p. 229). The old selves Jean intends to recover are clearly those of her mature single life, but ironically she is to recover more selves than she expects. She rejects Bill Durrant because she realizes that she "had not really liked nor understood" him. In words that echo Holtby's about herself,[71] Jean explains, "When she was with him, she had always thought of herself . . . She had trained herself so long in detachment that she had become a miser of herself; she could not give herself away" (p. 262).

Between the final chapter and the epilogue entitled "Recessional," Jean Stanbury marries Maurice Durrant, and when we see her again, she is entertaining the IHA commission members at a Knightsbridge flat as Maurice's pregnant wife. It is not only because the courtship happens offstage that this marriage seems improbable. It is also a reversal of Jean's view of her own life and, at least to some extent, of her values. Maurice has been responsible for the rescue of the commission members; he has taken risks; he is no longer jealous of his brother. And in return he is given the mother he has always needed. Not only is Jean about to become a biological mother, but the reasons Holtby gives for the marriage make it clear that she is already Maurice's mother. He still irritates her; she cannot share his "overwhelming reverence for The Right Wines, The Right Company, The Right Ritual of social amenities" (p. 372). But "she loved Maurice. She loved him with a passion of tenderness for the lonely, vulnerable little boy he had been" (p. 372). She looks round the table, "a big, handsome woman, strong and maternal" (p. 375).

Why does Holtby marry Jean Stanbury to Maurice Durrant when it is fictionally difficult and inconsistent with her character? The inconsistency is perhaps the point. Jean's recovering of her maternal self begins the process of reclaiming, in a different form, the rejected values of the mother, a process characteristic of the third stage. Holtby may also be exploring new selves here, as she had perhaps begun to do in the marriage of Eleanor de la Roux. She is playing, if somewhat awkwardly, with a whole range of possibilities for herself and, through herself, for her characters. They are, of course, possibilities she does not now expect to live to experience. Like Jean Stanbury, Holtby is all too well aware that life is "a very precarious affair, a delicate treading over brittle

ice" (p. 373). But they are possibilities that represent the broad-ening of Holtby's fictional imagination which will culminate in the richness and deep humanity of her final novel, *South Riding*.

Holtby's awareness of the problems with her ending to *Mandoa, Mandoa!* is indicated by an omitted chapter to the novel, later published as "Episode in West Kensington" in the posthumous collection of Holtby's short stories, *Pavements at Anderby*. In the omitted chapter Jean visits her ex-colleague and friend, Evelyn Raye, at her small flat in West Kensington. It is the evening fol-lowing the luncheon party at the end of the novel and clearly some parts of the scene were later reworked into the chapter Holtby retained. For example, here, as at the lunch, Jean sees "life as very brittle—a crust of paper-thin ice above the black fath-omless waters of death."[72]

The omitted chapter is far more ambivalent about the future, much less positive than the actual ending of *Mandoa, Mandoa!* The picture of human isolation Holtby suggests in the description of Mr. Smith in flat number 149c, who "had been dead with a gas-pipe in his mouth for five days before the accumulating milk bottles outside his door suggested to the girl in number 149d that something might be wrong,"[73] is unrelieved by any alternate vi-sion of unity. Jean is conscious here of the distinct possibility of another world war, like the one "which had destroyed her broth-ers,"[74] and remembers Mandoa as "fierce and terrible."[75] The comparison between Mandoan slavery and the enslavement of women and of the poor is made specific in Evelyn Raye, who lost her fiancé in the First World War and works at a job she hates. Embittered and jealous of Jean, who has the world she hungers for, Evelyn says, " 'What do I care for slavery? I who am, from nine till five-thirty—and often to six or seven—every working day, a slave?' "[76]

Evelyn's prolonged verbal attack touches Jean where she is most vulnerable; she is all too aware of the immunity to such suffering as Evelyn's provided by her marriage to Maurice. Jean's defenses collapse. She weeps for Arthur Rollett, who did not compromise, confesses to still caring for Bill and to knowing that " 'Maurice will grow rich on reform.' "[77] In the end it is, ironically, Evelyn who must dry Jean's tears, just as Jean had earlier been forced to comfort Bill. Evelyn blames everything on her own jealousy, but Jean is not entirely convinced and the vision at the end of the

episode is of a very cautious optimism overshadowed by the possibility of "the disaster which would wreck all dreams."[78]

The two women in the episode seem to me to represent Holtby's continued ambivalence about her own immunity. The Jean Stanbury in her is accepted, has enough money to live comfortably, is secure and successful. But the Evelyn Raye questions this security and still sees herself as marginal and living on the fringes of other people's lives. A particularly bitter speech by Evelyn even suggests Holtby's resentment of some aspects of her life with Brittain. When Jean offers her a place in the country with her family, Evelyn draws her limits. She will not be " 'a useful aunty' " to Jean's children, " 'give them presents and be their godmother . . . When you're tied to your children, I'll flaunt my freedom at you. When you're sick and ill I'll take advantage of my health . . . I'll work for Mandoan slaves, longing for half a chance to oppress any one but myself.' "[79] Evelyn's anger is no doubt an exaggeration of one of Holtby's temporary moods, but the conflict between the two women does suggest that beneath the Holtby who chose to end *Mandoa, Mandoa!* with confident optimism remained a woman still ambivalent about her own success. At this point Holtby had not quite reached the serenity that was to inspire *South Riding*.

Holtby's other 1933 publication, *The Astonishing Island,* is a dystopia that is closely related to the satiric sections of *Mandoa, Mandoa!* It sustains the satiric tone that Holtby employed only periodically in the earlier work but makes no attempt at its depth or complexity. The protagonist, Robinson Lippingtree Mackintosh, leaves his island of Tristan da Cunha and arrives by chance at an island called The Island, which is identical to Great Britain. Like *Gulliver's Travels, The Astonishing Island* is a travel satire with a male protagonist, designed to expose the evils and absurdities of its author's own country. But despite using a male protagonist, Holtby has written a female version of this genre. The protagonist is a stranger to the country whose customs are satirized, perhaps a reflection of women's sense of lacking a geography of their own, of being outside their society. Robinson does not colonize a desert island or, like Gulliver, expose the absurdities of his own society by trying to make sense of them in conversation with a stranger. He spends his time on The Island in complete astonishment and

frequent misunderstanding of the most ordinary English customs.

Holtby makes fun of customs regulations that prohibit the importation of such disparate objects as tomatoes and copies of *The Well of Loneliness,* of beach games, of swimming in cold water for pleasure, of the claim that football and cricket build character while tennis does not, of the transient nature of fame—curiosity about Robinson lasts for one day, whereupon he is replaced in the newspapers by a seven-year-old girl who has swum the Channel—and of crowded picnics in the country. Part of the comedy, as in *Mandoa, Mandoa!* derives from verbal misunderstandings. In a trip to the Egyptian section of the British Museum, Robinson hears a talk about mummies, "which of course was quite right, Mother-love being such an inspiration to the Islanders."[80]

Many of Holtby's other targets are the more serious ones of *Mandoa, Mandoa!* and *Poor Caroline.* Holtby links colonization, racism, and war to British arrogance and false notions of heroism, a connection Brittain was making simultaneously, though in a quite different mode, in *Testament of Youth*: "If an ordinary amateur has a good reason to want a man to die, because he makes his life a misery . . . and if he kills him, that is called Murder, and the judge orders the killer to be hanged till dead, and his photograph is put in all the papers with last letters and what his mother said. But if a whole lot of Islanders decide they would like to do some killing they all put on fancy dress . . . and kill as many foreigners as they can; and that is called war, and the killers . . . are called heroes and given medals."[81]

Holtby's method in the second part of *The Astonishing Island* is that of *Eutychus*: Robinson tests the clichés he has heard by traveling the country and talking to those he meets. The reality does not match the accepted truths, however. He looks for "the working classes," but no one admits to belonging; he cannot find "a true woman," nor the ideal "home of their own," for which, he has been told, all girls wish to marry. He understands that women come in different forms—frustrated spinsters, mothers, modern girls, housewives, and vampires—but Robinson gets confused and cannot identify them. The stereotypes no more exist here than they do in *Poor Caroline.*

Although it is a slighter work than either *Poor Caroline* or *Man-*

doa, Mandoa! The Astonishing Island acts as a fitting summation to the second stage of Holtby's development. It tackles in brief the major themes of this period and sustains its dominant satiric tone. Appropriate too is the geographic metaphor that best defines the journeying outward and exploration of new territory characteristic of both Brittain and Holtby at this stage. At the end of *The Astonishing Island* Robinson returns home to his own island with renewed appreciation of its strengths. Similarly, Holtby returns to the world of her youth, the world of *Anderby Wold,* to reclaim it and remake it in *South Riding.*

Chapter 4

"Didn't women have their war as well?"

Testament of Youth

S ix years after the publication of *Testament of Youth* in 1933, Virginia Woolf was to write in *Three Guineas,* "As a woman, I have no country. As a woman I want no country. As a woman my country is the whole world."[1] Although she did not intend them to be, Woolf's words provide an insightful and concise commentary on Brittain's autobiography. Brittain's starting point is an awareness that women are given no place in public life, have no country, and that female friendship can provide a base upon which to stand, a sense of community and self that becomes in a way an alternative to country. *Testament of Youth* is an attempt, from the base formed by her friendship with Holtby, to claim a place in the public world, to see her personal life as representative of her generation, to relate the private to the public. *Testament of Youth* is also a powerful attack on the false values of nationalism and militarism and on their roots in patriarchy. As a woman, Brittain wants no country. Nevertheless, one answer she suggests for the evils of war is internationalism, a recognition of our common humanity that transcends national boundaries. In that sense Brittain's country is the whole world.

Since it is an account of her life written in the first person and apparently attempts to convey deeply felt emotion, most commentators have called *Testament of Youth,* as Marion Shaw does,

"highly personal and 'feminine.' "[2] In reality it is far from the outpouring of feeling that these words suggest. The part of *Testament of Youth* that covers the years 1913–17 at least—ironically, the part usually thought of as the most intimate and revealing—is actually a carefully crafted rewriting of far more personal and graphic documents, her diaries and letters. In this rewriting of her own earlier material Brittain looks for the general truths in her own individual experience and stresses what is typical of her generation. In many ways like Holtby in *Mandoa, Mandoa!* Brittain begins the second stage of her development by writing in a male genre with a female sensibility.

It is significant that as she was finishing *Testament of Youth,* Brittain began for the first time in fifteen years to keep another continuous diary. As if freed from the domination of the experiences described in the earlier diary, she was now able in some sense to begin life anew. Ironically, as Alan Bishop points out in his introduction to *Chronicle of Friendship: Vera Brittain's Diary of the Thirties, 1932–1939,* the new diary comes to resemble the old; "it was to record, harrowingly, the death of her closest friend and the destructiveness of a second Great War."[3]

In *Testament of Experience* Brittain claims that the death of her uncle Bill from the aftereffects of wartime work revived her memories of the war and was thus the initial impetus for *Testament of Youth.* A better clue to Brittain's reasons for writing the book probably lies in the section of *Testament of Experience* that describes Catlin's distressed reaction to the "passionate young ghost" Roland, who, he believed from reading Brittain's manuscript, would always stand between them. According to Brittain, however, her husband "had never allowed for the degree to which the actual decanting into words of past grief for lost loves is a form of exorcism."[4] She commented on the cathartic effect of writing also in her diary, saying, as she finished part 2, "It seems so strange that I have thought about little else but the War for eighteen years—and now, perhaps, shall never write of it again."[5] Brittain, then, needed to exorcise her memories of the war in order to live fully in her present life, and this need determined not only the material but the form the book would take. "*Testament of Youth,*" she wrote, "became the final instrument of a return to life from the abyss of emotional death."[6] Although the need to rid herself of the war was, I believe, her primary motivation for writing her

autobiography, the book also represents the effort begun with *Halcyon* to justify her choice in favor of her own work and against traditional marriage. This second motivation is manifested most clearly in the postwar section of *Testament of Youth*.

In the first flush of excitement over her idea for the book in 1926, she wrote to Holtby, who was traveling in South Africa, about the new novel that would cover the period 1913–15 and be called "The Incidental Adam." She knew it would be "dreadfully autobiographical" but did not envision it as anything other than fiction. She describes herself as aching "to write, at long last, about the war—all the glory and the grieving and the sacrifice and struggle and loss. It was, I felt, a book on which one ought to spend at least two years—and I wanted to finish it before I began to have a baby."[7]

By the time Brittain actually began serious work on *Testament of Youth* in 1929, she had already had one child and was pregnant with the second. There were several reasons for the delay, only one of which was the demands of a household with young children. Not until the life in London with Holtby was well established and provided the necessary emotional support could Brittain write the book that was to secure her reputation. She certainly writes of her envy of Holtby's life at this time, seeing it as a contrast to her own total lack of achievement: "She, at the proud summit of her career, went everywhere, met everyone and did everything, while I spent nearly all the time at home, looking after two energetic and exhausting babies, and trying to overcome a daily sequence of vexatious domestic problems in time to get an hour or two's work each evening on my autobiography."[8]

Nevertheless, it was Holtby's encouragement that kept her going when she periodically became tempted to abandon the project. "So I laboured on," writes Brittain. "Many times I did so only because she insisted."[9] When Gollancz accepted the book for publication, Holtby was as jubilant "as if the long-delayed reward had been her own,"[10] an indication of the bonding with Brittain that was reflected even in the attitudes of other people. "We are so extremely entangled now in people's minds," Holtby wrote to Brittain in November of 1934, "that Lady Steele-Maitland, my chairman at Thursday's meeting, introduced me as 'Miss Vera Holtby' to loud laughter and applause."[11] Brittain's letter in response to the notice Holtby wrote for *Testament of Youth*

illustrates the importance of Holtby's support: "Do you really see all this in my book? If so, it must be there—and my confidence in it is restored . . . now has come your lovely description to restore my faith in myself and in the possibility of succeeding in what I set out to do and to make other people *see*."[12]

The most immediate reason that Brittain began work in earnest on the autobiography in 1929 may well have been, as Paul Fussell points out, that 1928 was a key year for two kinds of books: "on the one hand, the first of the war memoirs setting themselves the task of remembering 'the truth about the war'; on the other, clever novels exhibiting a generation of bright young men at war with their elders."[13] So Remarque's *All Quiet on the Western Front* and Sassoon's *Memoirs of a Fox-hunting Man* shared bookshelf space with Huxley's *Point Counter-Point* and Waugh's *Decline and Fall*. Influenced perhaps by both genres, Brittain's book was both a "true" account of the war and an attack upon her "elders," the generation responsible for the war.

If her choice of autobiography over fiction was prompted on the personal level by a need to write directly about her own experiences in order to free herself from them, it was also in part prompted by an awareness of literary possibilities. As the male versions of World War I, both fictional and autobiographical, were published in increasing numbers, Brittain acknowledged a growing sense of their failure to reflect her own experience. After reading *Goodbye to All That, Death of a Hero, All Quiet on the Western Front, A Farewell to Arms, Undertones of War,* and *Memoirs of a Fox-hunting Man,* Brittain asked, "Didn't women have their war as well? They weren't, as these men make them, only suffering wives and mothers, or callous parasites, or mercenary prostitutes . . . Who will write the epic of the women who went to the war?"[14] Once Brittain realized that the antiwar attitude suggested by her original title, "The Incidental Adam," needed to be seen through the lens of a woman's viewpoint, the energy to write the book came to her.

Brittain's journalistic pieces from 1929 on stress both the absence of accounts of women's war work and the way in which this has disturbed our view of the parts both sexes played in the war. In a 1929 article she writes of "the large number of war records that . . . have in general ignored the active war-work done by women." In most war literature written by men, women

"have appeared chiefly in the role of passive sufferer."[15] In a 1930 letter to the editor of *Time and Tide,* Brittain praises Mary Lee's gigantic novel, *It's a Great War,* and Mary Borden's *The Forbidden Zone,* responding to a reviewer, A.D., in words that reflect her new approach to her own work: "I suggest, therefore, that women are not, as A.D. indicates, bored with war books but that their real interest has never been aroused. And it will not be aroused until a war book is published which removes the impression that one sex only played an active part in the war, and one sex only experienced its deepest emotions."[16] By 1933 Brittain was commenting not only on the desirable content for books about the war but on the preferred form. War novels were no longer as much in demand as "the serious autobiography which draws definite conclusions from the writer's experience."[17]

Despite her desire to record women's experience, it was to male memoirs that she looked for a model for her own "serious autobiography," since she believed that no women writers had yet written about the war: "With scientific precision, I studied the memoirs of Blunden, Sassoon and Graves. Surely, I thought, my story is as interesting as theirs."[18] Although Brittain's work is in many ways different from that of her male contemporaries, for example, showing little of the theatrical quality Fussell comments on in Sassoon and Graves,[19] she learned a good deal from them. They taught her in particular that a new form of autobiography was becoming fashionable; memoirs of famous people were no longer as popular as those that reflected the typical experience of a generation. Brittain felt that she could help speed the development of this kind of autobiography: "I meant to make my story as truthful as history but as readable as fiction, and in it I intended to speak, not for those in high places, but for my own generation of obscure young women."[20] She received encouragement for her project from Rebecca West, whose husband, Henry, suggested at a dinner party that Brittain's life was not interesting enough to write about. Rebecca West retorted, " 'You mean she's not a field-marshall? But it's the psychological sort of autobiography that succeeds nowadays—not the old dull kind.' "[21]

What Brittain did not realize in 1929 was how many firsthand accounts of the war women had actually written. In his bibliography of British autobiographies written before 1951, William Matthews lists seventy-two autobiographies by women either en-

tirely or partially concerned with World War I. They had not, of course, all been published by 1929, but a significant number had been.[22] What seems clear is that they received very little attention, which would account for their virtual disappearance by 1977, when Brittain's daughter, Shirley Williams, felt able to describe *Testament of Youth* as "the only book about the First World War written by a woman."[23]

The twentieth century has proved a great period for women's autobiography for some fairly obvious reasons. For the first time women saw themselves as typical, as representative of their times. When Brittain described the experiences recorded in *Testament of Youth* as "less my own than those of all my near contemporaries,"[24] she was justifying her work in a way absolutely characteristic of her female peers. "My experience is perhaps . . . typical of that of many women of my generation," writes Lady Rhondda.[25] In the twentieth century women were able to see their lives as representative and therefore worth recording because the enormous social changes of the period were reflected most clearly in women's lives. "From the dress allowance to the woman cabinet minister; from the thing not mentioned to the contraceptive in the handbag; . . . it is a long step to stride in three-quarters of a century," as Phyllis Bentley puts it.[26] "What is the record of my life worth," writes Brittain and Holtby's friend Storm Jameson, "perhaps little, except that as a life it spans three distinct ages . . . three ages so disparate that to a person who knows only the third the others are unimaginable."[27]

Central to the changes in women's personal lives were two public events: the struggle for female suffrage and World War I. If, as Karl Weintraub claims, "the essence of autobiography" lies in an author's perceiving his or her "life as a process of interaction with a coexistent world,"[28] then World War I, a public event that invaded women's lives as little had before, was likely to inspire some fine autobiographies. That Brittain shared Weintraub's views on the essence of autobiography is clear throughout *Testament of Youth* and overtly stated in her foreword. She aimed to tell her fairly typical story "as truthfully as I could against the larger background . . . to put the life of an ordinary individual into its niche in contemporary history, and thus illustrate the influence of world-wide events and movements upon the personal destinies of men and women" (p. 12). The influence of the public

upon the personal is a theme that echoes throughout Brittain's work, as it does in George Eliot's. Like her contemporaries E. M. Forster and Virginia Woolf, Brittain "had to learn again and again the terrible truth of George Eliot's words about the invasion of personal preoccupations by the larger destinies of mankind" (p. 472). As early as 1922, in her foreword to her as yet unpublished diaries of 1913–17, Brittain expressed a belief in the corollary to this idea of the public world's effect on the personal: the making public of the personal life may in turn influence public events. "I belong to the few," Brittain writes, "who believe in all sincerity that their own lives provide the answers to some of the many problems which puzzle humanity."[29]

The existence of the diaries that Brittain kept between 1913 and 1917, together with the letters written to her fiancé, Roland Leighton, her brother Edward, and their friends Victor and Geoffrey, made the immediacy of *Testament of Youth* possible. "These documents," as Brittain says, "review with fierce vividness the stark agonies of my generation in its early twenties" (p. 12). Brittain attempted to publish her diaries twice: once in 1922, when a publisher offered a prize for a personal diary or autobiography; again in 1938–39, six years after the publication of *Testament of Youth,* when, in her notes for an introduction, she stated her hope that they might act as a warning to a world preparing for another war. It was not until 1981 that Alan Bishop edited the diaries and published them under Brittain's own title, *Chronicle of Youth,* though the selection of passages differs in some respects from hers, most notably in the inclusion of material from 1917 that Brittain had omitted.

Originally Brittain tried to reproduce in *Testament of Youth* long passages from the diaries, "with fictitious names substituted for all the real ones out of consideration for the many persons still alive who were mentioned . . . with rather cruel candour" (p. 12). But the fictitious names "created a false atmosphere and made the whole thing seem spurious" (p. 12). Brittain had used her diaries in this fashion before in her novel *Not without Honour,* but the relationship between the diaries and *Testament of Youth* was eventually quite different. *Testament of Youth* is a reading of the diaries, a reading by a second self, someone as different from the original writer as that actual other, the female friend. Granting the inevitable shaping and distortion of any material by the very

act of recording it, *Chronicle of Youth* is "raw" in a way that *Testament,* for all its immediacy, is not. As Brittain says in her 1939 notes to the diaries, *Testament of Youth* "tried to give the perspective of the War seen for a long time—the forest, not the trees themselves. Here, because one sees the trees one by one, the forest never becomes quite clear. But diaries give one effect which *Testament of Youth* . . . could only partially convey—the cumulative effect of day-to-day suspense and anguish."[30] The relationship between the trees and the forest is certainly apparent if one comes to *Chronicle* after reading *Testament of Youth.* All the major themes of *Testament* are here: war, education, the situation of women, sexuality, public service. But Brittain's attitude to these issues in the diaries reveals much more ambivalence. The Brittain who wrote *Testament* had lived another twenty years and reread and rewrote that earlier self, with whom she felt "only a remote family relationship."[31] The mature Brittain was more reflective and much more definite in her views. She had also become a more skilled writer, though there is nothing in *Testament* to equal in impact the silent four days in her diary after the telephone call that tells her of Roland's death.

The perspective of the narrator of *Testament of Youth* differs in two ways from that of the girl whom Brittain herself called the "priggish" (p. 360) young writer of the diaries. First, she has a wider vision and frequently generalizes on the universal nature of her individual experience. "The experience of one person, as practical record and spiritual pilgrimage," she writes, "may be important in itself; its significance is doubled if the personal narrative is linked with the experience of many, and approaches the experience of all."[32] So, for example, the narrowness of her life in Buxton before the war is seen in the light of her vaster knowledge of other women's lives, Holtby's in particular, and she gives her chapter a title that implies this, "Provincial Young Ladyhood."

Second, the Brittain of *Testament* simply has a knowledge of the future that encourages her toward frequent foreshadowing. She frames her happiest experiences in black and thus heightens their significance by stressing their impermanence: "How fortunate we were who still had hope, I did not then realize; I could not know how soon the time would come when we would have no more hope, and yet be unable to die" (p. 137). She describes the pur-

chase of a black moiré and velvet hat trimmed with red roses, telling us she will "be indescribably happy while wearing it, yet in the end . . . tear off the roses in a gesture of impotent despair" (p. 112). A knowledge of the dreadfully destructive force of World War I colors her portrayal of a generation she calls "naive," "childish," and "idealistically ignorant" (p. 45). But while condemning their blindness, Brittain also recognizes that her contemporaries had the capacity to appreciate the summery mood of innocent pleasures whose passing she so much regrets. She quotes a letter she wrote to Roland at the front: " 'For me I think the days are over of sheltered physical comfort and unruffled peace of mind. I don't think they will ever come again.'" The older Brittain comments, "I thought rightly, for they never did" (pp. 138–39).

Brittain's awareness of herself in time, her capacity for self-reflection, is certainly suggested in *Chronicle,* as the possibility of Roland's death in war makes all their meetings potentially their last: "against our future communion the stern 'Nevermore' might be written in the annals of fate."[33] But diaries, of course, by definition cannot have the perspective of time, and it was that double perspective Brittain chose to employ in *Testament.* "The usual retrospective view," she writes, "would be combined with contemporary impressions and thus create the effect of a double dimension."[34]

Although Brittain employs the double perspective primarily to create irony and underline the futility of war, she also uses it to convey a sense of human connectedness and to set the stage for the resurrection from despair in the final section of the book. From time to time Brittain tells us what both Holtby and Catlin were doing before she met them, stressing particularly those times when, unbeknownst to her, they were within range of her own life. She hears the news of the German ships' raid on Scarborough and writes, "But no telepathic vision had shown me . . . the individual with whom my future was to be so closely bound, marching with her fellow-schoolgirls from Queen Margaret's, Scarborough, beneath the falling shells . . . five dark and adventurous years were to pass before I met Winifred Holtby" (p. 112). Catlin appears first as "the young rifleman" at the front, then as a postwar student at New College when Brittain is at Somerville (p. 480). References such as these give the effect of intentionality

and suggest a purposeful universe, in counterbalance to Brittain's increasing loss of faith in a caring God.

In *Testament of Youth* Brittain is constantly aware of the difficulties of the autobiographic act. She recognizes the impossibility of accurately recording a series of events that took place in past time, because of the inevitable distortions of both memory and the simplest linguistic act. So though she writes, "I have tried to write the exact truth as I saw and see it about both myself and other people" (p. 12),[35] a paragraph later she explains, "It is almost impossible to see ourselves and our friends and lovers as we really were seven, fifteen or even twenty years ago" (p. 13). She extends her commentary on this point by quoting Charles Morgan's words in *The Fountain*: " 'In each instant of their lives men die to that instant' " (p. 13).

Brittain's position in the transition from the Victorian to the modern world is reflected in her views of time and of history. Her view of time is essentially modern; she sees it as a continuous present. As Georges Poulet puts it, "To exist . . . is to be one's present, and also to be one's past and one's recollections."[36] Brittain comments at the end of *Testament of Youth,* "I was linked with the past that I had yielded up, inextricably and for ever" (pp. 660–61). Her view of history is, however, less modern. Burton Pike maintains that, unlike the nineteenth-century autobiographer who saw history as "the ideal external support for his individual problems with time and identity,"[37] the modern autobiographer "had lost the context of history as an external support for the transcendence of time."[38] Supporting Pike's view, Paul Fussell claims that World War I was the last to be seen as taking place "within a seamless, purposeful 'history.' "[39] Brittain rejects a modern perception of self based entirely on inner reality and still sees herself as "a whole personality . . . standing in a firm relationship to a whole culture."[40] In this she is more a product of her birth in the nineteenth century than of her education in the twentieth.

The skillful crafting of *Testament of Youth* is obvious from its opening pages. While briefly providing the usual information about her parents and their families, Brittain sounds the notes of her two dominant motifs. The first is that of death in war, described from the woman's perspective, as it will be throughout *Testament of Youth,* as a failure to return. When Brittain was four

years old, her uncle Frank died in the Boer War. In her description of this event Brittain sets the pattern that becomes increasingly powerful as the book progresses. As a child, noticing the banners flying in her hometown to celebrate the relief of Ladysmith, Brittain is told that her uncle Frank will be coming home. "But," Brittain comments, "Uncle Frank . . . never came home after all, for he died of enteric in Ladysmith half an hour before the relief of the town" (p. 22). The ironic connection between celebration and death is repeated fifteen years later when Brittain, celebrating Christmas in eager anticipation of Roland Leighton's return on leave, learns of his death. Brittain artfully reverses the pattern at the end of *Testament of Youth*. She emphasizes the possibility of recovery from grief not only by continuing the autobiography beyond 1918 into the period of her friendship with Holtby and engagement to Catlin, but by ending the book with a joyful reunion with Catlin at a railway station, scene of so many final partings with those who failed to return.

The second motif is the interplay of the personal and the public that Brittain establishes in the first sentence: "When the Great War broke out, it came to me not as a superlative tragedy, but as an interruption of the most exasperating kind to my personal plans" (p. 17). The irony of this opening, which at first seems merely an echo of Holtby's comment about the war interrupting the tennis match, lies in its much more tragic implications for Brittain's future and for the future of her generation. The self-absorbed adolescent, who must learn that the world is larger than the tennis court at Buxton, learns it through the cruelest and most definitive interruption to her personal plans—the deaths of her lover and her brother in the First World War. Brittain draws on her reader's awareness of the terrible significance of this war to establish from the first sentence "the ex post facto view of an action that," as Fussell points out, alone "generates coherence or makes irony possible."[41]

An examination of the changes Brittain made from *Chronicle of Youth* to *Testament,* from diaries to autobiography, reveals the crafting of *Testament* most clearly. The philosophical ambivalences of *Chronicle* become an argument in *Testament*. It is an argument against war, an "indictment of a civilisation" (p. 12) that educated its young men in the false heroics of militarism and tried to keep its young women ignorant. It is an argument for the

feminization of a culture, for a different definition of courage. The flesh on the skeleton of this argument is a classic love story.

The Brittain of *Chronicle* is at first enthusiastic about the war. She criticizes her father for not seeing her brother Edward's enlistment as "spiritual and noble and selfless,"[42] and she finds the activity the war generates for women a positive by-product: "If the war had come two years ago I should have been almost grateful to it for providing my unoccupied and unprofitable hours with employment."[43] By 1915, when Roland is at the front, she is inconsistent about it, sometimes within one diary entry. On April 15 she writes, "If only I could share those experiences with him I should glory in them" and a few sentences later, "It is too terrible—this reckless waste of life, the only thing worth having in the universe."[44] Recognizing her own ambivalence, she writes on April 25, "I wonder if . . . he would agree with my non-militarism now. I am not sure that I agree with myself in all I said to him."[45] After Roland's death, Brittain is anxious to know its circumstances, partly out of a strong desire to prove that his life was not "needlessly and recklessly thrown away."[46]

Lynne Layton comments on Brittain's ambivalence about the war: "The tension between her horror at wasted lives and her need for a noble cause lasted throughout the war."[47] She points out rightly that Brittain's letters reveal this ambivalence even more clearly than *Chronicle*. She quotes from Brittain's unpublished letters to Roland Leighton: "'Certainly war seems to bring out all that is noble in human nature, but against that you can say that it brings out all that is barbarous too!'"[48] Layton remarks on Brittain's emulation of Roland's military discourse, an echo of her desire to participate in the conditions of his life in the army. Brittain took up nursing because it was "the least safe thing that women could do,"[49] yet claimed, "'I do condemn war in theory most strongly.'"[50]

Brittain is similarly ambivalent about women's issues in *Chronicle*. She praises the feminism of Tolstoy's *The Kreutzer Sonata*, shares Olive Schreiner's feminist views with Roland, and goes to suffrage meetings at Oxford. But the feminism of the diaries is limited, insofar as it touches her own choices, to a desire for male privileges. She resents her father's assumption that Edward will go to Oxford while she must wait at home until marriage. Her desire to play a masculine role is stated directly in a letter to her

brother at the front: she wishes " 'desperately that I were a man and could train myself to play that Great Game with Death.' "[51] *Chronicle* suggests her dislike for the company of her own sex. She refers to "cackling women" at a first-aid class,[52] and comments, "I never loved my fellow-men—or fellow-women, rather, for I like most men."[53] She disapproves of the "disregard of dress" of women lecturers, yet is fascinated by Miss Lorimer and finds at least one of her fellow students "absolutely charming."[54] Most significantly, the theoretical understanding of *Testament* is completely absent from the diaries. As one might expect, the younger Brittain makes no connections between the education and social conditioning of men and women and the militarism of the culture.

Brittain did not become an absolute pacifist, that is, one who believes that war is never justifiable, until 1936, through her meeting with Canon Dick Sheppard, leader of the Peace Pledge Union. By 1933, however, she was well on the road to feminist pacifism, and *Testament of Youth* argues for that position. *Testament* transforms the material of *Chronicle,* drawing the connections between the education of boys and girls and the tendency toward war. It does so by telling Brittain's own personal story, reading it selectively, with all the advantages of hindsight, as a development toward feminist pacifism. In the process Brittain's individual story becomes the story of her generation, and the personal is rewritten as the public. Appropriately, it was to be this autobiography, which is so deeply concerned in a variety of different ways with the interrelation of personal and public, that finally gave Brittain the established place in the public world she had sought for so long.

Brittain's description of her childhood in an English provincial town in the years before the war highlights both its thoughtless insularity and its fragility as the double perspective is brought to bear on her experience. "Our condemned generation" (p. 27), she writes, were "easy victims . . . with our naive, uninformed generosities and enthusiasms, for the war propagandist" (p. 49). But the boys were naive in a different way from the girls, as Brittain makes clear in the contrast between her own upbringing and Edward's. The aim of girls' education was to keep them confined both physically and mentally and, of course, sexually ignorant. Brittain is "seized with an angry resentment" (p. 34)

at the memory of the restrictive clothing she was forced to wear even for sports. She talks about her own vagueness with regard to "the precise nature of the sexual act" (p. 48) and links this ignorance to the degree of psychological shock the war caused her contemporaries: "The annihilating future Armaggedon . . . could not possibly, I think, cause the Bright Young People of to-day, with their imperturbable realism, their casual, intimate knowledge of sexual facts . . . one-tenth of the physical and psychological shock that The Great War caused to the Modern Girl of 1914" (p. 45). In retrospect she sees that female education was intended to direct all female energy toward marriage and resents the assumption that "the acquisition of a brilliant husband" (p. 35) should have been seen as the only way for her to achieve her intellectual ambitions.

Brittain traces the origins of her feminism to her unusual good fortune at having a history teacher, Miss Heath Jones, "who from my knowledge of her temperament I now suspect to have been . . . an ardent though always discreet feminist" (p. 38). Atypically for the period, Miss Heath Jones acquainted her students with contemporary events, even allowing them to read cuttings from newspapers. "We were never, of course," Brittain adds, "allowed to have the papers themselves—our innocent eyes might have strayed from foreign affairs to the evidence being taken by the Royal Commission on Marriage and Divorce or the Report of the International Paris Conference for the suppression of the White Slave Traffic" (p. 39). Miss Heath Jones took some of the more senior girls to a suffrage meeting and lent Brittain Olive Schreiner's *Woman and Labour,* a book that was to have a strong influence upon her. Despite its lack of academic rigor, which she later condemned, Brittain presents St. Monica's in retrospect as providing an environment that fostered her feminism. "Thus it was in St. Monica's garden," she concludes, ". . . that I first visualized in rapt childish ecstasy a world in which women would no longer be the second-rate, unimportant creatures that they were now considered, but the equal and respected companions of men" (p. 41). Although Brittain clearly did benefit from such feminist influences as Miss Heath Jones, in stressing her own feminist development she perhaps tends to underestimate the extent to which she was also negatively affected by her education.

Her attitude toward marriage and her guilt about her own ambitions appear to have been harder to change than she admits.

She is far more consistent in *Testament of Youth* in her analysis of the problems with boys' education. Brittain crafts the Uppingham Speech Day scene very skillfully, deliberately altering passages from the diary to emphasize the weaknesses in public school education for boys and its links with militarism. It is one of a small number of scenes in the book that are made to carry the full weight of both Brittain's emotional intensity and her pacifist feminist philosophy.

In *Chronicle* Brittain expresses her envy of Edward's opportunities, in particular of his education at Uppingham: "For girls—as yet—there is nothing equivalent to public school for boys—these fine traditions and unwritten laws that turn out so many splendid characters have been withheld from them—to their detriment."[55] The diary description of Uppingham Speech Day in 1914 depicts "the fine sight" made by the boys in the Officer Training Corps as they are inspected by the headmaster, Dr. Mackenzie, who is, "in spite of his contempt for women, a splendid man."[56]

As the Uppingham Speech Day scene develops in *Testament of Youth,* Brittain moves backward and forward in time, her older self with her later knowledge recalling "the one perfect summer idyll that I ever experienced, as well as my last care-free entertainment before the Flood" (p. 91). The summer of 1914 was in actuality, as Fussell says, "warm and sunny, eminently pastoral." But it has also become a literary trope, assuming "the status of a permanent symbol for anything innocently but irrevocably lost."[57] So Brittain, who had "thought that spring must last for evermore," wonders whether she "ever shall recapture, once again, / The mood of that May morning, long ago."[58]

The Speech Day scene begins with a comment about loss: what she remembers of the school no longer exists because Edward's house has been replaced by the Uppingham War Memorial. Thus Brittain immediately suggests the tragic waste of all she is about to describe, a generation of boys just about to begin their lives, her own dawning love affair with Roland, the friendship between Roland, Edward, and Victor. These three young men march into the scene in the uniform of the Officer Training Corps, but al-

though she describes them as impressive, Brittain pays more attention to the ignorance of those watching: "I do not believe that any of the gaily clad visitors . . . in the least realized how close at hand was the fate for which it had prepared itself, or how many of those deep and strangely thrilling boys' voices were to be silent in death before another Speech Day" (p. 87). Drawing on the convention of the flawed pastoral that is so characteristic of World War I literature, Brittain believes that "an ominous stillness, an atmosphere of brooding expectation, must surely have hung about the sunlit flower gardens and the shining green fields" (p. 87).

The headmaster's speech to the audience is used in *Testament* as the occasion to point out the link between militarism and antifeminism. Although she tactfully avoids calling Dr. Mackenzie a "woman-hater," as she does in the diary, Brittain comments on the behavior of those men "who tended to regard women as 'irrelevant'" (p. 87) and points out the danger of inculcating "hatred and fear" (p. 88) of women in impressionable adolescents. The example of many schoolmasters who "appear to regard contempt for the female sex as a necessary part of their educational equipment" (p. 88) may, Brittain suggests, be a cause of male homosexuality. With this preamble she describes the headmaster's speech, which ends with a list of precepts for boys laid down by a Japanese general. "I shall always, however, remember," she writes, "the final prophetic precept, and the breathless silence which followed the Headmaster's slow religious emphasis upon the words: 'If a man cannot be useful to his country, he is better dead'" (pp. 88–89). So Brittain links "militaristic heroism unimpaired by the dampening exercise of reason" (p. 100) to a contempt for women. Brittain is, of course, not alone in making these connections. In his chapter "Soldier Boys," Fussell links public school education for boys with homoeroticism and militarism and, though he does not use the word, with antifeminism.[59] And in *Goodbye to All That* Robert Graves writes, "'In English preparatory and public schools romance is necessarily homosexual. The opposite sex is despised and hated, treated as something obscene.'"[60]

In the paragraphs that follow Brittain suggests both female participation in public life and internationalism as alternatives to male militarism. She mentions successful women: Roland's

mother, who was not present because she was finishing a book, and Rebecca West, whose husband, Henry Maxwell Andrews, was an alumnus of Uppingham. It is Andrews whom Brittain uses to introduce the concept of generous internationalism that eventually became one of her strongest arguments against war. In its respect for the equality of all people regardless of nationality, this concept of internationalism is equivalent to feminism as Brittain and Holtby defined it: the equality of men and women. Henry Andrews, Brittain tells us, was in Germany when the war broke out and was interned for four years. This "developed in him a measure of kindness and tolerant wisdom considerably beyond the standards of the average Englishman" (p. 89).

The Uppingham Speech Day scene continues with a picture of Brittain in her rose-trimmed hat discussing Olive Schreiner with Roland in the rose garden, which, despite the fact that Roland is doing the explaining and Brittain the listening, suggests the possibility of that serious equal companionship between heterosexual lovers that was part of Brittain's vision of the future. Brittain follows this immediately with a remembered conversation with Victor about the Speech Day that took place after Roland's death. Victor had accused Roland of loving Vera Brittain and Roland had denied it. Victor had made Roland promise to meet him on " 'Speech Day 1924 and see who is right' " (p. 90). Our knowledge that, though Victor is right about Roland's feelings, neither will be alive by 1924 colors our response to this conversation and renders ironic the sadness of the typical school-leaving good-byes that end the scene. Edward is depressed at the prospect of attending a different Oxford college from his friends, Brittain at saying goodbye to Roland. We are aware that these farewells will soon be more final than any of them can know.

The skillful crafting of *Testament* is obvious once again in the ending to the chapter in which the Speech Day scene appears. Brittain gives a brief account of taking the Oxford senior exam, a minor prerequisite for accepting the scholarship she has won to attend Somerville. The exam is taken at Leek Technical School, "not a heroic setting for the final stage of my prolonged battle" (p. 92). She describes herself as "surrounded by rough-looking and distinctly odiferous sixteen-year-olds of both sexes" (p. 92). Despite the elitist tone of this comment, Brittain's aim is clearly to contrast the distinctly privileged atmosphere of the boys' public

school with the struggle for education still necessary for most women and for the working class. It is a contrast reminiscent of the two meals Woolf describes in *A Room of One's Own* to emphasize the difference between life at men's and women's colleges. Brittain is also foreshadowing the way she will eventually overcome the despair caused by the losses of the war, through a friendship with Holtby formed at Oxford and through the exercise of her own talents. So the conclusion to the chapter, in which war is declared and Brittain's father initially refuses to send her to university even though she has passed the exam, certainly sets the mood for the losses of the war ahead but also offers a message of hope by suggesting her subsequent recovery at Oxford.

The Speech Day scene provides a forceful introduction to the arguments against war that dominate part 2 of *Testament of Youth*. As Brittain carefully selects her responses to the First World War to make this the story of the development of a pacifist, she presents her case to the generation about to start the Second World War. Because her own struggle to reach her 1933 position had not been an easy one, she has an understanding of alternative views and she does not deny their power. Her analysis of the period immediately following the declaration of war, a period that saw the enlistment of Roland and Edward, her engagement to Roland, and her first year at Oxford, reveals an awareness of the attractions of war that make pacifism so difficult. "It is, I think, this glamour, this magic, this incomparable keying up of the spirit in a time of mortal conflict, which constitute the pacifist's real problem," Brittain writes. "The causes of war are always falsely represented; its honour is dishonest and its glory meretricious, but the challenge to spiritual endurance, the intense sharpening of all the senses, the vitalising consciousness of common peril for a common end, remain to allure those boys and girls who have just reached the age when love and friendship and adventure call more persistently than at any later time" (pp. 291–92). Even in 1933 she still believed "that war, while it lasts, does produce heroism to a far greater extent than it brutalises" (p. 370).

Even when doubts about the war began to creep in, Brittain, like many others, constantly rededicated herself to an end she went on trying to believe lofty and ideal. While Roland and Edward were at the front, she found it imperative to believe that they were fighting for something worthwhile. After Roland's

death it became even more important to think that the war was necessary, that he had not died in vain. She wondered whether his death had been "heroism or folly . . . In those days it seemed a matter of life or death to know" (p. 243). Before she could really affirm her pacifism, Brittain had to separate her respect for his courage from idealism about the war itself.

Despite acknowledging her understanding of support for the war, Brittain represents this support in retrospect as entirely mistaken. In *Testament of Youth* there is none of the ambivalence of *Chronicle,* and she stresses her early doubts about the war through carefully selected quotations from her diaries and letters to Roland. A diary entry quoted from 1914 shows her intellectual realization of the horrors of battle. " 'It is impossible,' " she says, " 'to find any satisfaction in the thought of 25,000 slaughtered Germans, left to mutilation and decay' " (p. 97). But, Brittain explains, it took Roland's letters from the front and her own experiences nursing the wounded to bring her to an emotional realization of what was actually meant. Initially her opposition to war was a response to the sheer number of people killed. In a 1916 poem called "A Military Hospital," she talks of "A mass of human wreckage, drifting in / Borne on a blood-red tide."[61] In "The Troop-Train" Brittain describes watching the waving hands of the troops as they went up the line and wonders "How many of those laughing souls / Came down the line again."[62] This emphasis on numbers is echoed in *Testament* as she talks of her horror at a newspaper paragraph stating that by July 1915 the estimate of war casualties was already five million dead and seven million wounded (p. 175). Of the so-called victory at the Battle of Jutland Brittain writes, "The one indisputable fact was that hundreds of young men, many of them midshipmen only just in their teens, had gone down without hope of rescue or understanding of the issues to a cold, anonymous grave" (p. 271). This statement is typical of Brittain also in its stress on the waste of young lives, a motif that understandably occurs most frequently when she talks of Roland. She quotes from her diary: " 'When I think how suddenly, instantly, a chance bullet may put an end to that brilliant life, may cut it off in its youth and mighty promise, faith in the *increasing purpose* of the ages grows dim' " (p. 142).

Testament of Youth is unrelenting in its description of the physical horrors of dying or being wounded in battle, since this counter-

argument to the notion of "dulce et decorum est pro patria mori" made a major contribution toward changing Brittain's views. The first dressing at which she assists presents her with "a gangrenous leg wound, slimy and green and scarlet, with the bone laid bare," and turns her "sick and faint" (p. 211). Later though, like the other nurses, she will become relatively immune to the obscene horrors that lie waiting for her "beneath each stinking wad of sodden wool and gauze" (p. 410). For the reader, as for Brittain, the most powerful impression of suffering comes not from the description of mutilated human bodies but from the account of the return of Roland's clothes after his death: "I wondered, and I wonder still, why it was thought necessary to return such relics—the tunic torn back and front by the bullet, a khaki vest dark and stiff with blood, and a pair of blood-stained breeches slit open at the top by someone obviously in a violent hurry. Those gruesome rags made me realise, as I had never realised before, all that France really meant" (p. 251). The message of Roland's clothes is clear; Brittain writes to her brother that if he had seen them, he " 'would have been overwhelmed by the horror of war without its glory' " (p. 251). Like such other accounts of the war by women as Enid Bagnold's *A Diary without Dates* (1918) or Helen Zenna Smith's *Stepdaughters of War* (1930), Brittain's contrasts the experience of those who have actually seen the gross mutilations of the wounded in France with the unthinking sentimentality of the war supporters in England. It is a theme that runs through much World War I literature.

Brittain's insistence on stark, graphic language to describe the horrors of battle is an attack both on the British tendency to elevate the idiom of war and on "the presumed inadequacy of language itself to convey the facts about trench warfare."[63] Like Lloyd George she believed that if the war could be adequately described, "people would insist that it be stopped."[64] But like British memoirists male and female, Brittain also employs pastoral conventions to heighten through contrast the sense of those horrors that graphic language alone cannot adequately convey. "Pastoral reference," as Fussell says, "whether to literature or to actual rural localities and objects, is a way of invoking a code to hint by antithesis at the indescribable."[65] Brittain selects quotations from her letters and poetry and from Roland's that make powerful use of this technique. In her first year at Oxford she

writes to Roland that " 'during the calm and beautiful days we have had lately it seems so much more appropriate to imagine that you and Edward are actually here enjoying the Spring than to think that before long you may be in the trenches fighting men you do not really hate' " (p. 127). Similarly, Roland writing from Ypres listens to the artillery bombardment on " 'a glorious morning' " from a hill where " 'we could see the country for miles around' " (p. 148). Brittain remembers the summer term at Oxford as "a tranquil hour spent securely in a sunny garden before setting out on a harsh and dangerous journey" (p. 150). Roland's poetry combines violets and mangled bodies (p. 135); Brittain's joins May mornings, cowslips, and songbirds with " 'individual hell' " and " 'the stricken sod of France' " (p. 269).

This technique works so well in *Testament of Youth* because, like Brittain's autobiography as a whole, it depends for its effect on a double perspective. But it was not a technique she employed only, or even primarily, there. By 1916 it came so naturally to anyone writing about the war, particularly to those steeped through education in English poetry, that it can be found, for example, in some form in almost every poem Brittain wrote. It is particularly prominent in the poems she wrote after Roland's death. She writes in "Perhaps," "And I shall find the white May blossoms sweet, / Though You have passed away";[66] in "Then and Now," "The weeds where once the grasses used to grow / Tell me that you are dead";[67] in "In a Summerhouse," "Little we knew of summer, / Tossed on a flood-tide red. / How could we dream of roses / Who only saw the dead?"[68]

The scene in which Brittain learns of Roland's death, the scene with which she ends part 1, presents the results of war as powerfully as the Uppingham Speech Day scene had presented its causes. It brings together many of Brittain's arguments against war: the horrors of the trenches, the waste of promising young lives, the suffering of waiting women who experience war as their loved ones' failure to return. The scene begins several weeks before Christmas when Brittain is nursing and Roland is expecting to get leave. The section in *Chronicle* that covers this period does not, somewhat surprisingly, focus entirely on the subject of Roland's leave. Brittain talks also of Oxford and its failure to honor women war workers. When she does talk about the leave, she stresses her apprehension that it will not occur. On December 15

she hears rumors that "another big move is impending on the Western Front and that all leave is cancelled."[69] On December 17, after hearing that Roland expects to land on Christmas Day and be home until December 31, she writes "Of course I was wildly thrilled, anxious and in a turmoil, and greatly troubled lest something should happen in the meantime to stop it, as other people's leaves have been stopped."[70]

The scene in *Testament* creates its impact largely by contrasting the unsuspecting and joyful anticipation of Brittain awaiting her lover with his failure to arrive. The knowledge that Roland will die two days before Christmas is in the older narrator and in the reader but not in the younger Brittain, who has none of the apprehensions recorded in *Chronicle*. As readers we have already been told what will happen and are specifically reminded by Brittain's choice to wear the black moiré rose-trimmed hat, the one she was to tear the roses from "in a gesture of impotent despair" (p. 112). The only other note of foreboding is sounded by the quotation from an earlier letter from Roland in which he describes the dreadful conditions in the mud-filled trenches and the accidental deaths of three men. It is the idea of such meaningless loss of life, death in war without even the illusion of heroism, that will soon make Brittain so eager to discover the details of Roland's death.

But when the scene opens, the emphasis is on how well everything seems to be going. The two families are close by, since the Brittains are temporarily in Brighton; Brittain's hospital matron has promised to give her leave to coincide with Roland's; Edward has written to say that he and Victor will be able to get leave at the same time. Since it is Christmas, even the mood on the hospital ward is one of celebration. A fellow nurse teases her for her "irrepressible excitement" and, Brittain writes, "I dared to glorify my days—or rather my nights—by looking forward" (p. 233).

A large part of the scene is devoted to Brittain's speculations on the possibility of marriage during this leave. She prays for a baby, "something of himself to remember him by if he goes" (p. 234). The prayer, of course, will not be granted, and thus Brittain suggests the two great losses of this period: the waste of Roland's life and the lives of any children he might have had; and the loss of her own faith, a theme invoked again later in the scene

when she attends chapel to "thank whatever God might exist for the supreme gift of Roland and the love that had arisen so swiftly between us" (p. 235). As Brittain weeps out of "joy and gratitude," she listens to the words " 'though he were dead, yet shall he live' " (p. 236). It is a moment of bitter irony for, as we know, Roland is already dead.

Brittain communicates the tension of waiting by frequent references to time. She looks back at the previous year, when they were "really both children still" (p. 234), and promises that this reunion will be even better. Christmas Eve slips into Christmas Day and "I could count, perhaps even on my fingers, the hours that must pass before I should see him" (p. 235). It is "eight o'clock," then "ten o'clock at night" (pp. 235–36), and Brittain tries to find reasons why she has not heard from him. The older narrator tells us that Roland's family waited for him till after midnight and, ironically, "drank a toast to the Dead" (p. 236). The message finally comes the next morning, and for all our previous knowledge, the end of the scene has almost the raw immediacy of the diary, whose words Brittain echoes with only slight editing: "Believing that I was at last to hear the voice for which I had waited for twenty-four hours, I dashed joyously into the corridor. But the message was not from Roland but from Clare; it was not to say that he had arrived home that morning but to tell me that he had died of wounds at a Casualty Clearing Station on December 23" (p. 236).

The only argument Brittain uses against war that does not appear in the scene of Roland's death is the case for internationalism. This is probably because that idea developed most strongly in Brittain after Roland's death, when she was nursing wounded German soldiers. She is typical in coming to pacifism through a particular kind of internationalism in which people of both sides in a war are seen as linked in their suffering, their impotence, and their common humanity. In a 1915 poem called "Five Souls" that appeared in the *Nation,* five ordinary soldiers, from Poland, Austria, France, Germany, and Scotland, each end the stories of their deaths with the words, " 'I gave my life for freedom—This I know; / For those who bade me fight had told me so.' "[71] As in this poem, the true enemy is seen to be the anonymous leadership that makes the decisions and that Brittain finds guilty of "the crudest and most elementary failures of intelligence"

(p. 363). Similarly, Virginia Woolf in *Jacob's Room* (1922) had indicted the old men responsible for a war that they would never have to fight. As the title of Charles Yale Harrison's novel about the war puts it, *Generals Die in Bed* (1930).

Brittain's internationalism is founded on her personal experience of contact with the Germans. Nursing a German soldier she thinks, "How ridiculous it was that I should be holding this man's hand in friendship when perhaps, only a week or two earlier, Edward up at Ypres had been doing his best to kill him" (p. 376). She comes to see the "Huns" as "the patient, stoical Germans whom I had nursed in France" (p. 470) rather than as the gigantic, ruthless monsters the war propaganda suggested they were. In a 1917 poem entitled "The German Ward," she writes, "For I learnt that human mercy turns alike to friend or foe / When the darkest hour of all is creeping nigh, / And those who slew our dearest, when their lamps were burning low, / Found help and pity ere they came to die."[72] Brittain deplores the Treaty of Versailles, which reduced the Germans to misery and humiliation, and remembers her thoughts when she toured Europe after the war: "All that expenditure of noble emotion, that laying down of life and youth, of hope and achievement and paternity, in order that German men and women might suffer indignity and loss, that German children might die of starvation, that the conquerors might stride triumphant over the stoical enduring conquered" (p. 644).

Brittain quotes several of the international legends that came out of World War I and adapts others to give them an international significance. She quotes the tale Roland wrote to her in 1915 of the self-congratulatory British soldiers who buried some German soldiers and created a wooden cross inscribed with the words " 'Here lie two gallant German officers.' " Several days later when they advanced into German territory, they found a similar grave and the words " 'Here lie five brave English officers' " (p. 144). Soldiers in the hospital tell her a classic story of seeing their dead comrades fighting side by side with them again. "Angels of Mons still roaming about," she thinks. "Well, let them roam, if it cheers the men to believe in them!" Brittain then adds an international conclusion to this tale: "No doubt the Germans, too, had their Angels of Mons; I have often wondered what happened when the

celestial backers of one Army encountered their angelic opponents in the nocturnal neutrality of No Mans Land" (p. 416).

On the surface *Testament of Youth* argues for a feminist vision as strongly as for a pacifist one. As I suggested earlier, Brittain clearly understood the connections between male education and militarism and believed that equality of experience for men and women in education and professional opportunity would contribute to a softening of those attitudes that lead to war. She celebrates the changes that the war brought for women even while she deplores the war. The free-and-easy movements of female war workers that have already "begun to modify convention" (p. 177) are reflected in her uninterrupted day alone with Roland. When she is first nursing at Camberwell, she finds it "still an adventure to go about London alone" (p. 225) and recognizes that "whatever the disadvantages of my present occupation, I was at least seeing life" (p. 213).

Brittain's own fight to go to Oxford against the initial opposition of her family indicates her belief in women's right to intellectual ambition and satisfaction. Most of her comments on marriage suggest that she has faith in the possibility of such ambition's compatibility with marriage. She quotes a comment from her diary in which she claims she " 'could not endure to be constantly propitiating any man, or to have a large range of subjects on which it was quite impossible to talk to him' " (p. 102), but she finds Roland's "a mind in tune with mine" (p. 103). She contemplates marriage with Catlin as an attempt to demonstrate "that marriage and motherhood need never tame the mind, nor swamp and undermine ability and training, nor trammel and domesticise political perception and social judgment" (p. 654).

Brittain also clearly expresses her recognition of the conflicts for modern women caught between the expectations of two worlds, the prewar world, usually represented by families, and the post-1914 world. Brittain describes one of her cousins being summoned home from canteen work in Boulogne to take care of her parents, and she is later summoned home by her own father when her mother has a breakdown. " 'As your mother and I can no longer manage without you,' " he wrote, " 'it is now your duty to leave France immediately and return to Kensington' " (p. 241). This is a "duty," Brittain realized, that only women

have: "If I were dead, or a male, it would have to be settled without me" (p. 422). The older narrator comments on "the violent clash between family and profession, between 'duty' and ambition, between conscience and achievement, which has always harassed the women now in their thirties and forties" (p. 422).

However, although Brittain is conscious of the conflicting social pressures on the women of her generation, she is not always as conscious of the extent to which she has internalized them.[73] Brittain was an equality feminist; that is, she saw feminism in terms of equal rights for both sexes and she fought hard for women's opportunity to compete on equal terms with men. She did not, as some feminists have, subscribe to the idea of a female ethic that fundamentally challenged not only patriarchal oppression of women but those very values of competition, ambition, and success upon which patriarchy is built. Because Brittain put herself in direct competition with men for their world, her sense of violating the prescribed female role was probably greater than it might otherwise have been. Certainly *Testament of Youth* was written in part to warn another generation against war, but it was also written as the fulfillment of a sacred promise to those "who because they had died too soon would never make books for themselves." The success of the book, Brittain claims, meant less than "the significance of that memorial and its challenge to the spiritual bankruptcy of mankind."[74] Therefore the need to write it, of course, morally transcended any guilt she may have felt for putting her work before a traditional marriage or duty to other people and for surviving when others had died. That she did feel this understandable though quite unnecessary guilt is, I think, suggested by the insistence on her own "normality" and interest in that of other women, which I have remarked upon before, and by the hallucination of growing a beard she experienced after the war.

There is, then, a subtext to *Testament of Youth* that expresses the conflict Brittain still feels between her intellectual ambitions and her femininity, despite overt protestations to the contrary. Nina Auerbach says, Brittain "lives on to become a writer and marry another man, but this guilt-ridden self-mortification dominates the second half of the book . . . Vera Brittain's memoir seems a testament to horrors other than war's."[75] This conflict is first seen in the ambivalences of the diary. Brittain describes Miss

Hayes Robinson, an Oxford don, as "nearer to the ideal type of woman—to the woman we hope the future will bring—than at any rate any [other] don I have ever met."[76] Miss Hayes Robinson's ideal quality lies apparently in leading a life "purely concerned with intellect, without losing any atom of her womanliness and feminine attractiveness, without having her humanness warped or her sympathies blunted."[77] Although she is plain, "as most dons seem to be," "she is very far from sharing the donnish disregard of dress."[78] She might have been "an excellent wife and really the ideal and equal companion of some brilliant man."[79] In seeing Miss Hayes Robinson as an exception, Brittain expresses a typically nineteenth-century view of female intellectual endeavor as antithetical to truly feminine characteristics. It is not far from the notion that women who use their minds will have problems using their wombs. She is still close to this view in *Testament* when, in her description of her desire to bear Roland's child, she writes, "Before that time I had always been too ambitious, too much interested in too many projects, to become acutely conscious of a maternal instinct" (p. 233).

In *Testament of Youth* Brittain stresses her own femininity as traditionally defined, her interest in clothes, her "normal" heterosexual impulses. The momentary "inexplicable repulsion" she feels toward Roland on the trip to Oxford and records in her diary[80] does not appear in *Testament*. Any suggestion of being physically drawn to women is also omitted from *Testament*. There is no equivalent to her comment in the diary that her interest in Miss Lorimer "deepens and grows keener every day,"[81] nor to the passage that describes Miss Rose: "I was so possessed by Miss Rose's beauty tonight that I was simply impelled to look in her direction and nothing seemed at all attractive to me in comparison. Nothing draws me like beauty; it exercises an almost immoral influence—especially when she got up to speak and her tall figure and rather deep gracious voice enhanced the effect of her face's loveliness."[82] By contrast, in *Testament of Youth* Brittain describes her first reaction to Holtby's tall figure, golden hair, and vitality as envy (p. 487).

I am not trying to estimate here what Brittain felt sexually, only to suggest that she takes great care not to be considered anything but "truly feminine," that is, heterosexual. In the years between the diary entries and *Testament of Youth*, not only Brittain

but a whole generation had taken several giant steps toward sexual sophistication, and it was no longer possible for a woman to make innocent comments about the attractions of her own sex. The postwar sections of *Testament* indicate most clearly that Brittain had accepted the contemporary Freudian attitudes to sexuality. As Hilary Bailey puts it, "Vera had some faith in the theory that marriage was essential and celibacy highly deleterious to women."[83] Bailey argues that the idea that without sexual and maternal fulfillment women could become deranged was particularly convenient to a society trying to reclaim male jobs from women who had been doing them for four years. "There had to be a reason why women, and particularly the women most willing and available for work, were not really qualified to do it. The 'frustrated spinster' argument was the answer."[84] Brittain seems unaware that in talking of the "neuroses" (p. 332) that result from living only with women or "the biological needs" (p. 499) that drove her into a brief postwar engagement at Oxford, she is approving the very attitudes being used to frustrate her own ambitions.

The first result of the conflict in Brittain between the desire to work and society's expectations for women is her decision to leave Oxford after her first year and become a volunteer nurse with the VADs. The reasons she gives are both patriotic and personal: she wants to do something more obviously useful than read books in a time of national crisis; she most particularly wants to do something to help Roland. But it is obvious too that the service ideal represented by nursing, especially in wartime, is a socially approved activity for women and therefore a more comfortable way to exercise the energy she has previously put into intellectual pursuits. Interestingly, since this choice can be read as a temporary return to the mother's values, Brittain expresses her feelings about the choice through a description of her mother's reaction to it: "My mother co-operated willingly in these schemes, for she was sorry for me, and kind. She perhaps found love, even for a suitor whose brains were his capital, a more comprehensible emotion than harsh and baffling ambition" (p. 146). For a while nursing provides a solution to the conflict in Brittain, but the conflict reasserts itself once the war is over in a minor breakdown that Brittain describes but does not fully analyze.

The breakdown took the form of hallucinations made all the

more painful, no doubt, for being endured in secret. "I was ashamed to the point of agony," she writes, "of the sinister transformation which seemed, every time I looked in the glass, to be impending in my face, and I could not bring myself to mention it even to Winifred, who would probably have dispelled the illusion by a sane reassurance that I was neither developing a beard nor turning into a witch. Nothing has ever made me realise more clearly the thinness of the barrier between normality and insanity than the persistent growth, like an obscene, overshadowing fungus of these dark hallucinations throughout 1920" (pp. 496–97).

Since she had survived the deaths of Roland, Edward, his two closest male friends, and the countless other wounded men she had nursed, Brittain's postwar reaction is hardly surprising. What would now be recognized as survivors' guilt took a significant form, though. On the simplest level the incipient beard on her face was a growth that should not be there. Seeing no reason for her continued life when so many had died—"'Why couldn't I have died in the War with the others?'" (p. 490)—she describes the beard as a "persistent . . . obscene . . . fungus," that is, as the inappropriate growth she now felt herself to be.

The first appearance of the hallucination, after leaving a summer school course at Girton College, Cambridge, suggests these connections. Brittain had arranged to meet a friend, Nina, at Girton to study Italian history and art because she wished to learn more about the country for which she "thought of Edward . . . as having died" (p. 483). When she arrives at Girton, she receives a message that Nina is ill and cannot come. Disliking the "shrill, garrulous crowd" (p. 484) at Girton, Brittain escapes to the home of two women friends who live nearby. When a letter comes to say Nina is dead, Brittain flings herself into tennis parties. "I was sick beyond description," she writes, "of death and loss" (p. 484). One evening before she leaves, Brittain "thought, with a sense of uncommunicable horror, that I detected in my face the signs of some sinister and peculiar change. A dark shadow seemed to lie across my chin; was I beginning to grow a beard, like a witch" (p. 484)?

The most obvious reading of a woman's imagining she had a beard would surely be that the beard symbolized the male role, and indeed, that reading works well here, since Brittain was in conflict over her adoption of a traditionally male life. Not only

were her intellectual opportunities and professional ambitions un-feminine but they were also, in her guilty imagination, stolen from Roland and Edward and those other men no longer there to compete.[85] Was she denying her femininity in seizing her op-portunities? Was her beard the outward sign of some inner per-version? The stress of war, the need to bury the dead in order to survive, her whole training as a woman in that society, were conducive to those anxieties.

What is perhaps equally significant, though, is the fact that Brittain does not wonder whether she is growing a beard like a man, surely the most obvious conclusion, but three times con-nects the beard with witches. Is she trying, probably subcon-sciously even in 1933, to avoid any implications of mannishness in herself and thus selecting the one explanation, however bizarre, that would explain the beard but leave her female? And to what extent, if any, is the need to avoid the obvious explanation rein-forced by her friendship with Holtby, the beginnings of which are described on the same pages of *Testament of Youth* as the ac-count of her breakdown?[86] Interestingly, Brittain attributes the cure, not the cause, of her hallucinations to the satisfaction of her literary and political ambitions and to her friendship with Holtby, claiming that "*Oxford Poetry, 1920*, and the objective, triumphant struggle for women's degrees were probably, together with Winifred's eager and patient understanding, jointly responsible" (p. 500) for the fact that her hallucinations did not completely destroy her.

In some ways *Testament of Youth* ends with the armistice. The suspense and the interest provided by public events do not extend beyond Edward's death five months before the war ended. Brit-tain ends part 2 with a description of herself walking alone in "cold dismay" (p. 462) through the cheering crowds of Whitehall celebrating Armistice Day. She writes, "Everything that had hith-erto made up my life had vanished with Edward and Roland, with Victor and Geoffrey. The War was over; a new age was beginning; but the dead were dead and would never return" (p. 463). However, Brittain does not end here but goes on to tell the story of her return to Oxford, friendship with Holtby, and engagement to Catlin. She wanted the book to leave a message of hope, to describe what in fact it was to be the instrument of achieving, many years later: "a return to life from the abyss of

emotional death."[87] So part 3 is necessary. It is necessary also to provide an apparent resolution of the subtext, the conflict in Brittain between ambition and her idea of femininity.,

The surface text of part 3 is the story of coming to terms with the deaths of Roland, Edward, Victor, and Geoffrey. It culminates in a visit to the graves in France and Italy with Holtby. The pastoral imagery, used earlier to heighten the sense of war's devastation, is now used partly as a symbol of hope. She puts rosebuds and a small asparagus fern on Edward's grave; as she leaves, a small child, himself a pledge to the future, hands her "a bunch of scabious and white clover that he had picked by the roadside" (p. 527). Yet the old uses of the pastoral remain to haunt her. It seems a "strange irony" that Roland, "the impetuous warrior," should sleep "calmly in this peaceful complacent earth with its suave covering of velvet lawn" (p. 533) and that the graves should resemble flower beds. Brittain and Holtby recognize "that for us no beauty of spring flowers could blind us to the tears of the bereaved, no song of melodious birds extinguish the heartbroken mourning of the conquered" (p. 568). It will in the end take the writing of *Testament of Youth* for Brittain to come to terms with the tears of the bereaved.

Testament is less successful in resolving the other conflict in Brittain, although structurally it gives the appearance of doing so. The independent life of personal achievement is now within reach. Oxford provides Brittain with models of female success among her peers—Dorothy Sayers, Hilda Reid, Rebecca West, Margaret Kennedy—and their names echo throughout part 3 as she describes her new life in London with Holtby. Brittain's choice of this way of living is justified through the views of her parents: "They understood now that freedom, however uncomfortable, and self-support, however hard to achieve, were the only conditions in which a feminist of the War generation—and, indeed, a post-Victorian woman of any generation—could do her work and maintain self-respect" (p. 536).

It is her parents, too, who are used to express the other side of Brittain's conflict: "I was clearly enough aware that parents brought up in the nineteenth-century tradition would have preferred, not unnaturally, a happily married daughter producing grandchildren to a none-too-triumphant Oxford graduate floundering unsuccessfully" (p. 545). While Brittain repudiates any

suggestion that marriage should be a goal for women, she is nevertheless very concerned with it as a topic in part 3. The arrival of Catlin can certainly be read as an opportunity to prove herself clearly heterosexual, feminine, and fruitful while retaining her right to her own work. Brittain quotes long passages from Catlin's and her own letters "discussing how best I could combine writing and political work with temporary residence in America and the production of a family" (p. 653). He promises her " 'as free a marriage as it lies in the power of a man to offer a woman' " (p. 652). Her choice to marry Catlin and, effectively, to abandon the relationship with Holtby is surely, at least in part, motivated by a strong need to reconcile the conflict between ambition and the desire to prove herself feminine by asserting her heterosexuality. The speed with which she makes the decision and the language in which she describes the reasons for it both suggest this. It is an attempt " 'to solve the problem' " (p. 653) or an "attempt to prove" (p. 653).

The conflict is that of the older narrator as well as that of the young woman of 1925. As *Testament of Experience* tells us, marriage to Catlin did not resolve it any more than it had laid to rest the ghosts of the past. Independent work and marriage were not to be as easily combined as Brittain had hoped, and the friendship with Holtby was much more necessary to her self-fulfillment than she had known. In 1933 she is still refuting rumors about the household that combines both Catlin and Holtby and still has not completely resolved her old conflict. *Testament of Youth* is an attempt to do so. Brittain reverses or repairs the events of the past. She gives lectures instead of listening to them; Roland Leighton is replaced by Catlin and she even plans to marry him carrying roses like the ones Roland had given her; reunions at train stations replace final farewells. But the sense of closure is merely apparent; *Testament of Youth*, powerful statement though it is, only superficially resolves its tensions.

Between the acceptance of *Testament of Youth* by Victor Gollancz early in 1933 and its publication on August 28, Brittain again visited the war graves in France with Holtby, perhaps, as Bailey suggests, "feeling the relief of someone who, at last, has paid their tribute in the only way they could; perhaps, also, to see if the ghosts had been finally exorcised."[88] The response to *Testament* was overwhelming. The third printing was sold out in three

weeks and by 1939 120,000 copies had been sold. The positive reviews were numerous, the negative few and far between. Brittain wrote in her diary the week after publication, "Never did I imagine that the *Testament* would inspire such great praise at such length."[89] The fan mail poured in, along with the offers of work that included a marathon three-month lecture tour of the United States the following year. Originally offered to both Brittain and Holtby, who turned it down because of her health, the tour involved "forty-one lectures, two broadcasts, and an incalculable quantity of flowers, flattery, invitations, and applause."[90] Brittain had her place in the public world at last.

The one negative reaction to *Testament of Youth,* one that had the power to sour her happiness, was Catlin's. Although in his own autobiography he calls it "perhaps the great book of woman's experience in the First World War,"[91] and condemns the "sheer malice"[92] of those who suggested he must be jealous of his wife's success, his private reaction was a good deal less positive. Brittain herself remarks on his fear, after reading about Roland, that she could never love him. But an unpublished letter from Holtby to Catlin in April of 1933, now in the McMaster collection, makes it clear that it was the final section of the book he objected to most strongly. Condemning the last chapter of the manuscript as a publicity stunt, he apparently found certain sections both " 'intolerable' " and " 'horrible.' " Since it is surely as hard for any reader as it was for Holtby to see how Catlin could consider the book damaging or even embarrassing to his reputation, the reasons for his reaction may perhaps have been more complex than those he apparently gave. Holtby in her own way calls *Testament* publicity also, telling Catlin in this letter that Brittain saw it as "the justification for her way of life," "her life's vindication." On some level perhaps Catlin recognized the unresolved tensions of *Testament* and felt used as a careful brushstroke in Brittain's portrait of herself.

Holtby's reading of *Testament of Youth* can be seen in two short works she wrote between 1934 and 1935 when she was already racing against time to write the novel that was to make her name. The first of these is a play, *Take Back Your Freedom,* written in 1934 and later published with revisions by Norman Ginsbury in 1939, the only play of Holtby's to see print. A play about a dictator, Arnold Clayton, who founds the British Planning party,

Take Back Your Freedom examines and attacks the sort of fascism Holtby could see rapidly gaining strength in Europe. Whereas Brittain's *Testament* argues against war by examining the past, Holtby's play does so by hypothesizing a future, but both works are in fundamental agreement over its causes.

Like Brittain, Holtby condemns the values of the public schools where her protagonist, Clayton, learned to worship his sports hero friend Dick Lawrence and ever since has been "trying to force himself into the position of a man of action just to show he's not afraid."[93] Clayton is presented as his mother's pawn and himself quotes a psychologist who claims that "the urge to power is a symptom of belated adolescence usually associated with homosexuality and the mother fixation."[94] Like Brittain seeing male education as the root cause of the repression of women, Holtby excuses Clayton's mother by making it clear that her desire to succeed through her son was the result of a world in which "we take away clever women from their work."[95] Mrs. Clayton also saves the country in the end by shooting her son. This kind of violence is echoed in the woman who tries to kill Clayton because she has "a crippled, ineffective life."[96] Free love is advocated in the new society. "We can be free as animals now, all night and day," says the woman. "But we wanted to be free as human beings."[97] *Take Back Your Freedom*, like *Testament of Youth,* advocates the necessity for the respect of individuals and of their right to make their own choices. When society forgets this, say both Holtby and Brittain, the result is a willingness to sacrifice human lives in war.

Holtby's second response to *Testament of Youth,* and the more interesting one, took the form of a short but very cogent and mature book entitled *Women and a Changing Civilisation* (1934). She had been invited by John Lane to contribute this volume to his Twentieth Century Library series and, despite her involvement with writing *South Riding,* accepted the assignment. She felt that "the subject was so important that . . . she must not refuse lest the task should fall into the wrong hands."[98] Brittain's brief account of the book in *Testament of Friendship* describes it as a history of women's position in the world that stresses "the triumphant climax of the woman's movement on its political side in the decade following the War, and faces the new threat to freedom made by the economic slump and the anti-feminist doctrines

of the totalitarian states."[99] Brittain devotes one paragraph out of two to Holtby's comments on women's right to work. In other words, Brittain points out Holtby's interest in the topics she herself considered of most importance. There are also many other views Holtby expresses that she and Holtby shared. She confirms much of Brittain's thinking on the subject of marriage and motherhood, arguing that women who have the opportunity to work in fact make better wives and mothers. She agrees with her too on the connection between war and the exclusion of women from public life.

But the strength of *Women and a Changing Civilisation* lies in the subtlety of Holtby's analysis of the problems she describes, and this analysis leads her to emphasize some issues that Brittain rarely deals with. She sees the dangers of chivalry that claims to elevate women's position; she traces the roots of the separation of women's intellect from biological function to convent life; she recognizes the subtle influence on children of observing that God, policemen, engine drivers, and politicians are men; she argues that racism and antifeminism spring from the same fear and that "the fear of the thing we think to be inferior, the fear of the master for the slave, is a fear which scars the soul."[100] The connection among all these issues, Holtby makes clear, is a refusal to recognize "individuals as individuals, not primarily as members of this or that race, sex and status."[101]

Of course, Brittain agrees with this principle and, as in *Testament of Youth,* uses it to argue against the mass hysteria of war propaganda. But, as Holtby points out in *Women and a Changing Civilisation,* no one applies the principle to sexuality who sees only one choice for women as "normal" and by implication right. "We do not know how much of what we usually describe as 'feminine characteristics' are really 'masculine,' and how much 'masculinity' is common to both sexes," writes Holtby. "We do not even know . . . whether the 'normal' sexual relationship is homo- or bi- or hetero-sexual." Holtby's demand is for the "richness of variety," a refusal "to reduce all men and women to the same dull pattern."[102] This strong plea for sexual tolerance is given a prominent place at the very end of her book and is clearly of great importance to Holtby, perhaps in part because she saw Brittain's continuing tensions on the subject in *Testament.*

In retrospect, however, it is hard not to see the most significant

statement of Holtby's book as her comments on the need to "be free from the domination of the body." Acutely aware now of the betrayal of her own body, she argues powerfully that women must not be seen nor see themselves as merely bodily creatures. "Freedom," she reminds us, "is not only a question of law; it is a habit of the mind . . . Only when physical needs, feelings, actions and preoccupations become less important and less significant than intellectual and spiritual life, does the individual really escape from the 'body of this death' which is mortality."[103]

Chapter 5

"We are members one of another"

South Riding and *Honourable Estate*

First novels are supposedly autobiographical, but it is less frequently noted that novels of maturity are often a reworking of the same experiences, a reconciliation with the past, albeit in a less obvious form. Just as psychological maturity lies in an understanding and acceptance of self, which often comes about through an examination of one's past, so literary maturity may involve a rereading and reworking of one's own earlier material. This was certainly true for Holtby and Brittain and for their finest works, *South Riding* and *Honourable Estate*. Although still part of a conversation with each other, these novels are also works in which the authors engage their earlier immature selves.

For Brittain and Holtby, as I suspect is often true for women writers, reconciliation involved coming to terms with, a sort of reclaiming of, their mothers. Rachel Blau DuPlessis explores this motif within modern *kunstlerromane* by women writers and relates it to "a specific biographical drama": "Such a novel is engaged with a maternal figure and, on a biographical level, is often compensatory for her losses . . . The daughter becomes an artist to extend, reveal, and elaborate her mother's often thwarted talents . . . In these works, the female artist is given a way of looping back and reenacting childhood ties, to achieve not the culturally approved ending in heterosexual romance, but rather the reparenting necessary to her second birth as an artist."[1] Both *South Riding* and *Honourable Estate* have reconciliation as a theme and

both provide reconciliation for Holtby and Brittain with mothers or substitute mothers. This reconciliation involves, although in a different form, a reclaiming of some of the traditional values of the mother, values that they previously rejected in the name of independence. It also involves a vindication of the mother's life and work. In order to achieve this, the female protagonist, like Brittain and Holtby themselves, has "to try to change the life in which she is also immersed."[2] In *South Riding* Holtby witnesses to her own mother's life as her protagonist, Sarah Burton, comes to appreciate the values of Mrs. Beddows, a character based on Alice Holtby. In *Honourable Estate* Brittain vindicates a substitute mother, Janet Rutherston, a frustrated feminist and lesbian, modeled on Catlin's mother.

Brittain's comments on *South Riding* speak directly about its place in Holtby's development. She calls it the "first typical work" of Holtby's maturity and points out that "when compared to her first novel, *Anderby Wold,* it gives the uncanny appearance of completion to her literary cycle."[3] "Winifred wrote her autobiography in *South Riding*," Brittain claims, "as clearly as she had once written it in *Anderby Wold,* and far more profoundly."[4] Comparing Holtby's first and last novels, Brittain also addresses the issue of reconciliation: "As Winifred herself grew older, she realized that memory and tradition become dearer with time; the fight against them is over and won, and the conqueror can perceive with detached eyes the virtues which were invisible to the fervent belligerent."[5]

South Riding took shape in Holtby's mind as she nursed her dying father in early 1933. " 'I've got a new novel all bubbling and boiling in my head. It's all about local government and aldermen and county councillors—a romance!' "[6] *Testament of Youth* had just been accepted for publication, and as Holtby shared Brittain's jubilation at "the long-delayed reward,"[7] she must have known that she was unlikely to live to see her own. She had already lived longer than her doctors had predicted, and although this allowed her to tell Brittain she had outwitted them, she realized that the completion of *South Riding* was a race against time. The novel was published in March of 1936, six months after her death.

Lady Rhondda wrote to Brittain early in 1936 that Holtby's work for the past few years must have been full of references to

her own death " 'if one had the key,' " to which Brittain added, "and this is truer of Winifred's last novel than of anything else she wrote."[8] As Brittain points out, many of the characters in *South Riding* have suffered disease and premature death: Robert Carne has angina; his wife is permanently insane and he fears the same tragedy for his daughter; Joe Astell could die of tuberculosis if he does the work he loves; Mrs. Holly dies in childbirth; Lily Sawdon is dying of cancer. Through Lily Sawdon Holtby shows what serious illness and great pain can do: "Then the pain uncurbed itself and seized her, and she crouched, sick and dumb in her fireside chair, clutching to herself the blistering hot rubber bottle which, while it brought no relief, was a sort of counter-irritant."[9] Through Joe Astell she shows how illness can make one a stranger to oneself but also how courage can challenge the risk of death. For *South Riding* is not only the novel that demonstrates Holtby's understanding of terminal illness and approaching death, it is also the place where she comes to terms with them.

The two years in which Holtby wrote *South Riding* were interrupted, as her life always was, by other commitments both personal and professional. In addition to *Take Back Your Freedom* and *Women and a Changing Civilisation,* she also wrote three-thousand-word monthly book reviews for *Good Housekeeping* and in 1934 published a collection of her short stories, *Truth Is Not Sober.* She contributed a chapter on the manufacture of arms to Storm Jameson's pacifist collection *Challenge to Death* and edited a monograph for William Ballinger entitled *Race and Economics in South Africa.* Holtby was remarkably active during this period on behalf of the causes she cared for most, and though she had earlier given up public speaking because of her health, her hatred of the fascism rapidly spreading in Europe made her resume it. She also remained director of *Time and Tide.*

Despite all these activities, Holtby escaped periodically to work on *South Riding* alone, renting cottages in the small towns of Withernsea and Hornsea on the Yorkshire coast. There the activities that all her life had deprived her of time for writing finally became its subject. *South Riding* was to be "that novel in which the artist and social reformer" in Holtby "met and mingled in final cooperation."[10] Holtby was right to work on the novel in Yorkshire, for its direct roots are her mother's work as a county

alderman and her own Yorkshire experiences. In her prefatory letter to her mother, to whom she dedicated the novel, Holtby explains that it was listening to her mother's descriptions of her work that first gave her an interest in local government. "What fascinated me," she said, "was the discovery that apparently academic and impersonal resolutions passed in a county council were daily revolutionising the lives of those men and women whom they affected" (p. 3). There is, of course, no South Riding of the county of Yorkshire, although there are North, West, and East ridings, since *riding* comes from the Anglo-Saxon word *thriding,* meaning a third. Holtby invented the South Riding, which is essentially the East Riding where she grew up and where Mrs. Holtby was an alderman.

That she needed to return to Yorkshire to write *South Riding* is made clear in a letter she wrote to St. John Ervine in January 1933: "'I have made false start after false start, and am always checked by the feeling that I must get back to the East Riding to-day.'"[11] In that letter Holtby explained that she needed to experience directly the effects of the agricultural slump: "'I mind the ruin of the land itself as much as I mind the financial ruin of the farmers, who, in many cases, asked for it by trying to live like squires. I can't go back to the old pre-war days. I said all I knew then in *Anderby Wold.*'"[12] Her notebooks call *South Riding* "'*Anderby Wold* theme post-war, but active, not passive.'"[13] Brittain identifies specific incidents in Holtby's life that found their way in the novel: the snowstorm scene was observed as she nursed her dying father; Alfred Huggins came from an entertaining preacher she heard in 1934; an old man described to her the horror of finding bodies in the Leame estuary, where Carne's body is discovered; Cold Harbour Colony is based on an ex-servicemens' settlement ten miles from Withernsea where she went to a "Grand Variety Concert" like the one given by Madame Hubbard; and she stayed in the dreary hotel in Manchester where Sarah Burton and Robert Carne meet by chance.[14] But more than upon any specific incident, *South Riding* is built upon Holtby's love of the land in which she grew up and upon her understanding of and compassion for its people. It is a novel by a woman who knew intuitively and intimately the places and characters she wrote about but also by one who had returned to them with the wisdom and perspective of thirteen years. The novel begins with an epigraph from Vita Sackville West's poem *The Land*: "'I tell the

things I know, the things I knew / Before I knew them, imme-morially'" (p. 11).

The literary roots of *South Riding* lie in the tradition of George Eliot; like *Middlemarch,* the novel gives us a panoramic view of a section of English society and demonstrates its interconnected-ness. It works in space rather than, like *Honourable Estate,* in time, dealing with so many characters that Holtby provides a four-and-a-half page annotated list of them at the beginning but taking place in only two years. Most immediately, *South Riding* has con-nections with Phyllis Bentley's novel *Inheritance,* a generational novel of a mill-owning family called Oldroyd that must also have had an influence on *Honourable Estate,* and with Brittain's *Testa-ment of Youth.* In different ways each of these works demonstrates the links between the public and the private worlds, a theme that Holtby declares to be hers also: "we are not only single individ-uals, each face to face with eternity and our separate spirits; we are members one of another" (p. 6).

This concept provides both the theme and the structure of *South Riding,* which consists of a series of short scenes each in-troduced by an extract from the minutes of local government meetings. Each scene demonstrates the effects of the government actions on the individual lives of a South Riding community. Seen separately at first, the characters interact in ways that in turn affect the future actions of local government. So voting on the new road is influenced by the money-making schemes of Alder-man Snaith and Councillor Huggins; placement of the new road affects the business of Tom Sawdon's pub and the building of the new housing estate; the housing estate accelerates the marriage of Mr. Holly to Mrs. Brimsley, which liberates Lydia Holly from the care of her younger siblings and allows her to return to school. Pudsey explains why he might not vote for Carne this way: "'Carne's out to stop 'em building, isn't he? And if he stops 'em building, there's no new home for Mrs. B. She won't go to Shacks. And if she doesn't get off with Holly, our home's no place for me with Peg stuck as a mule and Nat round every night mucking up kitchen till there's no place to sit for them canoodling'" (p. 405).

The words *private* and *public* and their synonyms are brought together frequently in the novel: "Mrs. Holly's death may have seemed to her friends and family a private matter, but it had public repercussions which she could not have foreseen" (p. 199); "It

was not possible for a man like Huggins to conduct his personal life perpetually as though it were a public meeting" (pp. 283–84); when Mrs. Beddows's "own affairs became intolerable, she could stifle all thoughts of them by public business" (p. 256). Holtby and Brittain share this interest in the relationship between private and public worlds, but their definitions of the public world are slightly different. Far more than Brittain in *Testament of Youth*, Holtby shows the public world to be the private worlds of other people. She stresses our membership in one another's lives.

Nevertheless, life is also a chancy business in *South Riding*, and events are not always the result of the deliberate actions of other people. Illness, accident, and war play their part as well. Mrs. Holly gets pregnant and dies in childbirth because her daughter makes a cup of tea. Robert Carne's failing heart brings about the riding accident that kills him. Astell's tuberculosis is contracted in a war that also deprives Sarah Burton of her fiancé, Mrs. Beddows of her son, Robert Carne of his wife, and Bob Heyer of his arm. Although in a sense omnipresent in the novel, World War I is less the great oppressor of *Testament of Youth* than one of many uncontrollable forces that affect human lives.

And despite Holtby's desire to demonstrate the importance of human connections, she never underestimates the difficulty of relationships. The characters of *South Riding* are very isolated people; few relationships work and people communicate even less well than in *Anderby Wold*. Even where affection or passion are reciprocal, the partners are separated—the Mitchells, for example, by poverty and the Sawdons by death. The three major characters have no hope of reciprocal love: Sarah Burton is in love with Robert Carne, who is still in love with his hopelessly insane wife; Mrs. Beddows, married to a mean, unimaginative man, is in her own way in love with Carne despite being twenty years his senior. As she came to the end of her own life, Holtby must have been increasingly aware both of relationships that had come to nothing—that with Harry Pearson, for example—and of the inevitable isolation of the dying, a sense she communicates so well in Lily Sawdon. Nevertheless, it is the struggle to overcome this isolation that she celebrates and that, through Sarah Burton, becomes the story of *South Riding*.

Despite the fact that *South Riding* shows more respect for connection than her earlier novels, Holtby still stresses the value of

independence, particularly female independence. There is no happiness for her characters without achievement and self-respect. The successful people of *South Riding* are two strong and independent women, Sarah Burton and Mrs. Beddows. They form the mother-daughter pair of this novel and illustrate the conflict Holtby claimed was the core of *South Riding,* "between the people who want to plan and change things by deliberate will, and the people who just want to 'let things happen.'"[15]

Sarah Burton, high school principal, feminist, and advocate for social change, is the David Rossitur of this novel. Since *Anderby Wold* Holtby has in some ways tempered her political views, become reformer rather than radical, but she makes their spokesperson a woman rather than a man. The portrait of Sarah draws on the experiences of Holtby's friend Jean McWilliam, a high school principal in South Africa, but it is most obviously a portrait of Holtby herself. "Winifred thought of Sarah Burton as herself," Brittain writes, "though she made her heroine small and red-haired, with the appearance of Ellen Wilkinson, M.P., whom she had always liked and admired."[16] In accepting the job as principal of Kiplington High School Sarah, like Holtby, has returned to the scene of her childhood, and as a blacksmith's daughter become teacher, she has, again like Holtby, returned successful. Sarah is the independent Muriel Hammond many years later, a more self-assured and energetic Jean Stanbury. She disapproves "on principal of sacrifice" (p. 67) and asserts, " 'I was born to be a spinster, and by God, I'm going to spin'" (p. 67). Her crises are the crises of middle age, that time when one comes to terms with mortality even if one is not terminally ill. Sarah's words often echo Holtby's own in letters and conversations: " 'Do I look buried? Do I look half-dead? I tell you I'm alive and I'm happy and I love my work. I love being alive'" (p. 178); " 'There are certain things I hate—muddle, poverty, war and so on—the things most intelligent people hate nowadays, whatever their party'" (p. 122).

Sarah is a sexually passionate person. Against her better judgment she falls in love with a local conservative landowner, Robert Carne, although she knows "I oppose everything he stands for . . . feudalism, patronage, chivalry, exploitation" (p. 193). This is, of course, Holtby's characteristic heterosexual love relationship, perhaps based on her own with Harry Pearson, in which

attraction reaches across wide differences in personality and views. She has reversed the situation of *Anderby Wold* in which conservative Mary Robson loves socialist David Rossitur, but the pattern is the same. Sarah's desire for Carne is convincingly portrayed in the hotel scene, where they meet by chance and she invites him to her room, but Holtby does not romanticize sexual desire. The romanticism of Mary Robson has no place in Sarah Burton's life. Holtby replays the scene from *Anderby Wold* when "heroine" suddenly meets "hero," "a big dark man on a big dark horse" (p. 137). This time, however, the "heroine" herself comments ironically on the echoes of *Jane Eyre*: "into Sarah's well-educated mind flashed the memory of Jane Eyre and Mr. Rochester" (p. 138). Sexuality is a powerful but not central part of Sarah Burton's life, and because society now allows her to express her feelings much more freely, it has far less control over her than it might have had in an earlier era. Holtby's world has come a long way from the prewar one of Mary Robson and even further, of course, from that of Maggie Tulliver.

Nowhere in *South Riding* does Holtby suggest that women can successfully combine marriage and a career. Indeed, Holtby continues what seems to have been an ongoing debate with Brittain over the necessity of marriage for fulfillment. As she had in *Women and a Changing Civilisation,* Holtby challenges Brittain's suggestions in *Testament of Youth* that the single life is somehow psychologically undesirable by ridiculing those women who want marriage at any cost and by dignifying those who have made other choices. When Dolores Jameson, a teacher at the high school who constantly advertises her engagement to a weak man several years her junior, accuses Miss Parsons of being "an envious, embittered and frustrated spinster" (p. 270), Sarah speaks to Miss Parsons. "'There's too much fuss about virginity and its opposite altogether,'" she says. "'And I think Miss Jameson may have been reading too many of those rather silly books that profess to serve up potted psychology'" (p. 269). Miss Parsons is comforted: "She would have her memories. All human appetites for love and self-sacrifice would have been amply satisfied. She would take a little cottage, or rooms with some nice woman; she would have a wireless set, a dog, a subscription to Boots' Library" (pp. 270–71).

Holtby's sympathy is most in evidence in her portrayal of

Agnes Sigglesthwaite, the unmarried science teacher who cannot control the students and is treated by them as a figure of fun. Through Sarah Burton Holtby creates respect for her scholarship and understanding for her need to teach to support her elderly mother. Holtby even attributes to Agnes Sigglesthwaite a particularly significant spiritual experience of her own that had occurred just after she learned she had only two years to live and that she did not describe to Brittain until three months before she died. Walking in despair close to a hillside farm, Holtby broke the ice for some lambs who needed water. "Suddenly, in a flash, the grief, the bitterness, the sense of frustration disappeared; all desire to possess power and glory for herself vanished away, and never came back."[17] Similarly, watching the lambs frolic in early spring gives Agnes Sigglesthwaite the courage not to commit suicide. In Agnes Sigglesthwaite, as in Caroline Denton-Smyth, Holtby has created sympathy for a character who in most novels would be merely comic.

In some ways Holtby allows Sarah Burton the best of both worlds. Single but not virginal, childless but responsible for the children of others, she resembles those few fictional and actual teachers whom Brittain describes approvingly as being educated professionals who have retained traditional feminine virtues. These are not, however, terms Holtby herself uses. Nevertheless, she clearly agrees with Brittain that sexuality and intelligence are not necessarily antithetical. The same combination of physical and mental energy is seen in the next generation's version of Sarah Burton, Lydia Holly, a clever child, forced because she is poor and female to leave school and look after her young siblings when her mother dies of one too many pregnancies. Lydia expresses her sexual energy in dancing and in her adoration of Sarah Burton, who, like Holtby herself, has a high tolerance of sexual variation.

Sarah's attempt to help Lydia is one expression of her fundamental belief that "we are our own redeemers" (p. 179). At the beginning of the novel Sarah is the embodiment of Holtby's often-expressed faith in "the individual will" (p. 179): " 'Take what you want,' said God. 'Take it—and pay for it.' To choose, to take, with clear judgement and open eyes; to count the cost and pay it; to regret nothing; to go forward, cutting losses, refusing to complain, accepting complete responsibility for their own decisions—this was the code which she attempted to impress

upon the children who came under her influence—the code on which she set herself to act" (p. 179). "'I think we have to play our own providence—for ourselves and for future generations,'" Sarah says to Mrs. Beddows, who disagrees with her. "'If the growth of civilisation means anything, it means the gradual reduction of the areas ruled by chance—providence if you like'" (p. 206). Significantly, it is not Sarah Burton's efforts that rescue Lydia Holly in the end, but the same sexual energy that had imprisoned her, her father's. Mr. Holly kills his wife by careless sexual contact when he knows one more pregnancy will destroy her, and Lydia has to leave school; but he soon woos and wins a widow who takes over the household responsibilities and liberates Lydia.

Alderman Mrs. Beddows, the other strong woman of *South Riding,* does not share Sarah's philosophy. She knows life depends more on chance than Sarah will admit and that others as well as ourselves pay for the choices we make:

She saw the wreckage of the mental hospitals, which she had to visit, the derelicts in the county institutions, the painful optimism of the coughing, bright-eyed patients in the sanatoria, the bleak defeat of hope and independence which brought applicants before the public assistance committees. She saw Carne of Maythorpe, betrayed in love, in fatherhood, in prestige, in prosperity, by circumstances which neither courage nor intelligence could have altered. She had seen compassion impotent and effort wasted. She was an old woman (p. 207).

Mrs. Beddows is Holtby's portrait of and tribute to her mother, as Brittain recognizes, despite Holtby's protestations to the contrary in her prefatory letter. Mrs. Beddows may have some minor weaknesses of character, like her fondness for the aristocracy, but it is hard to see why Mrs. Holtby should have objected as strongly as she did to this portrait of herself, for Mrs. Beddows also has ambition, courage, and generosity. The woman who was later to say to Brittain, "'Literature be damned'" and to oppose the publication of *South Riding* is not apparent in Mrs. Beddows. Despite the fact that Brittain was clearly placating Holtby's mother in *Testament of Friendship,* written when Mrs. Holtby was still alive, Brittain's description of the character of Mrs. Beddows as Holtby's effort at reconciliation with her mother's world, and thus with her own past, is an accurate one: "The beauty and tenderness of her relationship to her mother, triumphant over all

distinctions of age, education and values, appears undiminished."[19] Brittain's account of Mrs. Holtby in *Testament of Experience,* written after her death, is much more critical.

Like Sarah Bannister and Mary Robson in *Anderby Wold,* Mrs. Beddows is caught in the old conflict between the subservience expected of women in marriage and the need to express her own energies. Sarah Burton "thought of the women of Mrs. Beddows' generation and of how even when they gave one quarter of their energy to public service they spend the remaining three-quarters on quite unnecessary domestic ritual and propitiation" (p. 201). Mrs. Beddows is a woman who "might have gone anywhere, done anything," but also "always set limits upon her powers through her desire not to upset her husband's family" (p. 201). Mrs. Beddows claims she prefers to " 'see a cock crow on his own dunghill' " (p. 254), but she dislikes her husband's meanness and arrogance and is left consoling herself with the thought of her children. " 'I've got Chloe,' " she says; " 'I've got Sybil' " (p. 256).

Although Holtby's position is clearly Sarah Burton's rather than Mrs. Beddows's on the issue of male dominance in marriage, and this is not one of the traditional values she has any intention of coming to terms with, she nevertheless makes Mrs. Beddows's conservatism palatable. Mrs. Beddows may love Robert Carne partly because of his social background, but the loneliness of that love for a man twenty years younger and the impulse it gives her to protect the motherless Midge, his disturbed and unattractive daughter, make her entirely sympathetic. It is indeed primarily as a mother that Holtby presents Mrs. Beddows, despite her acknowledgment, rather rare among novelists, that sexual feeling does not necessarily disappear with age. Holtby's view of motherhood has been tempered since *Anderby World.* She no longer presents mothering merely as possessiveness and control but recognizes its value for those who cannot look after themselves—the young Holly children, for example, or Midge Carne. She suggests too that the same impulse to protect and nurture that makes Mrs. Beddows the good mother directs her attitude to society at large in her work as alderman. The figure of the mother in Holtby's last novel is no longer a selfish social climber like Mrs. Hammond, who sees her daughter only as an extension of herself, but a Mrs. Holly "whose sharp tongue cut across tedium, whose rare

rough caress lit sudden radiance" (p. 195), a Mrs. Brimsley who provides "hard-boiled eggs, ham-cake, cheese cakes and buns and oranges" (p. 483) for the children's picnic, and a Mrs. Beddows.

The portrayal of positive images of mothering is one of the ways in which Holtby reclaims her mother and comes to terms with her past. The same impulse toward reconciliation governs the whole novel. Lily Sawdon finally tells her husband about her illness and allows him to understand her behavior; Mrs. Huggins is finally restored to "his lost home comforts" (p. 336) when a button from his sleeve accidentally pulls off his wife's hairnet. And independent, socialist reformer Sarah Burton in the end learns humility from conservative Mrs. Beddows. They meet in a final scene over Robert Carne, the man they both love, who has just died in a riding accident. Carne is the representative in *South Riding* of the old patriarchal order, married to the aristocracy, controlling the land, and driving women crazy, in this case literally. Sarah describes him as one of the "vindicators of tradition against experiment, of instinct against reason, of piety against progress. They were pleasant people, kind, gracious, attractive. They cultivated a warm, human relationship between master and servant. They meant well. And they did evil" (p. 125). Sarah loves him despite his values, just as Mrs. Beddows loves him for them.

Instead of providing a romantic reconciliation between Robert Carne and Sarah and a traditional ending, Holtby reduces Carne to a mere means of reconciliation between two women. In their final scene, believing it may cost her the job she loves, Sarah gives Mrs. Beddows the gift of knowing that Carne was a sick man and did not kill himself. She confesses her love for Carne and tells Mrs. Beddows about the attack of angina in the hotel bedroom that had prevented their becoming lovers. In turn Mrs. Beddows praises Sarah's work as principal and asks her to continue it. She describes her own feeling for Carne as that of a mother for a son and, in recognizing the strength of Sarah's passion for him, establishes a maternal role toward her also. She even gives Sarah the gift of a final affectionate message from Carne: "'Give her my love. Tell her she's a grand lass. I wouldn't miss quarrelling with her for a great deal'" (p. 491). So this scene resembles the type that Rachel Blau DuPlessis describes in which the modern artist daughter is reconciled with a mother who defines herself

through what she lacks. Like Mrs. Beddows, the mother sends the daughter back to her work with her blessing, work that the mother might well have done herself if she had been born a generation later. The artist daughter, though, is of course Holtby herself, who in writing *South Riding* witnessed to the importance of her mother's work.

Sarah Burton's independence and belief in the power of the individual will are tempered at the end of *South Riding* as she comes to recognize the interconnectedness that makes us each other's rather than our own redeemers. This represents a significant change in Holtby's philosophy, one clearly brought about by the experience of coming to terms with her own imminent death. It is reflected in the compassion with which she portrays even the more unattractive characters of her novel. "She was drawing so close to the border-line between life and death," writes Brittain, "that she saw men and women as the God of Mercy sees them, with infinite pity and loving compassion."[20]

But it is reflected most obviously in the experience of Sarah Burton in the final few pages of the novel. In despair after Carne's death, Sarah has wanted to die but is shaken from this despair by coming very close to death when a small plane in which she is flying crashes on its return trip. Thinking, as Holtby herself was as she wrote these words, that death must come soon, Sarah "smiled at death, unwilling but unafraid" (p. 504). When she is rescued uninjured, she experiences "a senseless exultation" and finds "she had been shaken out of her sorrow . . . She would live out her time and finish the task before her, because she knew that even the burden of living was not endless. Comforted by death, she faced the future" (p. 505).

The final scene at the Jubilee Service, a nationwide celebration that in itself epitomizes Holtby's statement about connection, encapsulates in brief Holtby's whole career. Sarah's message to the schoolchildren is that of the Holtby of *A Crowded Street,* " 'Question everyone in authority, and see that you get sensible answers to your questions'" (p. 506). Thinking of her ongoing work in the public sphere, she recalls the Holtby of *Mandoa, Mandoa!* "If we have done nothing else, thought Sarah, falling into line in the procession behind the girls, we have saved Lydia Holly" (p. 507). But at the service, she is overwhelmed by a sense of connection: "Sarah could not remain immune. Question everything she had

urged, and was guarded against acceptance" (p. 508). It is Mrs. Beddows's words that come to her mind now and bring her to Holtby's final view: "She recalled her earlier certainties. Take what you want, said God: take it and pay for it. She remembered Mrs. Beddows' caveat: Yes but who pays? And suddenly she felt that she had found the answer. We all pay, she thought: we all take; we are members one of another. We cannot escape this partnership. This is what it means—to belong to a community; this is what it means, to be a people" (p. 509).

Sarah's appreciation of the members of her community, her compassionate observation of each small detail, even of "the lined faces of the women, their swollen hands reddened by work, the wedding rings embedded deep in the rheumatic flesh" (p. 509), is characteristic of Holtby's perception throughout *South Riding*. It is this capacity for appreciating life's richness that makes Holtby's final novel what Brittain calls "a lovely and hopeful book" (p. 422), full of "wisdom and clarity" (p. 421).

In a scene somewhat uncharacteristic of her, Holtby expresses Sarah's change of heart in specifically Christian terms. Hearing the words of the minister, Sarah wonders whether "the more lasting wisdom" (p. 510) could be founded upon Christ. Was it the influence of Brittain, to whom religious language came far more easily, or a sense of her own imminent death that made Holtby end *South Riding* with this thought? The novel argues throughout against organized religion. Minister Huggins has been portrayed as a weak and greedy adulterer; his view of Alderman Snaith as "identified with the powers of darkness" (p. 465) is seen as wrong. Snaith is a passionless, isolated man because he was raped as a small boy. The humanistic not the religious view predominates. Yet Holtby's final message is one of humility expressed in Christian terms.

Although the language is religious, it is with human love and consolation that Sarah Burton ends the novel as Holtby gives us an image of reconciliation between mother and daughter. Sarah looks at Mrs. Beddows and sees "a half-teasing affectionate admiration. Sarah, smiling back, felt all her new-found understanding of and love for the South Riding gathered up in her feeling for that small sturdy figure" (p. 510).

Holtby died before seeing the publication and success of the novel she had fought her illness to finish, but *South Riding* suggests

that she had come to terms with death. Brittain, who was left to see Holtby's novel through the press, took longer to accept her friend's death, if she ever did. It is clear that Brittain had warded off knowledge of the seriousness of Holtby's illness for several years. She explains that she wanted to believe that Holtby was a special case and that her doctor "could go on working the miracle that he had undoubtedly performed."[21] She admits that her "mind refused to accept the warning so clearly offered to it,"[22] and in the February before Holtby died, she wrote to Holtby, who had sent cheering news about her latest medical tests, " 'This is quite the best news I have had for ages. I don't deliberately worry you about your health more than I can help or discuss it with you, because I know this would only irritate you and would do no good; but I think about it constantly. Not only on your account, but for the most selfish possible reasons . . . I don't believe even my work would give me much pleasure now if I hadn't you to share its success or failure with.' "[23]

As Bailey points out, Brittain, who had been a nurse herself, had plenty of evidence to work out how dangerous Holtby's situation was. What Bailey calls her "wilful blindness" was not "because she did not care; it was because she cared too much and could not bear to hear the truth."[24] Brittain's attempt to hide the knowledge from herself in a flurry of activities and other relationships, though, was surely not the selfish act that Bailey suggests. Bailey accuses Brittain of needing Holtby to help run the household and of throwing "herself into the relationship with Phyllis Bentley, a kind of surrogate Winifred."[25] Brittain's inability to face the truth was partly the result of her wartime experiences and partly a measure of her closeness to Holtby. To admit that one cannot even enjoy one's creative work without the participation of someone else is not selfish so much as symbiotic. And given the number of deaths Brittain had endured, how could she also face losing her second self? Her response was typical of her and, if not admirable, was not in the obvious sense self-serving. Just as she had responded to Nina's death immediately before the onset of the beard hallucination by throwing herself into tennis parties, so she responded to the idea of Holtby's by busying herself with other activities and people.

Bailey does not suggest that the affair Brittain appears to have had with her American publisher, George Brett, in the summer

of 1935 might equally well have been a response to the thought of losing Holtby. While pointing out that Brett had served in the trenches in World War I, Bailey does say that "the association between sexual love and death . . . was still strong" in Brittain.[26] And it was, of course, Holtby's death that Brittain faced that summer. The somewhat cryptic entries in *Chronicle of Friendship* suggest a sexual relationship with Brett, and this is confirmed by Brittain's unpublished letters. Brittain met Brett, who had published *Testament of Youth* in the United States and made her famous, during the lecture tour of America in the fall of 1934. The relationship did not last beyond Holtby's death, though Brett became the model for Eugene Meury, the young American captain with whom Ruth Alleyndene has an affair in *Honourable Estate.*

Nevertheless, *Honourable Estate* is not, as Bailey calls it, "George's book."[27] It is more certainly Holtby's book than any other Brittain wrote. From October 1935 to January 1936, Brittain worked simultaneously on the uncorrected typescript and then the proofs of *South Riding* and *Honourable Estate,* the first novel she had attempted in more than ten years. Reading *South Riding,* some of it for the first time, Brittain affirmed the words she had written in her notebook as Holtby lay dying the previous September: " 'There is no God and no hereafter; no angels guide our steps nor protect our paths. The only benevolent force in the Universe is man himself, a tiny indefatigable unit persistently fighting against the hostility of Nature and the malevolence of fate.' "[28] They are words, interestingly, that the young Sarah Burton, but not the mature one, would have agreed with, that Holtby might have affirmed except at the end of her life, and that describe the underlying philosophy of *Honourable Estate* more accurately than any other novel by Brittain.

Nevertheless, *Honourable Estate* is deeply influenced by *South Riding,* through which Holtby spoke to Brittain even after her death. As she read Holtby's book, "some phrase recalling conversations between us would make me start and look round, as though she were standing behind my chair."[29] As she corrected proofs of *South Riding,* Britain "kept getting ideas for 'Hon. Estate' instead," and wrote in her diary, "What a strange experience of communion with her spirit this proof-correcting is! In her book, all the time, she says the things that we both thought and

said to one another."[30] Like *South Riding, Honourable Estate* takes reconciliation as its theme and provides the means of reconciliation between the writer and a surrogate mother to whose life and work the novel witnesses. It is also Brittain's response to Holtby's insistence on recognizing other people and other relationships than those called "normal." And as such it witnesses to their own friendship.

Honourable Estate is generally agreed to be the richest and most fully realized novel Brittain wrote, the work of her maturity. "The book has more solidity and drive," writes Bailey, "a better construction and more genuine feeling than any novel Vera Brittain wrote before or was to write later."[31] It is as if *Honourable Estate* caught from *South Riding* Holtby's appreciation of life and its rich texture of loving details. It is, in a sense, the novel Brittain and Holtby wrote together and the one in which Brittain began to come to terms with her friend's death. Writing, she said later, "is a method of coming to terms with life, of reconciliation with the all-but-irreconcilable."[32]

Honourable Estate is an autobiographical novel in the same way that *South Riding* is. It is a retelling of Brittain's life in a form that heals the wounds of the past and is in part a fictionalization of *Testament of Youth*. The strength of Brittain's protestation to the contrary in the 1936 foreword to the novel—"This novel is not autobiographical. It makes no attempt at any self-portrait, and nowhere is the story, as related here, that of my own life"[33]— suggests a concern that the material of the novel may be considered damaging to those represented in it, a concern that perhaps accounts for Brittain's best novel being the only one still out of print in 1989.

Despite her 1936 denials, in describing the origins of the novel in *Testament of Experience,* Brittain makes its roots in her own and her husband's families very clear. *Honourable Estate* was originally planned as two separate novels. Before her marriage Brittain had made some notes for a book, "Kindred and Affinity," inspired by her father's accounts of his Staffordshire family. By 1925, she writes, "the characters were already coming to life; the fictitious Alleyndenes bore a likeness to my forebears which they were eventually to retain."[34] Her father appears as Stephen Alleyndene, Brittain herself as Ruth Alleyndene, the daughter who becomes

a Labor politician (as her own daughter, Shirley Williams, was to do many years later), and her brother Edward as Richard, Ruth's brother.

The second novel, "The Springing Thorn," was to be the story of Catlin's mother, Edith Kate Orton, "a turbulent, thwarted, politically-conscious woman who had died prematurely in 1917."[35] Brittain's account of her relationship to this dead woman makes clear the themes of reconciliation and reclaiming of the mother that Edith Orton came to embody. Ironically, as she wrote *Honourable Estate,* Brittain was asked to write an article to be called "My Mother and What She Has Taught Me." As she struggled with the difficult first two years of her marriage and fought for autonomy within it, Brittain told herself she "was fulfilling in another generation my dead mother-in-law's aspirations for women."[36] She dedicated the novel to "E.K.C. who worked for a day she never saw." Brittain cast her own daughter, Shirley, in the role of savior-daughter after a dream in which Edith Orton appeared and said nothing but sat with Shirley on her lap. Foreshadowing DuPlessis's concept of the artist daughter, Brittain writes: "From that time the idea of Shirley as her grandmother's future standard-bearer laid an increasing hold on me. By the age of three, she resembled Edith Kate's early portraits as closely as a human being can resemble a photograph. Might she not also grow up to resemble her in intellect and aspirations, and hence bring her as near resurrection as a frustrated person can be brought by one who is fulfilled?"[37] It is Brittain herself, however, who is actually responsible for the "resurrection" of Edith Orton through the creation of Janet Harding Rutherston in *Honourable Estate.*

Honourable Estate is a generational novel and thus, while resembling *South Riding* in its scope, differs from it by taking place in time rather than in space. The structure of the novel provides a paradigm of its theme of reconciliation as the two plots and the two families are interwoven. The most obvious example of this is the marriage between Ruth Alleyndene and Denis Rutherston, but small events illustrate it also, as when Ruth learns of the death in World War I of Gerald Cosway, a political organizer with whom Janet Rutherston had flirted, or when Ruth wins the Drayton College prize awarded by Gertrude Ellison Campbell, a dramatist whom Janet had loved.

Honourable Estate is more overtly concerned with national politics than *South Riding,* using historical events and such "real" people as Christabel Pankhurst, Annie Kenny, and the Pethick-Lawrences, for the purpose, Brittain claims in her foreword, of verisimilitude. She introduces her own friends also, placing Storm Jameson, Phyllis Bentley, and Winifred Holtby in an audience addressed by Gertrude Campbell. Brittain describes the novel as a companion piece to *Testament of Youth,* an attempt to do for feminism what *Testament of Youth* had done for pacifism: "*Honourable Estate* purports to show how the women's revolution—one of the greatest in all history—combined with the struggle for other democratic ideals and the cataclysm of war to alter the private destinies of individuals" (pp. xi–xii). An awareness of rapid social change and its effect upon women in particular permeates *Honourable Estate*: Miss Hilton gives an address confusing "modern values with ancient standards," a confusion characteristic "of the teachers belonging to Miss Hilton's era—the era that was so soon to plunge its bewildered societies into the catastrophe by which their old conventions and continuities would be broken for ever" (p. 282). Like *South Riding* and *Testament of Youth, Honourable Estate* interprets public events "through their effect upon personal lives" (p. xii). Just as Brittain felt that the impact of fascism upon Europe made such statements as *Testament of Youth* a matter of some urgency, so she justifies *Honourable Estate* by claiming that "living in a period of reaction makes it the more important to contemplate that which was gained during the first decades which ended in 1930" (p. xiii).

Part 1 of the novel takes place between 1894 and 1919. It is the story of the dissolution of a marriage between a conventional Victorian clergyman, Thomas Rutherston, and his much younger wife, Janet. In its rejection of traditional female values it recapitulates Brittain's earlier novels, *The Dark Tide* and *Not without Honour.* Part 1 also begins the story of the Rutherston's son, Denis, a character based on Brittain's husband, George Catlin. Like Holtby in *South Riding,* Brittain presents two strong women, Janet Rutherston and Gertrude Ellison Campbell, but these two, unlike Sarah Burton and Mrs. Beddows, have an unacknowledged lesbian bond. They represent the two different approaches to social change for women that are still current today, and the conflict over these approaches finally separates them. Janet believes in

organizations, political and legal change, and so creates suffrage groups and takes part in protest marches. Gertrude dislikes the civil unrest associated with the women's movement, in part because her work for suffrage draws Janet away from her, and believes in working within the existing system. Only successes by individual women, she believes, will improve the situation.

Brittain uses Janet to express the frustrations of an intelligent, energetic, and ambitious woman trapped in a conventional marriage of the period. It is a portrait harsher and more detailed than Holtby's of the Beddowes' marriage. Janet has little education—her girls' school has not even taught her to spell—and has had a completely sheltered upbringing. Thomas Rutherston, a clergyman eighteen years her senior, understandably appears to represent an expansion of her life. But marriage proves for Janet a narrowing rather than a broadening experience, a far from honorable estate. Thomas wants to own her, body and soul; objects when she will not share her "inner life" (p. 14), by which he means thoughts about religion; and demands total submission of her desires and actions in the name of wifely duty. He denies her any privacy, believing he has a right even to read her diary; controls her private income; and refuses her a woman doctor.

Janet has no knowledge or understanding of sex when she marries, develops an "obstinate preference" (p. 23) for her own room, and gives birth to a son before she is in any way ready for motherhood. The agony of Denis's birth, which leads her to write in her diary, "Women doctors? YES!!" (p. 33), makes her unresponsive to the child, for whom she feels nothing but resentment. Superficially Janet resents the demands of a sickly infant that keep her from her political work, but the resentment is deeper than this. Denis represents the lack of choice and forced sexuality of her marriage. In a scene where Thomas makes Janet kneel by their bed and repent for having terminated a second pregnancy, the link between male arousal and female submission is made powerfully clear: "He looked with virtuous satisfaction at Janet's bowed head, at the soft curves of her figure which shuddered with cold and emotion . . . his histrionic temperament enjoyed the drama of that moment as keenly as his senses appreciated the dejected but seductive outlines of his wife's body" (p. 76).

Brittain's stress on Janet's lack of feeling for her son is, as Muriel Mellown points out, deliberately shocking: "In an age

when contraception was still a controversial issue and motherhood was still widely regarded as the most natural goal for women . . . Janet's attitude and character indicate the author's bitter rejection of the old sentimental myths, which, by sanctifying the maternal relationship, robbed many women of the means of self-fulfill-ment."[38] This was a position Brittain had argued strongly in both *Halcyon* and several articles published in the *Manchester Guardian* in the years in which she was herself trying to combine moth-erhood and work.[39] Later in *Honourable Estate,* when Ruth suc-cessfully raises twins and begins a political career, Brittain argues the case that women with outside interests, far from neglecting their children, do indeed make better mothers because they are personally fulfilled.

Janet Rutherston first attempts to escape from the limitations of her marriage through Gerald Cosway, a Liberal party organizer whom she meets through her political work. Brittain perhaps recalled Holtby's only detailed portrait of a loveless marriage, one also between an older man and a younger woman. Like that of David Rossitur and Mary Robson in *Anderby Wold,* the relation-ship between Janet and Gerald ends because of a kiss in a field. Thomas learns of his wife's behavior, as John Robson perhaps does of Mary's, and forbids Janet to continue her political work. Gerald, however, turns out to be insignificant in Janet's life com-pared with Gertrude Campbell, who borrows something of Holt-by's height and coloring as well as her interest in writing plays. Seeing Gerald after a brief absence, Janet is surprised by her lack of emotion and thinks, "Should I have forgotten him so quickly if Gertrude hadn't come into my life and brought me into contact with a world so much more brilliant and fascinating than the one I used to share with him?" (pp. 101–2).

The "brilliant and fascinating" world to which Gertrude intro-duces Janet is that of the London theater. Gertrude's career as a dramatist develops steadily and successfully throughout the novel until she becomes "The Grand Old Maid of English Drama." She arrives in Janet's life at the beginning of this career as a guest speaker for a drama group Janet has organized. They are in im-mediate sympathy with one another, exchange intimate life his-tories, since both for different reasons have been deprived of close friendship, and rapidly become each other's second self. Janet writes weekly letters to Gertrude when they are not together and

finds them "an escape and consolation which now periodically replaced her diary as a record of events" (p. 91). Gertrude writes to Janet, "You have not nearly enough scope for your brains and your energies; that has always been the trouble, hasn't it? You belong to *my* world, not to the narrow, petty little world of clerical duties and conventions" (p. 93). Although Brittain raises the question, through the voice of Ruth Alleyndene at the end of the novel, whether the relationship might be "pathological" (p. 593), in *Honourable Estate* for the first time she seems willing to reject some of the easy psychological truisms of her day. Her position is essentially Holtby's and her portrayal of this female friendship deeply sympathetic.

It is hard to know to what extent Brittain's choice to deal directly with homosexuality in this novel was a response to Holtby's death, a need in some way to acknowledge a relationship that "did not fit into the stereotypical pattern which man had evolved for his social conduct" (p. 587). Certainly in *Honourable Estate* Brittain indicates her positive response to Holtby's continued plea for tolerance of a variety of sexual relationships and eccentric characters. It is probable too that the homosexuality of Ruth's brother Richard, who chooses to die with his male lover in battle rather than face exposure, is Brittain's acknowledgment of her brother Edward, whose difficulties with women are apparent in *Testament of Youth*. Despite a rather strange defense of homosexuality as justifiable in war because "decent" men have no access to women except prostitutes, Brittain shows compassion toward male homosexuality, if not complete understanding. When Eugene Meury first brings her the letter that contains her brother's confession, Ruth blames only her "'family, for teaching us, as they always did, that so-called immorality was worse than death or any other horror. I'm beginning to think there are plenty of things far, far more deserving of punishment'" (p. 346).

Whatever her reason for dealing with this subject at this time, Brittain certainly emphasizes the fact that the relationship between Janet and Gertrude was not merely a typical nineteenth-century romantic friendship between women but an unconsummated love affair. Gertrude's "heart seemed to turn over as it did whenever she met Janet after a long separation" (p. 103); Janet makes her realize "'what Ruth meant when she said to Naomi: "The Lord do so to me, and more also, if aught but death part

thee and me" ' " " (p. 105); she feels "resentment and bitterness against any interest which might rival her unchallenged ascendancy in Janet's personal life" (p. 117). Looking back on the relationship with Janet in old age, Gertrude remembers that "when emotions came it proved too disturbing; it made her feel too much. This particular emotion at any rate had done so. There was something strained and feverish about it that she could not explain, some abnormal quality which sought to dominate, to possess, to exclude all rival claims and competitive interests" (p. 585).

Despite Ruth's later distinction between Gertrude as "abnormal" and Janet as "a normal woman whose talents had been thwarted, whose natural affections had been starved" (p. 593), Brittain portrays Janet's response to Gertrude as equally passionate. When Gertrude "kissed her worn fingers," Janet whispers, " 'I too will be faithful to you till death' " and turns away "to hide from Gertrude the tears that sprang to her eyes. Long after Ellison Campbell had gone back to Scotland she relived that episode, which gave a fleeting joy and glamour to her recollection of the small Devonshire town" (p. 105).

Janet and Gertrude are in fact separated long before death by Gertrude's opposition to the women's movement and by her stubborn pride. Already quite ill but unaware of it, Janet misses the first night of Gertrude's new play because she collapses after walking in a procession to honor Emily Davison, who died trying to stop the king's horse on the Derby racecourse. Gertrude never forgives Janet for her "disloyalty" and both their lives are made emotionally barren as a result. Through Gertrude Campbell Brittain makes a strong statement against exceptional women working within a system that oppresses other women in order to achieve personal success. Unquestioning of the social pressure that ties her to an invalid brother who verbally abuses her, Gertrude even encourages Janet to stay within her marriage "because the world has no pity for a woman who leaves her husband and child" (p. 93). Gertrude eventually becomes president of a league opposing women's suffrage.

In this novel as elsewhere Brittain still has a tendency to portray single women as frustrated and lonely. The portrait of Gertrude Campbell is paralleled to that of Emily Alleyndene, Ruth's aunt. Ruth's mother, Jessie, wonders whether her sister-in-law's "de-

spised and resented spinsterhood had anything to do with her dislike of children . . . Evidently marriage *was* better for you than being an old maid" (p. 240). But Jessie becomes a convert to modern ideas and tells her son many years later, " 'I'd give a good deal to be a young woman nowadays. They all have such interesting lives, and so many things to do that no one ever thought of when I was a girl' " (p. 576). Even in *Honourable Estate* Brittain retains her faith in "the developing science of psychology," but she also celebrates "the changes in moral values" that make us "more merciful to one another than we used to be" (p. xiv). Brittain not only heard Holtby's voice when she wrote this novel but listened to it.

Part 2 of *Honourable Estate* begins the story of the Alleyndenes, pottery manufacturers and owners of Dene Hall. It is Victorian in its account of the runaway marriage of conservative Stephen Alleyndene, the eldest son, with Jessie Penryder, governess of his younger brother and sister; of the birth and upbringing of their three children, Norman, Richard, and Ruth; and of Stephen's quarrel with the politically radical clergyman of Witnall, Thomas Rutherston. It is, however, modern in its analysis of Jessie's lack of sexual feeling, of Stephen's response to this, and of Ruth's education at Oxford, and experience of World War I.

Ruth is, as Muriel Mellown says, "obviously in many ways an idealized version of the author herself."[40] She has a brother with whom she is very close; she is educated at Playden Manor, a school much like St. Monica's; she has a close female friend at Oxford who, like Holtby, dies prematurely, and a male lover, Eugene Meury, who dies in the war. Ruth's feelings for Eugene, an American, engaged to a girl back home, perhaps suggest in both their intensity and their illicitness Brittain's for George Brett, but they also clearly recall her relationship with Roland Leighton. When Eugene is killed Ruth dreams the dream that Brittain had of Roland: "The dream took at first its usual shape, in which he returned to her when the war was over to explain that he had never really been dead, but only missing. He was a prisoner of war, mutilated, ashamed of his wounds, and afraid to meet her who had known him in the full vigour of his young, virile manhood" (p. 501).

Like Brittain, Ruth becomes a VAD nurse during the war, a war that she comes to oppose for Brittain's reasons. She can no

more think of individual Germans as enemies than Brittain can and acquires the same sense of internationalism: "Yet it was still impossible to think of handsome, vivacious Frieda as an enemy, a Bosche, a Hun" (p. 304). In her brother Richard's paintings Ruth finds the same use of pastoral convention that characterized *Testament of Youth*: "a field of tall pale daisies and scarlet sinister poppies and between them a dark evil face peeping above a half-concealed gun" (p. 339). She experiences the same survivor's guilt that gave Brittain hallucinations and asks the same question: "What was the use of going on living when everyone who mattered was dead?" (p. 427). Years after the war Ruth marries Denis Rutherston, who, like Catlin, takes a shortened course at Oxford, and with him creates a loving though not passionate marriage that combines work and family. She even makes a lecture tour of America to argue for a pacifist position.

But Ruth's story is indeed an "idealized" version of Brittain, that is to say a rewritten story in which Brittain puts right those things she regrets. So Ruth achieves first-class honors at Oxford whereas Brittain earned second-class; she has the opportunity to consummate her love for Eugene before he is killed, an opportunity Brittain never had with Roland; and Denis raises no difficulties over Ruth's balancing her responsibilities to her political career with the twins and her marriage. Indeed, he constantly praises her as a good mother. He even encourages her to leave them all for a while and go on the lecture tour of the United States. Significantly, it is Ruth not her husband who has the political career; Denis is content to remain an academic. With these changes Brittain rewrites her own life and *Honourable Estate* reconciles its author to her own past.

Part 3 of the novel reconciles present to past in a variety of ways. As he pictures his mother's death, Denis asks himself, "Could one atone to the dead by seeking to mitigate the suffering of the living, or did one only comfort oneself for previous sins of omission? . . . he was beginning to understand that the attainment of reconciliation was a duty that a man owed to himself" (p. 446). The great reconciler of the novel, though, is Ruth, whom Brittain uses to document both the interrelationship of the personal and the political and the moral and social changes of the period. Ruth realizes, "The barriers seemed to be down everywhere, broken in pieces for that still young generation which had

been so fast bound by authority. She was part of an age of transition to which her own most poignant experiences had unconsciously contributed" (p. 461). These changes in sexual mores allow Ruth, now a middle-aged Englishwoman of the early twentieth century, to identify with her grandmother's cook, Agnes, who was punished for having an illegitimate child, and to witness to this foremother's life as she will, much more strongly, to Janet's. After her sexual experience with Eugene, Ruth realizes, " 'Yes, I shall count the days—like any little maid-servant seduced by her master, like my grandmother's Agnes when she conceived the child for which she was punished and condemned' ' " (p. 401). Later Ruth tells the story of Agnes to Denis, testifying once more to her sense of identification with her. She reclaims with Agnes all sexual outlaws, and Brittain witnesses through her to Holtby's beliefs: " 'I've believed that cruelty is the greatest of all immoralities. It may be that I'm only trying to excuse myself, but the way my grandmother treated Agnes seems to me a far greater sin than any unorthodox relationship between men and women— or for that matter between women and women or men and men' " (p. 472).

Witnessing necessarily involves making a public statement of some sort, and since in fiction it is easiest to show this in conversation between characters, the key scenes of testimony to others' lives in *Honourable Estate* involve at least two characters and are often the occasion for shared intimacy. As such they also become scenes of connection in the present moment. Denis takes Ruth to see his mother's grave and strengthens his own relationship with her as he testifies to his mother's life: " 'I vowed I'd never bring any woman unhappiness in marriage. I prayed that my own desires might be denied and my own powers frustrated, rather than I should be the means of causing anyone such misery as my mother had suffered'" (p. 467). Similarly, after Ruth tells Denis about Eugene and faces with him the place on Wimbledon Common where Eugene first told her he loved her, she becomes reconciled with that part of her past: "Henceforth, she thought, life at its best will be like these tranquil woods and this brown autumn heath—pleasant, friendly, reassuring" (p. 475).

Brittain rewrites her mother-in-law, Kate Orton, and compensates for her losses by using her diaries to create *Honourable Estate*. In the novel Ruth reclaims her mother-in-law, Janet Rutherston,

by reading her letters and diaries and discussing with Denis Janet's relationship with Gertrude Campbell. " 'It was just as if they'd both been waiting all these years for someone to discover the truth and give them peace' " (p. 590). Brittain emphasizes Ruth's position as Janet's surrogate in another generation by pointing out their resemblance. " 'You're the woman she wanted to be and never was,' " says Denis to Ruth, " 'because circumstances in those days were too strong.' " (p. 476). " 'How my mother would have appreciated you' " (p. 453).

Gertrude Campbell meets Ruth and Denis at a luncheon and is reminded of Janet more by Ruth than by Janet's son, Denis: "Gertrude thought that she detected in Ruth the same dynamic energy, the same impatient vitality, the same refusal to be chained by circumstance, the same swift intelligent responsiveness to unspoken suggestions and half-framed ideas" (p. 586). Alone in her hotel room, Gertrude plays out in her imagination her own scene of reconciliation in which she tells Ruth in Janet's place "that she had never really meant to quarrel with Janet or forsake her . . . how often she had wished that there might be a resurrection of the dead for one reason only—that she could see Janet and explain" (p. 586). She dies with Janet's name on her lips.

Honourable Estate provides reconciliation between the living as well as with the dead. In her lecture tour of the United States Ruth meets Dallas Lowell, the woman to whom Eugene Meury had been engaged. In a moving scene she reveals to Dallas that she and Eugene were lovers and Dallas absolves her guilt by saying, " 'I'll always remember you with gratitude for giving him what I couldn't give. I'll feel less lonely because there's someone in the world who loved him just the same as I did' " (p. 550). After the reconciliation with Dallas, Ruth feels Eugene's presence with her and thinks about the impact of his death on both their lives. " 'My task is to reconcile, as Dallas has done,' " she says to herself, " 'the fact that you lived and died with all that I am and do. To forget or ignore the past is not enough. One can't see life as a whole and accept what one sees, until one has accepted the fact of death. Once I have done that, I can never really lose you again' " (p. 556). Similarly, Brittain, through writing *Honourable Estate,* came to terms with her own past, with the conflict between her ambition and her idea of femininity, and with the deaths of both Roland Leighton and Winifred Holtby.

It was surely Holtby Brittain was thinking of when she has Ruth say that the dead live on primarily " 'in the things we do that we should never have done if they had not lived' " (p. 556). For *Honourable Estate,* a novel she wrote without Holtby's living presence, is of all Brittain's books the one most surely indebted to their working partnership. It is, more than *Testament of Youth,* the work of Brittain's "honourable estate—the state of maturity, of true understanding" (p. 598). She ends the novel, as Holtby had ended *South Riding,* with a church service, in which Denis looks at Ruth with the same understanding as Sarah Burton had felt in looking at Mrs. Beddows. She includes in this scene a modest expression of hope that does not appear in *South Riding* but is undoubtedly spoken for Holtby as well as herself and for us who read them as they once read each other: "Perhaps from . . . his book . . . a few words would penetrate the minds of the men and women who listened or read, and remaining there to influence their thoughts and actions, become a permanent part of human inheritance" (p. 600).

Epilogue

S ince this has been a study of the relationship between Brittain and Holtby, of their interaction, Holtby's death seems to provide it with a natural ending, a structural neatness. Life, however, is never quite that tidy and in this respect the stories of Holtby and Brittain are no exception. Holtby's tribute to her mother in *South Riding* provided reconciliation for Holtby herself and gave completion to the development that began with *Anderby Wold*. But Holtby's gesture was completely misunderstood and rejected by Mrs. Holtby. Brittain managed to keep from Holtby as she was dying the knowledge that her mother was only "concerned with the effect of a book about a County Council on her own position in the East Riding."[1] " 'It makes a mock of my work,' " she said to Brittain.[2] Mrs. Holtby tried to prevent the publication of her daughter's greatest novel and, when that failed, resigned from the work in local government to which the novel paid tribute. Fortunately, Brittain's position as Holtby's literary executor allowed her to trick Mrs. Holtby into believing that *South Riding* was already in the hands of the printers and could not be withdrawn without great expense.

Brittain's own story did not, in the most obvious sense, end in 1935. She lived until 1970, continuing both her political and her writing careers and her semi-detached marriage to Catlin. He remarried in 1971 and died in 1979. Brittain's commitment to the Peace Pledge Union, a pacifist organization founded in 1934 by an Anglican clergyman, Canon Dick Sheppard, colors all her later work. Her prose, claims Bailey, "is often emotionally religious."[3] Indeed, as Bailey says, her "earlier writings show little evidence of faith," and it was perhaps a measure of Brittain's loss of faith in other means that made her turn to God "as the only answer, now, to war."[4] But Brittain had always had a tendency toward emotionally religious prose, even as early as *The Dark Tide*, despite her cynicism about religious people. This tendency merely became stronger after Holtby's death.

Brittain remained in London during the blitz of World War II, often alone, since the children had been sent to friends in Minnesota and Catlin was frequently lecturing abroad. She worked with the ARP (air-raid precautions) in bombed areas and recorded her experiences in *England's Hour* (1941). She ran a pacifist newspaper and sat on a committee screening conscientious objectors. Brittain maintained an absolute pacifist position toward the Second World War, not an easy thing to do, and published such antiwar statements as *Humiliation with Honour* (1942), *One of These Little Ones . . . A Plea to Parents and Others for Europe's Children* (1942) and, with Catlin and Sheila Hodges, *Above All Nations* (1945). It was rumored that she was considered "unreliable" by the British government, although she eventually proved to have also been on Hitler's list of those to be arrested in the event of a German occupation of Britain. This list contained both her name and Catlin's on the same page as those of Winston Churchill and Neville Chamberlain. "The Gestapo List," she records after the war, "was now regarded almost as a Roll of Honour."[5] In later years, as one might expect, Brittain joined the Campaign for Nuclear Disarmament.

Brittain became a more prolific writer as time went on. She had delayed work on a biography of Holtby, despite pressure from friends to write one, believing the book would be all the better for waiting. The delay, she claimed later, "was abundantly justified" because a "quick topical study would necessarily have omitted *South Riding*."[6] As World War II became imminent, fearing she might die without writing it, Brittain began work on *Testament of Friendship*. "As I raced to finish my book with a sense of the oncoming crisis at my heels, I began to understand the quality of Winifred's race with death to complete *South Riding*."[7]

Brittain continued her own autobiography in *Testament of Experience,* published in 1957, and wrote two more novels, *Account Rendered* (1945) and *Born 1925* (1948). *Testament of Experience* begins where *Testament of Youth* ends, with Brittain's marriage, and, like *Testament of Youth,* concludes with a reconciliation with Catlin, but there the resemblances end. The painful moments that gave such intensity to the first testament are absent. Even Holtby's death is barely mentioned, probably since the details of it had already been recorded in *Testament of Friendship*. Far more than

Testament of Youth, it is concerned directly with public events, because Brittain is now a public person. The result is to make the interplay between the private and the public less dramatic since it becomes expected. Although Catlin preferred *Testament of Experience* to *Testament of Youth,* most readers surely find it less rewarding.

Account Rendered treats the psychological effects of shell shock through a study of a First World War veteran who murders his wife. Although the experience of Vietnam veterans confirms many aspects of Brittain's study of post-traumatic shock syndrome, the novel as a whole suffers from her unquestioning trust in current psychological theory, much of which now seems outmoded. Her protagonist, Francis Halkin, believes, for example, that industrial accidents are linked to preoccupations with eyes, spectacles, and marital relationships.

Born 1925 is much more closely autobiographical and at the time seemed to her "the most important novel I have written."[8] Brittain transforms her relationship with Catlin into a study of the marriage of Robert Carbury and Sylvia Mayfield and examines the effects on a family of four of the wife's inability to love her second husband as intensely as she had her first. Sylvia's first husband, like Roland Leighton, was killed in World War I. The novel is richer for the autobiographical material, as Brittain's work always is, and provides a sensitive examination of adolescent conflict throughout the character of Adrian Carbury, but it does not have the broad range and psychological profundity of *Honourable Estate.*

Although it may seem arbitrary to end the story of Brittain's development in the middle of her life, that is in many ways where it ended. She reached her maturity as a writer with *Testament of Youth* and *Honourable Estate* and never wrote as well afterward. As if aware of this decline, she wrote in *Testament of Experience* that "the confidence in continuous achievement created by the success of *Testament of Youth* had vanished."[10] I mean in no way to belittle her achievement; many better-known writers have never written anything as good as either *Testament of Youth* or *Honourable Estate.* What seems clear is that Brittain's relationship to her writing changed irrevocably with Holtby's death, in a way that demonstrates the accuracy of the words she had written to Holtby

earlier, that not "even my work would give me much pleasure now if I hadn't you to share its success or failure with."[11] It is a testimony to the quality of their working partnership.

Brittain and Holtby spent their careers turning their experiences into literature and at the end life seemed to do it for them, providing a final curtain to their play. As Brittain left the nursing home where Holtby lay dying, the public world once again echoed her private mood: "a newspaper placard confronted me: 'Abyssinia Mobilises.' Everything that Winifred and I had lived and worked for—peace, justice, decency—seemed to be gone."[12] The words that summed up their relationship and provided closure to the last act were actually spoken a few days before Holtby's death. Brittain was visiting Holtby at the nursing home when Holtby mentioned the debate at Oxford. Brittain said, "'But just think— if the debate hadn't happened I should never have come to you afterwards—and think what I should have missed.'" In complete agreement for once, Holtby echoed Brittain's words with a final tribute to their friendship: "'And what *I* should have missed,'"[13] she said.

Notes

Notes to Introduction

1. Paul Berry, in *Testament of a Generation: The Journalism of Vera Brittain and Winifred Holtby*, ed. Paul Berry and Alan Bishop (London: Virago Press, 1985), p. 3.

2. Martha Vicinus, *Independent Women: Work and Community for Single Women, 1850–1920* (London: Virago Press, 1985), p. 207: "Friendships between teachers were stigmatized as abnormal, and raves were attacked as permanently distorting."

3. Recent work on women's friendships falls into three categories: historical accounts of actual friendships, as in Vicinus, *Independent Women*, and in Lillian Faderman, *Surpassing the Love of Men: Romantic Friendship and Love between Women from the Renaissance to the Present* (New York: William Morrow, 1981); theoretical discussions of female friendship, as in Janice Raymond, *A Passion for Friends: Toward a Philosophy of Female Affection* (London: Women's Press, 1986), and in Louise Bernikow, *Among Women* (New York: Crown Publishers, 1980); descriptions of female friendships in literature or with literary figures, as in Carol Ascher, Louise DeSalvo, and Sara Ruddick, eds., *Between Women* (Boston: Beacon Press, 1984), in Janet Todd, *Women's Friendships in Literature* (New York: Columbia University Press, 1980), and in Elizabeth Abel, "(E)Merging Identities: The Dynamics of Female Friendship in Contemporary Fiction by Women," *Signs,* 6 (1981): 413–35.

4. Vicinus, *Independent Women,* pp. 199–206.

5. Carolyn Heilbrun, Introduction to Vera Brittain's *Testament of Friendship* (1940; rpt. New York: Wideview Books, 1981), p. xxiii. All references are to the 1981 edition.

6. Vera Brittain, *Testament of Youth* (1933; rpt. New York: Wideview Books, 1980), p. 555. All references are to the 1980 edition.

7. Heilbrun points out that "for Brittain and Holtby, friendship meant, as it had long meant for men, the enabling bond which not only supported risk and danger, but comprehended also the details of a public life." *Testament of Friendship,* p. xxiii.

8. Carol Dyhouse, *Girls Growing Up in Late Victorian and Edwardian England* (London: Routledge and Kegan Paul, 1981), p. 72. Neither kind

of life-style in itself, she points out, challenged the sexual division of labor.

9. *Selected Letters of Winifred Holtby and Vera Brittain (1920–1935)*, ed. Vera Brittain and Geoffrey Handley-Taylor (Hull: Brown and Sons, 1960), pp. 183–84.

10. Ibid., p. 29. Hilary Bailey suggests that one of the reasons Brittain and Holtby chose journalism as a career was that it was among the few professions open to women that did not require resignation upon marriage. *Vera Brittain* (Harmondsworth: Penguin Books, 1987), p. 47.

11. *Testament of Youth*, p. 73.

12. Ibid., p. 37.

13. *Testament of Friendship*, p. 86.

14. *Testament of Youth*, p. 578.

15. Helen Zenna Smith, *Stepdaughters of War* (New York: E. P. Dutton, 1930), p. 174.

16. *Testament of Youth*, p. 225.

17. Rayna Rapp and Ellen Ross, "'It Seems We've Stood and Talked Like This Before,'" *Ms.*, April 1983, pp. 54–56. Cf. Martha Vicinus, "Sexuality and Power: A Review of Current Work in the History of Sexuality," *Feminist Studies*, 8 (1982), 133–56: "Only with hindsight can we see that what appeared to be a liberation of female sexuality turned out to be a restructuring of traditional patriarchal sex roles"; Vicinus, *Independent Women*, p. 291: "The sexual revolution placed new strains upon marriage and pushed the unmarried to question their state as sexually abnormal"; Bailey, *Vera Brittain*, p. 43: "the old notion that unmarried women were failures had not changed but had merely been brought up to date by Freud." See also Sheila Jeffreys, *The Spinster and Her Enemies: Feminism and Sexuality, 1880–1930* (London: Pandora Press, 1985).

18. G. Stanley Hall, *Youth: Its Regimen and Hygiene* (New York: Appleton, 1906), pp. 320–21.

19. Bailey, *Vera Brittain*, p. 44.

20. *Testament of Youth*, p. 332.

21. Ibid., p. 499.

22. *Testament of Friendship*, p. 117.

23. Faderman, *Surpassing the Love of Men*, p. 310. Cf. Jeffreys, *The Spinster and Her Enemies*, p. 123: "Because of the suspicions which had accumulated . . . around the whole idea of women's friendships, she [Brittain] finds it necessary to deny quite explicitly that she and Winifred were involved in a lesbian relationship."

24. *Testament of Friendship*, p. 118.

25. Berry, in *Testament of a Generation*, p. 13.

26. Vera Brittain, *Radclyffe Hall: A Case of Obscenity?* (1968; rpt. New York: A. S. Barnes, 1969), pp. 10–11.

27. Winifred Holtby, *Women and a Changing Civilisation* (1934; rpt. Chicago: Academy Press, 1978), pp. 192–93. All references are to the 1978 edition.

28. Ibid., p. 133.

29. The unpublished material quoted in this study is from two sources: the William Ready Division of Archives and Research Collections, McMaster University Library, Hamilton, Ontario, Canada; the Local History Collection of Hull Central Library, Hull, Yorkshire, England. Material is from the Hull collection unless otherwise indicated. Vicinus points out that "single women had no weapons with which to fight the labeling of their friendships as deviant because they had understood sexual activity as heterosexual." *Independent Women,* p. 291.

30. Carroll Smith-Rosenberg, "The Female World of Love and Ritual: Relations between Women in Nineteenth Century America," *Signs,* 1 (1975), 1–29. For a history of the definition of *lesbian,* see Ann Ferguson, "Patriarchy, Sexual Identity and the Sexual Revolution," *Signs,* 7 (1981), 159–72.

31. Blanche Wiesen Cook, "'Women Alone Stir My Imagination': Lesbianism and the Cultural Tradition," *Signs,* 4 (1979), 738.

32. Adrienne Rich, "Compulsory Heterosexuality and Lesbian Existence," *Signs,* 5 (1980), 648.

33. *Selected Letters,* p. 50.

34. Dyhouse, *Girls Growing Up,* pp. 74–75. Cf. Vicinus, *Independent Women,* p. 172: "Self-development, a relatively novel idea for dutiful daughters, collided with deeply ingrained beliefs about family obligations."

35. *Testament of Youth,* p. 472.

36. *Testament of Friendship,* p. 89.

37. *Selected Letters,* pp. 369–70.

38. Vera Brittain, "The Lady of the Lamp," *Manchester Guardian,* Jan. 16, 1929.

39. Dyhouse, *Girls Growing Up,* pp. 55–78.

40. *Testament of Youth,* p. 38.

41. Ibid.

42. Dyhouse, *Girls Growing Up,* p. 54.

43. Vera Brittain, "Mrs. Pankhurst and the Older Feminists," *Manchester Guardian,* June 20, 1928.

44. *Selected Letters,* pp. 35–36.

45. *Testament of Friendship,* p. 18.

46. *Selected Letters,* p. vii.

47. Vera Brittain, *Testament of Experience* (1957; rpt. New York: Wideview Books, 1981), p. 437. All references are to the 1981 edition.

48. Meredith Skura, *The Literary Use of the Psychoanalytic Process* (New Haven: Yale University Press, 1981).

49. Vera Brittain, *On Becoming a Writer* (1947); rpt. as *On Being an Author* (New York: Macmillan, 1948), p. 10. All references are to the 1948 edition.

50. *Testament of a Generation,* p. 274.

51. Bell Gale Chevigny, "Daughters Writing: Toward a Theory of Women's Biography," in Ascher, DeSalvo, and Ruddick, *Between Women,* p. 361. Cf. ibid., p. 367: "Retrospectively, I see that my evolving engagement with Fuller . . . can be interpreted as a series of deepening endeavors to seek out and understand the sources of my position in the world, my current sense of myself."

52. Judith Gardiner, "Mind Mother: Psychoanalysis and Feminism," in *Making a Difference: Feminist Literary Criticism,* ed. Gayle Greene and Coppelia Kahn (London: Methuen, 1985), p. 138.

53. Judith Gardiner, "On Female Identity and Writing by Women," *Critical Inquiry,* 8 (1981), 349. Cf. Chevigny, "Daughters Writing," p. 358: "I suppose that it is nearly inevitable that women writing about women will symbolically reflect their internalized relations with their mothers and in some measure recreate them."

54. Dorothy Dinnerstein, *The Mermaid and the Minotaur: Sexual Arrangements and Human Malaise* (New York: Harper Colophon Books, 1977); Nancy Chodorow, *The Reproduction of Mothering: Psychoanalysis and the Sociology of Gender* (Berkeley: University of California Press, 1978); Adrienne Rich, *Of Woman Born: Motherhood as Experience and Institution* (New York: W. W. Norton, 1976); Carol Gilligan, *In a Different Voice: Psychological Theory and Women's Development* (Cambridge: Harvard University Press, 1982); Kim Chernin, *The Hungry Self: Women, Eating and Identity* (New York: Times Books, 1985). There is too much work on this subject now to list all the significant references. For a more detailed overview, though an early one, see Marianne Hirsch, "Mothers and Daughters," *Signs,* 7 (1981), 200–223.

55. See the work of Chevigny and Vicinus quoted above. See also Elizabeth Abel, Marianne Hirsch, and Elizabeth Langland, eds., *The Voyage In: Fictions of Female Development* (Hanover, N.H.: University Press of New England, 1983); Lee Edwards, *Psyche as Hero: Female Heroism and Fictional Form* (Middletown, Conn.: Wesleyan University Press, 1984); Rachel Blau DuPlessis, *Writing beyond the Ending: Narrative Strategies of Twentieth Century Women Writers* (Bloomington: Indiana University Press, 1985). Sharon O'Brien's biography, *Willa Cather: The Emerging Voice* (New York: Oxford University Press, 1987), makes particularly fruitful use of this work.

56. Hirsch, "Mothers and Daughters," p. 206.

57. Vera Brittain, Introduction to *Selected Letters,* p. ix.

58. *Testament of a Generation,* p. 273.

59. *Selected Letters,* pp. vii, x.

60. Chodorow, *The Reproduction of Mothering,* p. 207.

61. Gilligan, *In a Different Voice,* p. 170.

62. Gardiner, "On Female Identity," p. 352.

63. Chodorow, *The Reproduction of Mothering,* p. 137.

64. Vicinus, *Independent Women,* p. 189.

65. Abel, "(E)Merging Identities," p. 418.

66. Raymond, *A Passion for Friends,* p. 6.

67. Ibid., p. 8.

68. Chevigny, "Daughters Writing," pp. 373–74.

69. Ibid., p. 375. 70. Ibid., p. 374.

71. Patrocinio Schweickart, "Reading Ourselves: Toward a Feminist Theory of Reading," in Elizabeth Flynn and Patrocinio Schweickart, eds., *Gender and Reading: Essays on Readers, Texts, and Contexts* (Baltimore: Johns Hopkins University Press, 1986), p. 55.

72. Abel, "(E)Merging Identities," p. 434. Cf. ibid., p. 414: "Female bonding exemplifies a mode of relational self-definition whose increasing prominence is evident in the revival of psychoanalytic interest in object-relations theory and in the dynamics of transference and countertransference, as well as in the growth of literary emphasis on theories of influence and intertextuality."

73. Wolfgang Iser, *The Act of Reading: A Theory of Aesthetic Response* (Baltimore: Johns Hopkins University Press, 1978), p. 43.

74. Ibid., p. 132. 75. Ibid., p. 164.

76. Schweickart, "Reading Ourselves," p. 55.

77. Judith Fetterley, "Reading about Reading: 'A Jury of Her Peers,' 'The Murders in the Rue Morgue,' and 'The Yellow Wallpaper,'" in Flynn and Schweickart, *Gender and Reading,* pp. 150–51.

78. Virginia Woolf, "How Should One Read a Book?" in Woolf, *The Common Reader: Second Series* (London: Hogarth Press, 1932), p. 268.

79. For a fuller description of this theory see Jean E. Kennard, "'Ourself behind Ourself': A Theory for Lesbian Readers," *Signs,* 9 (1984), 647–63.

80. Joseph Zinker, *Creative Process in Gestalt Therapy* (New York: Random House, 1977), p. 202.

81. Iser, *The Act of Reading,* p. 158.

82. Edwards, *Psyche as Hero,* p. 166.

83. Raymond, *A Passion for Friends,* p. 152.

84. Marion Shaw, Introduction to Winifred Holtby's *Mandoa, Mandoa!* (1933; rpt. London: Virago Press, 1982), p. x. All references to *Mandoa, Mandoa!* are to the 1982 edition.

85. Ibid., p. xviii.

86. Edwards, *Psyche as Hero,* p. 165.

87. Northrop Frye, *Anatomy of Criticism: Four Essays* (1957; rpt. New York: Atheneum, 1969), p. 308.

88. DuPlessis, *Writing beyond the Ending,* p. 101.

89. See, for example, Vera Brittain, *Chronicle of Youth: Vera Brittain's War Diary, 1913–1917,* ed. Alan Bishop with Terry Smart (1981; rpt. New York: William Morrow, 1982), pp. 29, 73, 94. All references are to the 1982 edition.

90. Shaw, Introduction to *Mandoa, Mandoa!* p. xviii.

91. Abel, Hirsch, and Langland, *The Voyage In,* p. 13.

92. *Selected Letters,* p. 14.

Notes to Chapter 1

1. *Testament of Friendship,* pp. 92–93.

2. *Testament of Youth,* p. 487.

3. Ibid. 4. Ibid.

5. Ibid., p. 495. 6. Ibid., p. 491.

7. *Testament of Friendship,* p. 84.

8. Ibid., p. 93.

9. *Testament of Youth,* p. 521.

10. *Testament of Friendship,* p. 92.

11. *Testament of Youth,* pp. 517–18.

12. Ibid., pp. 546–47. For Brittain's comments on the importance to her of female companionship see *Chronicle of Youth,* p. 64 and p. 116: "Surely now, even though college life be narrow and its seclusion, as Roland says, a vegetation, I may begin to *live* & to find at least *one* human creature among my own sex whose spirit can have intercourse with mine."

13. *Testament of Youth,* p. 546.

14. Ibid., p. 547. 15. Ibid., p. 53. 16. Ibid., p. 56.

17. *Chronicle of Youth,* p. 28. Cf. ibid., p. 42: "if one was only sensible, would one ever rise beyond that dull level of respectable mediocrity whose meritorious shelter Mother and Daddy seem so terribly afraid of getting away from?"

18. Ibid., p. 430. 19. Ibid., p. 33.

20. Ibid., p. 82. Cf. ibid., p. 35: "A few hours ago I couldn't have imagined myself either confessing my loneliness to Mother or letting her see my distress, but I am glad of it instead of sorry if only to prove how great a darling I always knew she could be."

21. Ibid., p. 304.

22. Ibid., p. 269. Cf. ibid., pp. 29–30: "The smart clothes I know I possess—the prettiness which people say is mine—what satisfaction can they give at the height compared with the slightest of intellectual achievements?"

23. Ibid., p. 130. 24. Ibid., p. 114.

25. *Testament of Youth*, pp. 422–23.

26. Ibid., p. 401.

27. *Testament of a Generation*, p. 122. Cf. *Testament of Youth*, p. 59: "probably no ambitious girl who has lived in a family which regards the subservience of women as part of the natural order of creation ever recovers from the bitterness of her early emotions."

28. *Testament of a Generation*, p. 121.

29. Ibid.

30. *Testament of Youth*, p. 547.

31. Ibid., p. 548.

32. *Testament of Friendship*, p. 103.

33. Ibid., p. 104. 34. Ibid., p. 10.

35. Ibid., pp. 20–21.

36. Chodorow, *The Reproduction of Mothering*, p. 181. Cf. Chernin, *The Hungry Self*, p. 42.

37. *Testament of Friendship*, p. 19.

38. Ibid., p. 11. 39. Ibid., p. 47. 40. Ibid., p. 11.

41. Chernin, *The Hungry Self*, p. 83.

42. *Testament of a Generation*, p. 270.

43. Ibid., p. 275.

44. Winifred Holtby, *Pavements at Anderby*, ed. H. S. Reid and Vera Brittain (London: William Collins, 1937; rpt. New York: Macmillan, 1938), p. 73. All references are to the 1938 edition.

45. *Testament of Youth*, p. 597.

46. Ibid. 47. Ibid.

48. *Testament of Friendship*, p. 16.

49. *Testament of Youth*, pp. 517–18.

50. *Testament of Friendship*, p. 135.

51. Ibid., p. 120.

52. *Selected Letters*, p. 370.

53. Skura, *Literary Use of the Psychoanalytic Process*, pp. 29–31.

54. Mary Cadogan, Introduction to Winifred Holtby's *Anderby Wold* (1923; rpt. London: Virago Press, 1981), p. xiii. All subsequent references to *Anderby Wold* are to the 1981 edition and will be cited in the text.

55. *Testament of a Generation*, p. 274.

56. Ibid.

57. *Testament of Friendship*, p. 16.

58. Ibid., p. 137.

59. Judith Gardiner points out that "critics find the merging identities and blurred boundaries, which are attributed to women's relationships, in all aspects of writing by women." "Mind Mother," p. 137.

60. *Testament of Friendship,* p. 19.

61. Ibid., p. 136.

62. Winifred Holtby, *Letters to a Friend,* ed. Alice Holtby and Jean McWilliam (London: William Collins, 1937), p. 56.

63. For a fuller discussion of this pattern see Jean E. Kennard, *Victims of Convention* (Hamden, Conn.: Archon Books, 1978), pp. 159–63.

64. *Testament of Friendship,* p. 135.

65. *Letters to a Friend,* pp. 242–43.

66. *Testament of Friendship,* p. 137.

67. Ibid., p. 138. 68. Ibid., p. 137. 69. Ibid., p. 119.

70. Ibid. 71. Ibid.

72. Vera Brittain, *The Dark Tide* (1923; rpt. New York: Macmillan, 1936), p. 1. All subsequent references are to the 1936 edition and will be cited in the text.

73. *On Being an Author,* p. 156.

74. *Testament of Youth,* p. 519.

75. Ibid., p. 488.

76. *Testament of Friendship,* p. 119.

77. Skura, *Literary Use of the Psychoanalytic Process,* p. 65.

78. *Testament of Youth,* pp. 520–21.

79. Ibid., p. 536. 80. Ibid.

Notes to Chapter 2

1. *Testament of Friendship,* p. 140.

2. *Testament of Youth,* p. 608: "Quite definitely, now, I felt sure that I did not want to marry." This letter is now in the McMaster collection.

3. *Testament of Friendship,* pp. 161–62.

4. *Letters to a Friend,* p. 190.

5. Ibid., p. 183. 6. Ibid.

7. Claire Hardisty, Introduction to Winifred Holtby's *The Crowded Street* (1924; rpt. London: Virago Press, 1981), p. x. All subsequent references to *The Crowded Street* are to the 1981 edition and will be cited in the text.

8. *Letters to a Friend,* p. 110.

9. *Testament of Friendship,* p. 160. In *Letters to a Friend,* p. 244, Holtby calls *The Crowded Street* "more or less autobiographical."

10. *Letters to a Friend,* p. 288.

11. Ibid. 12. Ibid., p. 152. 13. Ibid.

14. *Testament of Friendship,* p. 162.

15. See, for example, Hardisty, Introduction to *The Crowded Street,* p. xiii.

16. *Testament of Friendship,* p. 160.

17. Sandra Gilbert, "Soldier's Heart: Literary Men, Literary Women and the Great War," *Signs*, 8 (1983), 422–50.

18. See, for example, Vera Brittain, "The Professional Woman: Careers and Marriage," in *Testament of a Generation*, pp. 123–26. Cf. *Testament of Youth*, p. 579: "For a woman as for a man, marriage might enormously help or devastatingly hinder the growth of her power to contribute something impersonally valuable to the community in which she lived, but it was not that power, and could not be regarded as an end in itself."

19. *Chronicle of Youth*, p. 304: "Mother was very nice—but I almost felt as if she were a stranger. One cannot pretend to live in any other than one's own atmosphere when one has reached the bedrock of life."

20. *Testament of Friendship*, p. 163. See also *Selected Letters*, p. 26 (Holtby to Britain): "So 'The Prophet' is finished . . . I can't help liking it unless the end is strangely different from the beginning and the middle."

21. *Testament of Youth*, p. 614.

22. Ibid., p. 615.　　23. Ibid.

24. Jane Marcus, "Witness to War's Waste: 'Chronicle of Youth,'" *New York Times*, Jan. 30, 1983, pp. 12, 17.

25. Alan Bishop, in *Chronicle of Friendship: Vera Brittain's Diary of the Thirties, 1932–1939*, ed. Alan Bishop (London: Victor Gollancz, 1986), p. 20.

26. Berry, Introduction to *Testament of a Generation*, pp. 12–13.

27. *Testament of Youth*, p. 56.

28. Vera Brittain, *Not without Honour* (London: Grant Richards, 1924), p. 28. All subsequent references will be cited in the text.

29. Cf. ibid., p. 92: "Even as she had learned that the fairest creatures of Nature and Art were only symbols of the glorious reality that lay beneath the surface of all life."

30. *Testament of Youth*, p. 54.

31. *Chronicle of Youth*, p. 350.

32. Cf. ibid., p. 41: "it was ridiculous a little slip of a girl arguing with him about what I didn't understand."

33. Cf. ibid., p. 41.　　34. Cf. ibid., p. 42.

35. Ibid., p. 53.　　　36. Ibid., pp. 57–58.

37. *Testament of Youth*, p. 608.

38. Ibid., p. 654.　　39. Ibid., pp. 654–55.

40. *Testament of Friendship*, p. 144.

41. *Testament of Youth*, p. 618.

42. *Testament of Friendship*, p. 145.

43. *Letters to a Friend*, p. 263: "it means losing Vera's companionship and noone can tell what she has meant to me these four years. But I

covet for her this richer life." Holtby always assured Brittain that she did not find Brittain's "happiness painful." *Testament of Friendship*, p. 171.

44. *Letters to a Friend*, p. 345.

45. *Testament of Friendship*, p. 166.

46. *Letters to a Friend*, p. 372.

47. Ibid., p. 289. 48. Ibid., p. 290.

49. Ibid., p. 289. 50. Ibid., p. 290. 51. Ibid., p. 289.

52. *Testament of Friendship*, p. 178.

53. *Letters to a Friend*, p. 301.

54. Ibid., p. 244. 55. Ibid. 56. Ibid., pp. 246–47.

57. Ibid., p. 212. 58. Ibid., p. 354.

59. *Testament of Friendship*, p. 181.

60. Ibid., p. 179.

61. All quotations are from the manuscript of "The Runners" in the Holtby collection at the Hull Public Library.

62. *Testament of Friendship*, p. 214.

63. Ibid., p. 189. 64. Ibid.

65. Ibid., pp. 187–88. 66. Ibid., p. 222.

67. *Letters to a Friend*, p. 345.

68. Winifred Holtby, *The Land of Green Ginger* (1927; rpt. Chicago: Academy Press Limited, 1978), p. 11. All subsequent references are to the 1978 edition and will be cited in the text.

69. *Testament of Friendship*, p. 222.

70. Quoted as an epigraph to *The Land of Green Ginger*.

71. *Testament of Friendship*, p. 222.

72. Ibid., p. 221. 73. Ibid., p. 222.

74. Ibid., p. 275: "To the heroine of the story, Joanna Leigh, Winifred gave her own character and imagination."

Notes to Chapter 3

1. Raymond, *A Passion for Friends*, p. 152.

2. *Testament of Friendship*, p. 291.

3. *Testament of Experience*, p. 48.

4. Ibid.

5. Vera Brittain, *Thrice a Stranger: New Chapters of an Autobiography* (London: Victor Gollancz, 1938), p. 11.

6. *Testament of Experience*, p. 33.

7. *Thrice a Stranger*, p. 53. Brittain's dislike of domesticity is documented in several articles. See, e.g., Vera Brittain, "I Denounce Domesticity," in *Testament of a Generation*, p. 139.

8. *Thrice a Stranger*, p. 110.

9. *Testament of Experience*, pp. 38–39.

10. Ibid., pp. 31–32.

11. *Thrice a Stranger,* p. 26.

12. Ibid., p. 25. 13. Ibid., p. 24. 14. Ibid.

15. Ibid., p. 113. For a defense of her position see Vera Brittain, "Semi-Detached Marriage," in *Testament of a Generation,* p. 130.

16. *Thrice a Stranger,* p. 120.

17. Vera Brittain, *Women's Work in Modern England* (London: Noel Douglas, 1928), p. 23.

18. Ibid., p. 86. 19. Ibid., p. 89. 20. Ibid., p. 67.

21. Ibid., pp. 65–66. 22. Ibid., p. 63.

23. Vera Brittain, *Halcyon, or The Future of Monogamy* (London: Kegan Paul, 1929; New York: E. P. Dutton, 1929), p. 47. All references are to the American edition.

24. Ibid., p. 85.

25. Ibid., p. 88. Since *Halcyon* is so clearly a defense of Brittain's own actions, it is difficult to avoid the assumption that this escape clause also justified some specific need.

26. *Testament of Experience,* p. 38.

27. Winifred Holtby, *Eutychus, or The Future of the Pulpit* (London: Kegan Paul, Trench, Trubner, 1928), p. 20.

28. Ibid., p. 24. 29. Ibid., p. 38.

30. Ibid., p. 75. 31. Ibid., p. 110.

32. Winifred Holtby, *A New Voter's Guide to Party Programmes: Political Dialogues* (London: Kegan Paul, Trench, Trubner, 1929), p. 18.

33. Ibid., p. 49. 34. Ibid., pp. 49–50.

35. George Davidson, Introduction to Winifred Holtby's *Poor Caroline* (1931; rpt. London: Virago Press, 1985), p. ix. All subsequent references to *Poor Caroline* are to the 1985 edition and will be cited in the text.

36. *Testament of Friendship,* p. 303.

37. Ibid., p. 288. 38. Ibid., p. 296. 39. Ibid., p. 306.

40. Ibid., p. 303. 41. Ibid., p. 305.

42. *Letters to a Friend,* p. 435.

43. Ibid., p. 451. 44. Ibid., p. 452.

45. Cf. *Poor Caroline,* p. 68: "She crouched above her kettle like a witch brewing enchantments." The sister of Laura Willowes is called Caroline. *Lolly Willowes* has a weak male character called Mr. Gurdon; *Poor Caroline* has one called Mr. Guerdon. For an interesting discussion of the Victorian fear of the spinster, see Nina Auerbach, "Old Maids and the Wish for Wings," in Auerbach, *Woman and the Demon: The Life of a Victorian Myth* (Cambridge: Harvard University Press, 1982).

46. Winifred Holtby, *Virginia Woolf: A Critical Memoir* (1932; rpt. Chicago: Academy Press, 1978), p. 29. All references are to the 1978 edition.

47. *Testament of Friendship*, p. 308.

48. *The Letters of Virginia Woolf*, ed. Nigel Nicolson and Joanna Trautmann, vol. VI (New York and London: Harcourt Brace Jovanovich, 1980), p. 43.

49. Ibid., p. 28.

50. *Testament of Friendship*, p. 337.

51. *Virginia Woolf*, p. 33.

52. Ibid., p. 94. 53. Ibid., p. 77. 54. Ibid., pp. 12–13.

55. Ibid., p. 13. 56. Ibid., p. 91.

57. Ibid., p. 114. 58. Ibid., p. 182.

59. *The Letters of Virginia Woolf*, VI, 381.

60. Ibid.

61. *Testament of Friendship*, p. 318.

62. Ibid. 63. Ibid., p. 319.

64. Ibid., p. 326. 65. Ibid., p. 328.

66. Shaw, Introduction to *Mandoa, Mandoa!* p. xv: The novel "occasionally shifts gears from caricature and near-fantasy into realism." All subsequent references to *Mandoa, Mandoa!* will be cited in the text.

67. *Testament of Friendship*, p. 347.

68. Ibid., pp. 345–46.

69. Ibid., p. 347. 70. Ibid., p. 240.

71. *Selected Letters*, pp. 35–36.

72. *Pavements at Anderby*, p. 308.

73. Ibid., p. 290. 74. Ibid., p. 292. 75. Ibid.

76. Ibid., p. 298. 77. Ibid., p. 313.

78. Ibid., p. 317. 79. Ibid., p. 310.

80. Winifred Holtby, *The Astonishing Island* (London: Lovat Dickson, 1933; New York: Macmillan, 1933), p. 131. All references are to the American edition.

81. Ibid., p. 48.

Notes to Chapter 4

1. Virginia Woolf, *Three Guineas* (London: Hogarth Press, 1938), p. 197.

2. Shaw, Introduction to *Mandoa, Mandoa!* p. xviii.

3. Alan Bishop, Introduction to *Chronicle of Friendship*, p. 11.

4. *Testament of Experience*, p. 92.

5. *Chronicle of Friendship*, p. 46.

6. *Testament of Experience*, p. 76.

7. Ibid., p. 36.

8. *Testament of Friendship*, p. 312. In an unpublished letter to Catlin dated Apr. 11, 1933, Holtby writes of Brittain: "The sparse literary

product of the past seven years has not entirely been unrelated to house-keeping, children and your interests; she has corrected your proofs; typed your articles; she has done a million chores of varying kinds."

9. *Testament of Friendship,* p. 336.

10. Ibid., p. 352.

11. *Selected Letters,* p. 339. Hilary Bailey calls Holtby Brittain's "alter ego." *Vera Brittain,* p. 77.

12. *Selected Letters,* p. 249.

13. Paul Fussell, *The Great War and Modern Memory* (New York: Oxford University Press, 1975), p. 109.

14. *Testament of Experience,* p. 77.

15. *Testament of a Generation,* pp. 206–7.

16. She also had high praise for Ruth Holland's *The Lost Generation* (1932); see *Chronicle of Friendship,* p. 79.

17. "Peace through Books," *New Clarion,* May 20, 1933.

18. *Testament of Experience,* p. 77.

19. Fussell, *The Great War,* pp. 199, 203.

20. *Testament of Experience,* p. 77.

21. Ibid., p. 79. Also quoted in *Chronicle of Friendship,* p. 30.

22. William Matthews, *British Autobiographies: An Annotated Bibliography of British Autobiographies Published or Written before 1951* (Berkeley: University of California Press, 1955). Brittain seems unaware of even the published accounts of wartime experience by women. See, for example, Enid Bagnold, *A Diary without Dates* (1918); Olive Aldridge, *Retreat* (1916); Olive Dent, *A V.A.D. in France* (1917); Maude Onions, *A Woman at War* (1929). As late as 1953 in *Lady into Woman: A History of Women from Victoria to Elizabeth II* (London: Andrew Dakers; New York: Macmillan, 1953), p. 183 (American edition), Brittain was still repeating her words "Who will write the epic of the women who went to the War?"

23. *Testament of Youth,* p. 10. All subsequent references to *Testament of Youth* in this chapter will be cited in the text.

24. *Testament of Experience,* p. 80. Cf. ibid., p. 79: "I did now believe my story to be worth recording, owing to the very fact that . . . it was typical of so many others."

25. Viscountess Margaret Rhondda, *This Was My World* (London: Macmillan, 1933), p. vii.

26. Phyllis Bentley, *O Dreams, O Destinations* (New York: Macmillan, 1962), p. 11.

27. Storm Jameson, *Journey from the North* (New York: Harper and Row, 1970), p. 15.

28. Karl Weintraub, "Autobiography and Historical Consciousness," *Critical Inquiry,* 1 (1975), 833.

29. *Chronicle of Youth,* p. 13.

30. Ibid., p. 15. Hilary Bailey's brief biography of Brittain provoked a discussion in the *Observer* of May 17, 1987, and the following week over whether or not Brittain had been guilty in *Testament of Youth* of "fudging, duplicity," and "finagling."

31. *Chronicle of Youth,* p. 16.

32. *Testament of Experience,* p. 14.

33. *Chronicle of Youth,* p. 140.

34. *Testament of Experience,* p. 78.

35. Cf. Fussell, *The Great War,* p. 310: "the memoir is a kind of fiction, differing from the 'first novel' (conventionally an account of crucial youthful experience told in the first person) only by continuous implicit attestations of veracity."

36. Georges Poulet, *Studies in Human Time* (Baltimore: Johns Hopkins Press, 1956), p. 24.

37. Burton Pike, "Time in Autobiography," *Comparative Literature,* 28 (1976), 330.

38. Ibid., p. 332.

39. Fussell, *The Great War,* p. 21.

40. Pike, "Time in Autobiography," p. 332. For an interesting discussion of the "split subject" in female autobiography see Domna Stanton, "Autogynography: Is the Subject Different?" in Stanton, ed., *The Female Autograph: Theory and Practice of Autobiography from the Tenth to the Twentieth Century* (1984; rpt. Chicago: University of Chicago Press, 1987).

41. Fussell, *The Great War,* p. 310.

42. *Chronicle of Youth,* p. 145.

43. Ibid., p. 131. Cf. ibid., p. 163: "I wanted anything to wake up life from stagnation, anything to change the order of things."

44. Ibid., p. 175. Cf. ibid., p. 157: "if I were a man I should want to go."

45. Ibid., p. 184. 46. Ibid., p. 311.

47. Lynne Layton, "Vera Brittain's Testament(s)," in *Behind the Lines: Gender and the Two World Wars,* ed. Margaret Higonnet and Jane Jenson (New Haven: Yale University Press, 1987), p. 72.

48. Ibid., p. 73. 49. Ibid., p. 75.

50. Ibid., p. 74. 51. Ibid., p. 73.

52. *Chronicle of Youth,* p. 93.

53. Ibid., p. 324. 54. Ibid., p. 121.

55. Ibid., p. 78. 56. Ibid.

57. Fussell, *The Great War,* pp. 23–24.

58. Vera Brittain, *Poems of the War and After* (London: Victor Gollancz, 1934; New York: Macmillan, 1934), pp. 21, 23. All references are to the American edition.

59. Fussell, *The Great War,* p. 270.

60. Quoted in ibid., p. 214.

61. *Poems,* p. 16. 62. Ibid., p. 31.

63. Fussell, *The Great War,* p. 170.

64. Ibid.

65. Ibid., p. 235. Like Sassoon, Graves, Owen, Brooke, and other male war poets, Brittain was influenced by the pastoral tradition of British poetry. She turns to Wordsworth, Shelley, and Browning for "some consolation." *Testament of Youth,* p. 133.

66. *Poems,* p. 14. 67. Ibid., p. 19. 68. Ibid., p. 59.

69. *Chronicle of Youth,* p. 294.

70. Ibid.

71. Quoted by Jane Addams, *The Second Twenty Years at Hull House* (New York: Macmillan, 1930), pp. 122–23.

72. *Poems,* p. 36.

73. Elaine Showalter comments: "Part of the problem was tension between the novelists' lives as women and their commitment to literature. Members of a generation of women in rebellion against the traditional feminine domestic roles, they tried free love, only to find themselves exploited; if they then chose marriage, they often felt trapped." *A Literature of Their Own: British Women Novelists from Brontë to Lessing* (Princeton: Princeton University Press, 1977), p. 244.

74. *Testament of Experience,* p. 80.

75. Auerbach, "Old Maids," p. 222.

76. *Chronicle of Youth,* p. 126.

77. Ibid. 78. Ibid.

79. Ibid., p. 125. 80. Ibid., p. 148.

81. Ibid., p. 127. 82. Ibid., p. 153.

83. Bailey, *Vera Brittain,* p. 44.

84. Ibid., pp. 43–44.

85. Linking female survival to witchcraft, Showalter points out that in *The Mill on the Floss,* Maggie Tulliver has "the option of angelic innocence, which leads to death, or 'witchlike' self preservation." *A Literature of Their Own,* p. 125.

86. Faderman finds it "surprising that there were so few accusations of lesbian sexual activity directed against witches." She quotes two authorities that specifically "discount the possibility of lesbianism among witches entirely." *Surpassing the Love of Men,* p. 423. In choosing to be witchlike, then, Brittain takes upon herself some heavy burdens of social disapproval but not, perhaps, the one she feared the most.

87. *Testament of Experience,* p. 76. Holtby's Apr. 11, 1933, letter to Catlin claims that the last chapter "describes the slow and painful attempt at resurrection to be faced by a generation. The personal story symbolises the political movement."

88. Bailey, *Vera Brittain*, p. 93.

89. *Chronicle of Friendship*, p. 148.

90. *Testament of Experience*, p. 117.

91. George Catlin, *For God's Sake Go!* (Gerards Cross: Colin Smythe, 1972), p. 128.

92. Ibid., p. 130.

93. Winifred Holtby, *Take Back Your Freedom*, revised by Norman Ginsbury (London: Jonathan Cape, 1939), p. 42.

94. Ibid., p. 67. Holtby's treatment of homosexuality as a disease here is highly unusual for her and is overtly refuted in *Women and a Changing Civilisation*.

95. *Take Back Your Freedom*, p. 35.

96. Ibid., p. 92. 97. Ibid., p. 93.

98. *Testament of Friendship*, p. 370.

99. Ibid., p. 382.

100. *Women and a Changing Civilisation*, p. 189.

101. Ibid., p. 192. 102. Ibid. 103. Ibid., p. 173.

Notes to Chapter 5

1. DuPlessis, *Writing beyond the Ending*, pp. 93–94. For an extended study of novelists who have countered the traditional heterosexual romance ending see Joseph Allen Boone, *Tradition Counter Tradition: Love and the Form of Fiction* (Chicago: University of Chicago Press, 1987).

2. DuPlessis, *Writing beyond the Ending*, p. 101.

3. *Testament of Friendship*, p. 410.

4. Ibid., p. 418. 5. Ibid., p. 421. 6. Ibid., p. 341.

7. Ibid., p. 352. 8. Ibid., p. 422.

9. Winifred Holtby, *South Riding* (1936; rpt. London: Fontana Paperbacks, 1954), p. 226. All subsequent references are to the 1954 edition and will be cited in the text.

10. *Testament of Friendship*, p. 406.

11. Ibid., p. 411. 12. Ibid., p. 412. 13. Ibid.

14. Ibid., pp. 416–17. 15. Ibid., p. 416.

16. Ibid., p. 420. 17. Ibid., p. 325.

18. *Testament of Experience*, p. 142.

19. *Testament of Friendship*, p. 419.

20. Ibid., p. 421. 21. Ibid., p. 386.

22. Ibid. 23. Ibid., p. 387.

24. Bailey, *Vera Brittain*, p. 89.

25. Ibid., p. 90. 26. Ibid., p. 95. 27. Ibid.

28. *Testament of Experience*, p. 134.

29. Ibid., p. 146.

30. *Chronicle of Friendship*, pp. 239–40.

31. Bailey, *Vera Brittain*, p. 113. Cf. Muriel Mellown, "Reflections on Feminism and Pacifism in the Novels of Vera Brittain," *Tulsa Studies in Women's Literature*, 2 (1983), 217: "The most successful of her novels, and the one that most fully presents the feminist point of view."

32. *Testament of Experience*, p. 134.

33. Vera Brittain, *Honourable Estate* (London: Victor Gollancz, 1936; New York: Macmillan, 1936), p. xi. All subsequent references are to the American edition and will be cited in the text.

34. *Testament of Experience*, p. 124.

35. Ibid. 36. Ibid. 37. Ibid., p. 125.

38. Mellown, "Reflections on Feminism," p. 219.

39. *Halcyon*, p. 66; and, e.g., Vera Brittain, "What Does Motherhood Mean? The Possessive Instinct," *Manchester Guardian*, July 4, 1928, p. 8.

40. Mellown, "Reflections on Feminism," p. 220.

Notes to Epilogue

1. *Testament of Experience*, p. 143.

2. Ibid., p. 144.

3. Bailey, *Vera Brittain*, p. 110.

4. Ibid.

5. *Testament of Experience*, p. 399.

6. Ibid., p. 135. 7. Ibid., p. 203. 8. Ibid., p. 437.

9. Bailey appears to agree with me since she ends her biography of Brittain thirty years before her death.

10. *Testament of Experience*, p. 376.

11. *Testament of Friendship*, p. 389.

12. *Chronicle of Friendship*, p. 217.

13. Ibid., p. 210.

Bibliography

Books by Vera Brittain

Above all Nations. Ed. George Catlin, Vera Brittain, and Sheila Hodges. London: Victor Gollancz, 1945.

Account Rendered. 1945; rpt. London: Virago Press, 1982.

Born 1925. 1948; rpt. London: Virago Press, 1982.

Chronicle of Friendship: Vera Brittain's Diary of the Thirties, 1932–1939. Ed. Alan Bishop. London: Victor Gollancz, 1986.

Chronicle of Youth: Vera Brittain's War Diary, 1913–17. Ed. Alan Bishop with Terry Smart. 1981; rpt. New York: William Morrow, 1982.

The Dark Tide. 1923; rpt. New York: Macmillan, 1936.

England's Hour. 1941; rpt. London: Futura, 1981.

Envoy Extraordinary: A Study of Vijaya Lakshmi Pandit. London: George Allen and Unwin, 1965.

Halcyon, or The Future of Monogamy. London: Kegan Paul, 1929; New York: E. P. Dutton, 1929.

Honourable Estate. London: Victor Gollancz, 1936; New York: Macmillan, 1936.

Humiliation with Honour. London: Andrew Dakers, 1942.

In the Steps of John Bunyan. London: Rich and Cowan, 1950.

Lady into Woman: A History of Women from Victoria to Elizabeth II. London: Andrew Dakers, 1953; New York: Macmillan, 1953.

Not without Honour. London: Grant Richards, 1924.

On Becoming a Writer. 1947; rpt. as *On Being an Author*. New York: Macmillan, 1948.

One of These Little Ones . . . A Plea to Parents and Others for Europe's Children. London: Andrew Dakers, 1942.

Pethick-Lawrence: A Portrait. London: George Allen and Unwin, 1963.

Poems of the War and After. London: Victor Gollancz, 1934; New York: Macmillan, 1934.

Radclyffe Hall: A Case of Obscenity? 1968; rpt. Cranbury, N.J.: A. S. Barnes, 1969.

The Rebel Passion: A Short History of Some Pioneer Peace-Makers. London: George Allen and Unwin, 1964.

Search after Sunrise. London: Macmillan, 1951.

Seed of Chaos: What Mass Bombing Really Means. London: New Vision Publishing Co., 1944.

Selected Letters of Winifred Holtby and Vera Brittain (1920–1935). Ed. Vera Brittain and Geoffrey Handley-Taylor. Hull: Brown and Sons, 1960.

The Story of St. Martin's. London: Pitkin, 1951.

Testament of a Generation: The Journalism of Vera Brittain and Winifred Holtby. Ed. Paul Berry and Alan Bishop. London: Virago Press, 1985.

Testament of Experience. 1957; rpt. New York: Wideview Books, 1981.

Testament of Friendship: The Story of Winifred Holtby. 1940; rpt. New York: Wideview Books, 1980.

Testament of Youth. 1933; rpt. New York: Wideview Books, 1980.

Thrice a Stranger: New Chapters of an Autobiography. London: Victor Gollancz, 1938.

Verses of a VAD. London: Victor Gollancz, 1918.

The Women at Oxford: A Fragment of History. London: George Harrap, 1960.

Women's Work in Modern England. London: Noel Douglas, 1928.

Books by Winifred Holtby

Anderby Wold. 1923; rpt. London: Virago Press, 1981.

The Astonishing Island. London: Lovat Dickson, 1933; New York: Macmillan, 1933.

The Crowded Street. 1924; rpt. London: Virago Press, 1981.

Eutychus, or The Future of the Pulpit. London: Kegan Paul, Trench, Trubner, 1928.

The Frozen Earth. London: William Collins, 1935.

The Land of Green Ginger. 1927; rpt. London: Virago Press, 1983.

Letters to a Friend. Ed. Alice Holtby and Jean McWilliam. London: William Collins, 1937.

Mandoa, Mandoa! 1933; rpt. London: Virago Press, 1982.

A New Voter's Guide to Party Programmes: Political Dialogues. London: Kegan Paul, Trench, Trubner, 1929.

Pavements at Anderby. Ed. H. S. Reid and Vera Brittain. London: William Collins, 1937; rpt. New York: Macmillan, 1938.

Poor Caroline. 1931; rpt. London: Virago Press, 1985.

Selected Letters of Winifred Holtby and Vera Brittain (1920–1935). Ed. Vera Brittain and Geoffrey Handley-Taylor. Hull: Brown and Sons, 1960.

South Riding. 1936; rpt. London: Fontana Paperbacks, 1954.

Take Back Your Freedom. Revised by Norman Ginsbury. London: Jonathan Cape, 1939.

Testament of a Generation: The Journalism of Vera Brittain and Winifred Holtby. Ed. Paul Berry and Alan Bishop. London: Virago Press, 1985.

Truth Is Not Sober. London: William Collins, 1934.

Virginia Woolf: A Critical Memoir. 1932; rpt. Chicago: Academy Press, 1978.

Women and a Changing Civilisation. 1934; rpt. Chicago: Academy Press, 1978.

Works about Vera Brittain and Winifred Holtby

Bailey, Hilary. *Vera Brittain.* Harmondsworth: Penguin Books, 1987.

Kelber, Mim. "Lost Women: Vera Brittain and Winifred Holtby: Testament of Friendship." *Ms.*, March 1981, pp. 31–37.

Layton, Lynne. "Vera Brittain's Testament(s)." In *Behind the Lines: Gender and the Two World Wars.* Ed. Margaret Higonnet and Jane Jenson. New Haven: Yale University Press, 1987, pp. 70–83.

Mellown, Muriel. "The Development of Vera Brittain's Pacifism." *Frontiers,* 8 (1985), 1–6.

———. "Reflections on Feminism and Pacifism in the Novels of Vera Brittain." *Tulsa Studies in Women's Literature,* 2 (1983), 215–28.

———. "Vera Brittain: Feminist in a New Age (1893–1970)." In *Feminist Theorists: Three Centuries of Key Women Thinkers.* Ed. Dale Spender. New York: Pantheon, 1983, pp. 314–33.

Pickering, Jean. "On the Battlefield: Vera Brittain's *Testament of Youth.*" *Women's Studies,* 13 (1986), 75–85.

Rintala, Marvin. "Chronicler of a Generation: Vera Brittain's Testament." *Journal of Political and Military Sociology,* 12 (1984), 23–35.

Spender, Dale. "The Whole Duty of Woman: Vera Brittain." In Spender, *Women of Ideas (And What Men Have Done to Them).* London: Ark, 1983, pp. 627–39.

Other Works Consulted

Abel, Elizabeth. "(E)Merging Identities: The Dynamics of Female Friendship in Contemporary Fiction by Women." *Signs,* 6 (1981), 413–35.

Abel, Elizabeth, Marianne Hirsch, and Elizabeth Langland, eds. *The Voyage In: Fictions of Female Development.* Hanover, N.H.: University Press of New England, 1983.

Addams, Jane. *The Second Twenty Years at Hull House.* New York: Macmillan, 1930.

Ascher, Carol, Louise DeSalvo, and Sara Ruddick, eds. *Between Women.* Boston: Beacon Press, 1984.

Auerbach, Nina. *Woman and the Demon: The Life of a Victorian Myth.* Cambridge: Harvard University Press, 1982.

Bagnold, Enid. *A Diary without Dates*. 1918; rpt. London: Virago Press, 1978.

Bentley, Phyllis. *O Dreams, O Destinations*. New York: Macmillan, 1962.

Berkin, Carol R., and Clara M. Lovett, eds. *Women, War and Revolution*. New York: Holmes and Meier, 1980.

Bernikow, Louise. *Among Women*. New York: Crown Publishers, 1980.

Bleich, David. *Subjective Criticism*. Baltimore: Johns Hopkins University Press, 1978.

Boone, Joseph Allen. *Tradition Counter Tradition: Love and the Form of Fiction*. Chicago: University of Chicago Press, 1987.

Borden, Mary. *The Forbidden Zone*. London: Heinemann, 1929.

Catlin, George. *For God's Sake Go!* Gerards Cross: Colin Smythe, 1972.

Chernin, Kim. *The Hungry Self: Women, Eating and Identity*. New York: Times Books, 1985.

Chodorow, Nancy. *The Reproduction of Mothering: Psychoanalysis and the Sociology of Gender*. Berkeley: University of California Press, 1978.

Cook, Blanche Wiesen. "'Women Alone Stir My Imagination': Lesbianism and the Cultural Tradition." *Signs*, 4 (1979), 718–39.

Crews, Frederick, ed. *Psychoanalysis and the Literary Process*. Berkeley: University of California Press, 1970.

Culler, Jonathan. *On Deconstruction: Theory and Criticism after Structuralism*. Ithaca, N.Y.: Cornell University Press, 1982.

Dinnerstein, Dorothy. *The Mermaid and the Minotaur: Sexual Arrangements and Human Malaise*. New York: Harper Colophon, 1977.

DuPlessis, Rachel Blau. *Writing beyond the Ending: Narrative Strategies of Twentieth Century Women Writers*. Bloomington: Indiana University Press, 1985.

Dyhouse, Carol. *Girls Growing Up in Late Victorian and Edwardian England*. London: Routledge and Kegan Paul, 1981.

Edwards, Lee. *Psyche as Hero: Female Heroism and Fictional Form*. Middletown, Conn.: Wesleyan University Press, 1984.

Faderman, Lillian. *Surpassing the Love of Men: Romantic Friendship and Love between Women from the Renaissance to the Present*. New York: William Morrow, 1981.

Ferguson, Ann. "Patriarchy, Sexual Identity and the Sexual Revolution." *Signs*, 7 (1981), 159–72.

Fetterley, Judith. *The Resisting Reader: A Feminist Approach to American Fiction*. Bloomington: Indiana University Press, 1978.

Fish, Stanley. *Is There a Text in This Class? The Authority of Interpretive Communities*. Cambridge: Harvard University Press, 1980.

Flynn, Elizabeth, and Patrocinio Schweickart, eds. *Gender and Reading: Essays on Readers, Texts, and Contexts*. Baltimore: Johns Hopkins University Press, 1986.

Frye, Northrop. *Anatomy of Criticism: Four Essays.* 1957; rpt. New York: Atheneum, 1969.

Fussell, Paul. *The Great War and Modern Memory.* New York: Oxford University Press, 1975.

Gardiner, Judith. "Mind Mother: Psychoanalysis and Feminism." In *Making a Difference: Feminist Literary Criticism.* Ed. Gayle Greene and Coppelia Kahn. London: Methuen, 1985, pp. 113–45.

———. "On Female Identity and Writing by Women." *Critical Inquiry,* 8 (1981), 347–61.

Gardner, Brian, ed. *Up the Line to Death: The War Poets, 1914–1918.* London: Methuen, 1964.

Gilbert, Sandra. "Life Studies, or Speech after Long Silence: Feminist Critics Today." *College English,* 40 (1979), 849–63.

———. "Soldier's Heart: Literary Men, Literary Women and the Great War." *Signs,* 8 (1983), 422–50.

Gilligan, Carol. *In a Different Voice: Psychological Theory and Women's Development.* Cambridge: Harvard University Press, 1982.

Graves, Robert. *Goodbye to All That.* 1929; rpt. New York: Doubleday, 1957.

Hall, G. Stanley. *Youth: Its Regimen and Hygiene.* New York: Appleton, 1906.

Hirsch, Marianne. "Mothers and Daughters." *Signs,* 7 (1981), 200–223.

Holland, Norman. *The Dynamics of Literary Response.* New York: Oxford University Press, 1968.

Iser, Wolfgang. *The Act of Reading: A Theory of Aesthetic Response.* Baltimore: Johns Hopkins University Press, 1978.

Jacobus, Mary, ed. *Women Writing and Writing about Women.* New York: Harper and Row, 1979.

Jameson, Storm. *Journey from the North.* New York: Harper and Row, 1970.

Jeffreys, Sheila. *The Spinster and Her Enemies: Feminism and Sexuality, 1880–1930.* London: Pandora Press, 1985.

Jelinek, Estelle C., ed. *Women's Autobiography: Essays in Criticism.* Bloomington: Indiana University Press, 1980.

Kennard, Jean E. *Victims of Convention.* Hamden, Conn.: Archon Books, 1978.

Klein, Holger, ed. *The First World War in Fiction.* London: Macmillan, 1976.

Leed, Eric. *No Man's Land: Combat and Identity in World War I.* Cambridge: Cambridge University Press, 1979.

McConnell-Ginet, Sally, Ruth Borker, and Nelly Furman, eds. *Women and Language in Literature and Society.* New York: Praeger, 1980.

Marwick, Arthur. *The Deluge: British Society and the First World War.* Boston: Little, Brown, 1965.

Matthews, William. *British Autobiographies: An Annotated Bibliography of British Autobiographies Published or Written before 1951.* Berkeley: University of California Press, 1955.

Mitchell, David. *Women on the Warpath: The Story of the Women of the First World War.* London: Jonathan Cape, 1966.

O'Brien, Sharon. *Willa Cather: The Emerging Voice.* New York: Oxford University Press, 1987.

Owen, Wilfred. *The Collected Poems.* New York: New Directions, 1965.

Pike, Burton. "Time in Autobiography." *Comparative Literature,* 28 (1976), 326–42.

Poulet, Georges. *Studies in Human Time.* Baltimore: Johns Hopkins Press, 1956.

Rapp, Rayna, and Ellen Ross. "'It Seems We've Stood and Talked Like This Before.'" *Ms.,* April 1983, pp. 54–56.

Raymond, Janice. *A Passion for Friends: Toward a Philosophy of Female Affection.* London: Women's Press, 1986.

Reilly, Catherine, ed. *Scars upon My Heart: Women's Poetry and Verse of the First World War.* London: Virago Press, 1981.

Rhondda, Viscountess Margaret. *This Was My World.* London: Macmillan, 1933.

Rich, Adrienne. "Compulsory Heterosexuality and Lesbian Existence." *Signs,* 5 (1980), 631–60.

———. *Of Woman Born: Motherhood as Experience and Institution.* New York: W. W. Norton, 1976.

Sassoon, Siegfried. *Memoirs of an Infantry Officer.* 1930; rpt. London: Faber and Faber, 1965.

———. *Selected Poems.* London: Faber and Faber, 1968.

Showalter, Elaine. *A Literature of Their Own: British Women Novelists from Brontë to Lessing.* Princeton: Princeton University Press, 1977.

——, ed. *The New Feminist Criticism: Essays on Women, Literature and Theory.* New York: Pantheon Books, 1985.

Silkin, Jon. *Out of Battle: The Poetry of the Great War.* Oxford: Oxford University Press, 1972.

Skura, Meredith. *The Literary Use of the Psychoanalytic Process.* New Haven: Yale University Press, 1981.

Smith, Helen Zenna. *Stepdaughters of War.* New York: E. P. Dutton, 1930.

Smith-Rosenberg, Carroll. "The Female World of Love and Ritual: Relations between Women in Nineteenth Century America." *Signs,* 1 (1975), 1–29.

Spender, Dale. *Time and Tide Wait for No Man.* London: Pandora Press, 1984.

Stanton, Domna C., ed. *The Female Autograph: Theory and Practice of Autobiography from the Tenth to the Twentieth Century.* 1984; rpt. Chicago: University of Chicago Press, 1987.

Suleiman, Susan, and Inge Crosman, eds. *The Reader in the Text: Essays on Audience and Interpretation*. Princeton: Princeton University Press, 1980.

Todd, Janet. *Women's Friendships in Literature*. New York: Columbia University Press, 1980.

Tompkins, Jane P., ed. *Reader-Response Criticism: From Formalism to Post-Structuralism*. Baltimore: Johns Hopkins University Press, 1980.

Vicinus, Martha. *Independent Women: Work and Community for Single Women, 1850–1920*. London: Virago Press, 1985.

———. "Sexuality and Power: A Review of Current Work in the History of Sexuality." *Feminist Studies,* 8 (1982), 133–56.

Weintraub, Karl. "Autobiography and Historical Consciousness." *Critical Inquiry,* 1 (1975), 821–48.

Wohl, Robert. *The Generation of 1914*. Cambridge: Harvard University Press, 1979.

Zinker, Joseph. *Creative Process in Gestalt Therapy.* New York: Random House, 1977.

Index

Abel, Elizabeth, 16, 17, 23, 197 n.72
Andrews, Henry Maxwell, 129, 141
Auerbach, Nina, 150
Austen, Jane, 37, 58
Authorization: women's of each other, 17, 55
Autobiography, 128, 129, 130, 134, 161, 206 n.35; women's, 129, 130, 205 n.22. *See also* Brittain, Vera; Holtby, Winifred

Bagnold, Enid, 144
Bailey, Hilary, ix, 5, 152, 175, 176, 177, 189, 194 n.10
Ballinger, William, 163
Benson, Stella, 85, 104
Bentley, Phyllis, ix, 23, 103, 112, 130, 165, 175, 179
Berry, Paul, ix, 5, 7
Bishop, Alan, ix, 67, 70, 131
Blunden, Edmund, 129
Boone, Joseph Allen, 208 n.1
Borden, Mary, 129
Brett, George, 175, 176, 184
Brittain, Edith (mother), 26; Vera Brittain's relationship with, 20, 26, 28, 30, 45, 48, 72, 152, 155, 162, 198 n.20, 201 n.19
Brittain, Edward (brother): Vera Brittain's relationship with, 21, 24, 25, 27, 51, 130, 135, 136, 137, 139, 141, 142, 145, 146, 148, 153, 154, 155, 178
Brittain, Thomas (father): Vera Brittain's relationship with, 70, 136, 155, 177
Brittain, Vera: *Above All Nations,* 190; *Account Rendered,* 191; ambitions of, 2, 8, 25, 28, 48, 55, 96, 150, 152, 154, 155, 198 n.22; appearance of, 2, 45; autobiographical elements in *Born 1925,* 191, *The Dark Tide,* 43, 45, 46, 47, *Honourable Estate,* 177, 184, 185, *Not with-*

out Honour, 71, 72; *On Being an Author,* 12; *Born 1925,* 12, 191; as character in *The Crowded Street,* 56, 57, *Land of Green Ginger,* 85, *Poor Caroline,* 107; children of (John Catlin, Shirley Williams), 92, 127, 130, 178; Christianity, attitude to, 134, 176, 189; *Chronicle of Friendship,* 126, 176; *Chronicle of Youth,* 26, 70, 71, 125, 126, 130, 132, 133, 135, 136, 139, 143, 145, 146, 150; *The Dark Tide,* 18, 20, 24, 25, 30, 43–54, 55, 56, 57, 58, 64, 65, 66, 75, 179; development as writer, 11, 12, 17, 20, 21, 91, 94, 126, 161, 190, 191; education of, 3, 138, at Oxford, 24–25, 26, 30, 48, 133, 142, 144, 145, 149, 151, 152, 154; *England's Hour,* 190; feminism of, 11, 17, 18, 50, 79, 94, 95, 125, 136, 137, 150, 181, 199 n.27; friendship with Holtby, 1, 2, 5, 6, 7–8, 11, 12, 15, 17, 21, 23, 24, 25, 30, 43, 46, 51, 56, 73, 76, 81, 90, 103, 112, 113, 127, 128, 142, 151, 153, 154, 155, 156, 161, 162, 175, 176, 177, 188, 190, 191, 192; *Halcyon,* 92, 95–97, 98, 127, 181; heterosexuality, attitude toward, 3, 5, 49, 74, 75, 96, 138, 139, 151, 152, 153, 154, 156, 169, 187; history, view of, 134; "Honeymoon in Two Worlds," 77, 93; *Honourable Estate,* x, 22, 161, 162, 165, 176–88, 191, relationship to *The Dark Tide,* 179, *Not without Honour,* 179; *Humiliation with Honour,* 190; lesbianism, attitude toward, 5, 67, 96, 109, 112, 151, 154, 177; marriage, attitude toward, 3, 10, 11, 15, 49, 56, 64, 65, 67, 73, 75, 93, 96, 97, 108, 109, 127, 146, 149, 156, 183, 200 n.2, 201 n.18; marriage of, 55, 67,